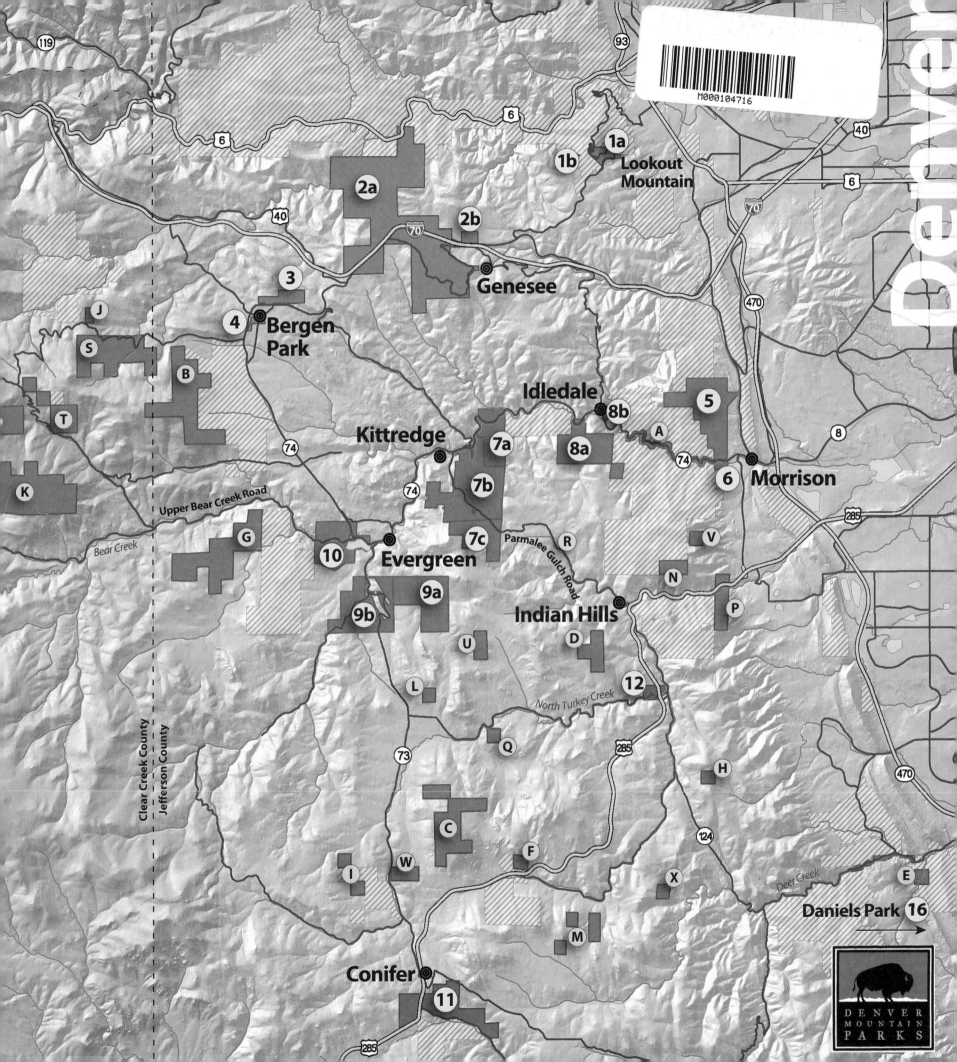

Denver

Lookout Mountain

Genesee

Bergen Park

Idledale

Kittredge

Morrison

Evergreen

Indian Hills

Conifer

Upper Bear Creek Road

Bear Creek

Parmalee Gulch Road

North Turkey Creek

Deer Creek

Clear Creek County
Jefferson County

Daniels Park **16**

DENVER
MOUNTAIN
PARKS

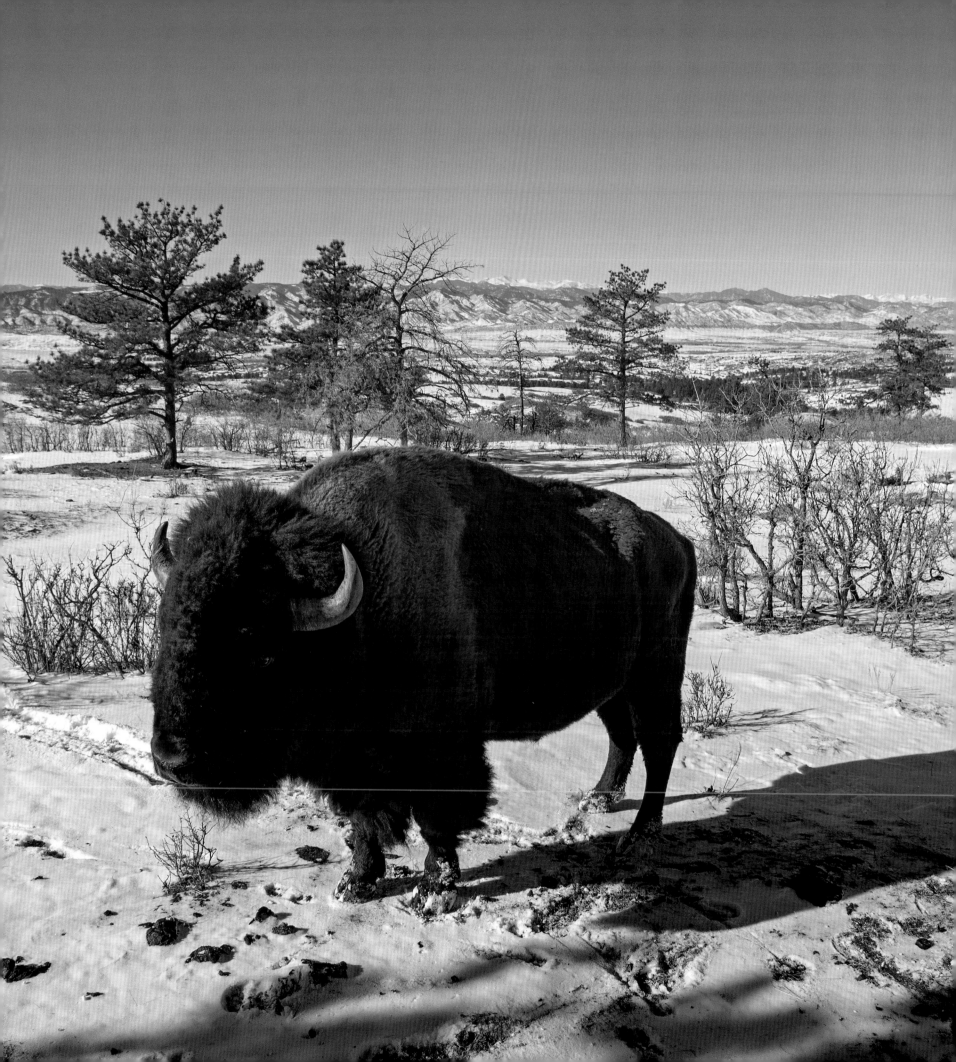

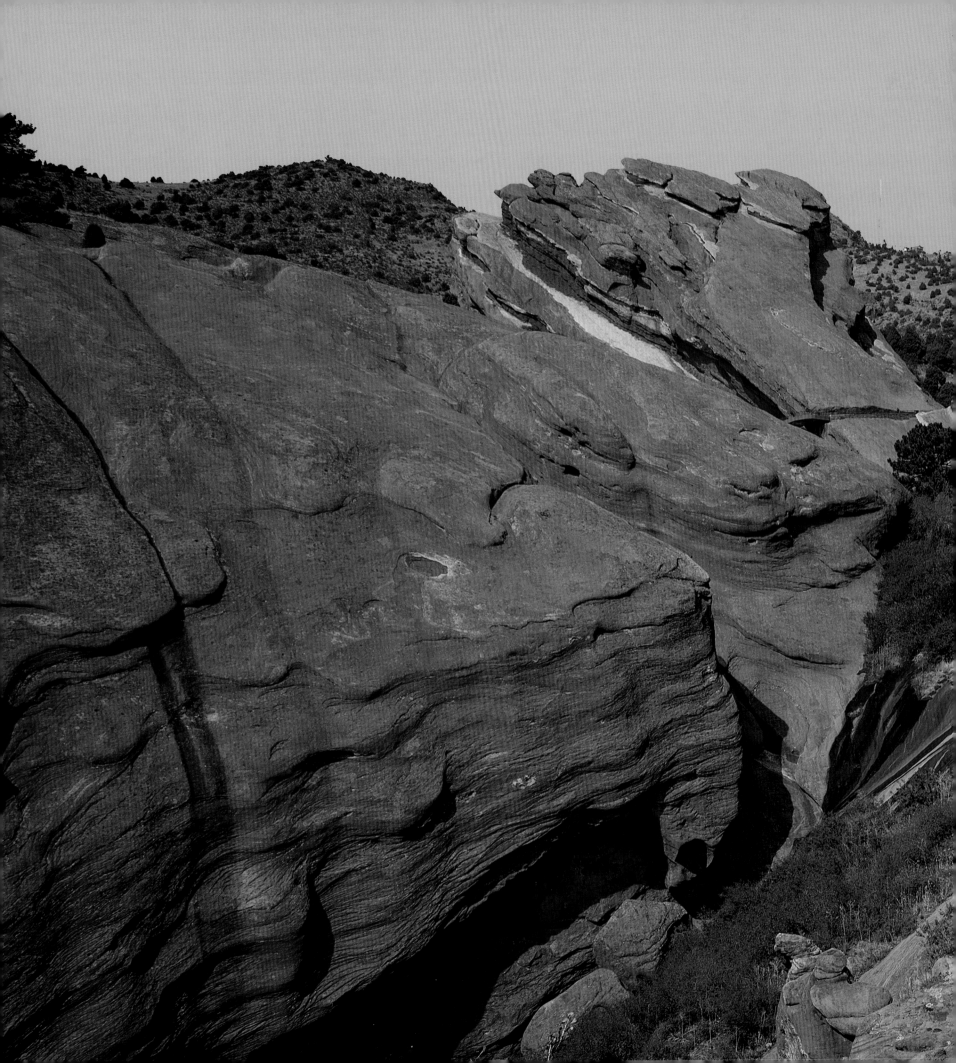

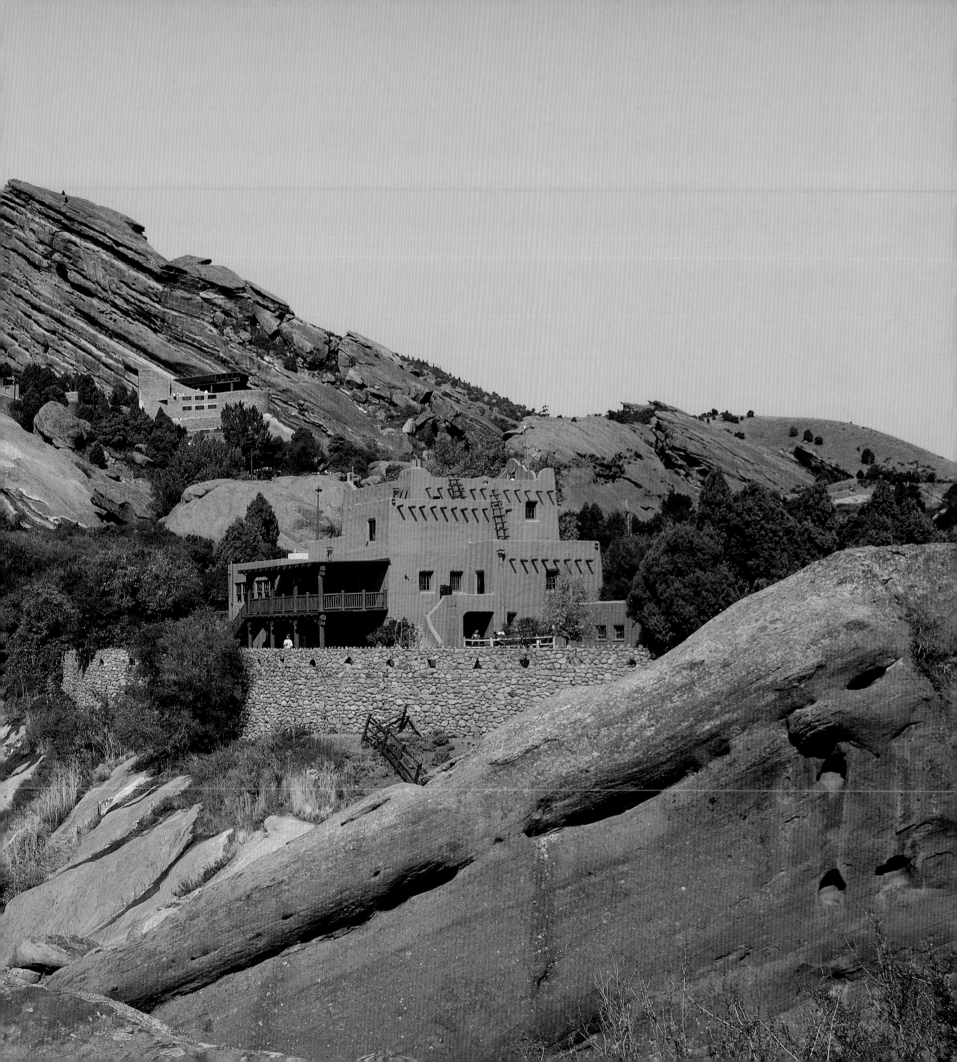

COVER: Fall view of Mount Evans from Summit Lake Park
FIRST FRONTISPIECE: Bison, Daniels Park; SECOND FRONTISPIECE: Red Rocks Park Trading Post and Amphitheatre
ABOVE: Berrian Mountain conservation area with Meyer Ranch in the foreground
BACK COVER: The tunnel on Creation Rock Drive provides access to the top of Red Rocks Amphitheatre. The "Natural
Color Post Card" by E.C. Kropp Co. (#5296, at left) in fact exaggerates the colors of the rocks and surroundings.

Denver
Mountain Parks
100 Years of the Magnificent Dream

PHOTOGRAPHY
AND PREFACE
John Fielder

FOREWORD
Thomas J. Noel

TEXT
Wendy Rex-Atzet,
Sally L. White, &
Erika D. Walker

AFTERWORD
W. Bart Berger
Denver Mountain Parks Foundation

JOHN FIELDER PUBLISHING
SILVERTHORNE, COLORADO

City and County of Denver

OFFICE OF THE MAYOR
CITY AND COUNTY BUILDING
DENVER, COLORADO • 80202-5390
TELEPHONE: 720-865-9000 • FAX: 720-865-8787
TTY/TTD: 720-865-9010

Michael B. Hancock
MAYOR

To Those Who Love Our Mountain Parks:

For the past century, the citizens of the City and County of Denver, along with countless visitors to Colorful Colorado, have had the benefit and privilege of enjoying our Denver Mountain Parks system. Today, our parks, open spaces, and natural areas have become a part of our Denver history and heritage, providing benefits for our region beyond what was ever imagined one hundred years ago. The lands protected and preserved in these parks enrich our lives and our children's lives, allowing us easy and accessible opportunities to connect with and experience the natural world.

As mayor, I am keenly aware that the legacy of these parks is a dynamic gift, and it is an honor to be part of the continued stewardship of these wonderful places. As we celebrate our Denver Mountain Parks' centennial, we look forward to discovering new ways to enhance the lives of our citizens through the enjoyment of these amazing spaces. We will continue the work of our predecessors and we will move forward boldly, forging partnerships and creating new relationships that will ensure a vibrant Denver Mountain Parks system for future generations.

Sincerely,

Michael B. Hancock
Mayor, City and County of Denver

Office of Michael Hancock

Sponsor Acknowledgments

Financial support for this book, in part, has come from the generosity of Cynthia R. Kendrick, K.C. Veio, Tim and Kathryn Ryan, Katy Uhl, Tim Collins, David C. Collins, Ron Loser, Susan Berger Sheridan, Andy and Connie Miller, Carlton Lindsay, Mike Bellamy, Dick Eason, Chris Bartling, Brad Buchanan and RNL Design, Bruce C. O'Donnell, Canton O'Donnell, Wick Downing, Richard Downing Jr., James J. Volker Family Trust, Jim Havey and Havey Productions, The Denver Beer Company, Mundus Bishop Design, and the Joseph O. and Geraldine C. Waymire Fund. Significant contributions have come from the William Falkenberg family (Bill, Janis, and Ruth) and the Department of Parks and Recreation of the City and County of Denver.

Foreword

Mountains.

They make Colorado special. Remember the uproar when someone proposed redesigning our license plates without the mountain silhouette? Even communities on the state's far eastern prairies and far western canyonlands often play up their views of the distant, snowcapped Rockies.

Thank the mountains, my grandmother used to say. They give us air that only the angels have breathed before. They give us water never drunk before. A relentless booster, Grandma never mentioned the weekend traffic jams as everyone headed for, and then back from, the hills.

Colorado's greatest attraction is its mountains. Anyone, on any day, can face those soaring peaks and get a spiritual lift. Those of us in the state's urbanized and suburbanized densities know we can escape in an hour or two to secluded mountain paths, streams, forests, alpine meadows, and snowfields.

A century ago, Denver created its Denver Mountain Parks as the first attempt to preserve, to celebrate, and to open up our mountains to sightseers, picnickers, anglers, and campers—and eventually to hikers, skiers, and snowboarders. Once the high country became a park instead of land to mine, log, buy, and sell, getting away to it became a ritual, a holy day, a holiday, the best day of the week.

Other cities have mountain parks, but have any developed such an extensive network outside of their municipal boundaries? What other system includes a large ski area, Winter Park, and a far-famed outdoor amphitheatre, Red Rocks—as well as two buffalo herds? Certainly no other city parks system nestles against a 14,264-foot peak, Mount Evans, accessible by the continent's highest paved road. Another, Lookout Mountain Park, boasts the grave and museum of the most celebrated and, some said, most handsome American of his age—William Frederick "Buffalo Bill" Cody. Because Wyoming and Nebraska also wanted the body and the tourist shrine centered on it, tons of concrete reinforced with railroad track were placed on top of Bill to discourage body snatchers. Let this be a reminder that we need to guard and protect our mountain parks.

Denver established its mountain parks to preserve the most dramatic high country settings. Fortunately, Denver acted when it did. Not until 1959 would Colorado finally get around to establishing a state parks system to protect special places. When the federal government created Rocky Mountain National Park in 1915, it did not include the much larger acreage proposed by park champions such as Enos Mills.

If Denver had not acted back in 1912, much of the land that is now mountain parks would have been developed. Residences, strip malls, and big-box stores keep creeping into the hills. Denver made the prescient effort to preserve mountains in their natural state for public enjoyment and recreation.

That story is told here for the first time in detail.

The storytellers are Wendy Rex-Atzet, whose scholarly research sheds new light on the legendary early decades, and mountain parks historian Sally White. Rex-Atzet and White are joined by Erika Walker, writer, educator, and great-granddaughter of John Brisben Walker, one of the key pioneer promoters behind the Denver Mountain Parks. Together they tell this important and inspiring story. John Fielder's powerful photos, each worth several thousand words, gracefully enhance the narrative throughout this book and balance the many historical images with contemporary views. To wrap things up, W. Bart Berger, founder of the Denver Mountain Parks Foundation, provides perspective on the mountain parks today and shows how Denver's foresight created a long-term asset for the citizens of the Front Range and beyond.

Happy reading and happy trails!

—THOMAS J. NOEL
Denver, Colo.

Thomas J. Noel is a professor of history at the University of Colorado Denver, the author of more than 40 books, a Sunday Denver Post *columnist, and "Dr. Colorado" for 9NEWS's "Colorado & Company."*

OPPOSITE: Early mountain parks supporters had views like this in mind. These foothills are seen at sunrise from Mount Evans looking due east to Denver across the many hilltops, valleys, and forests preserved by advocates of the Denver Mountain Parks system.

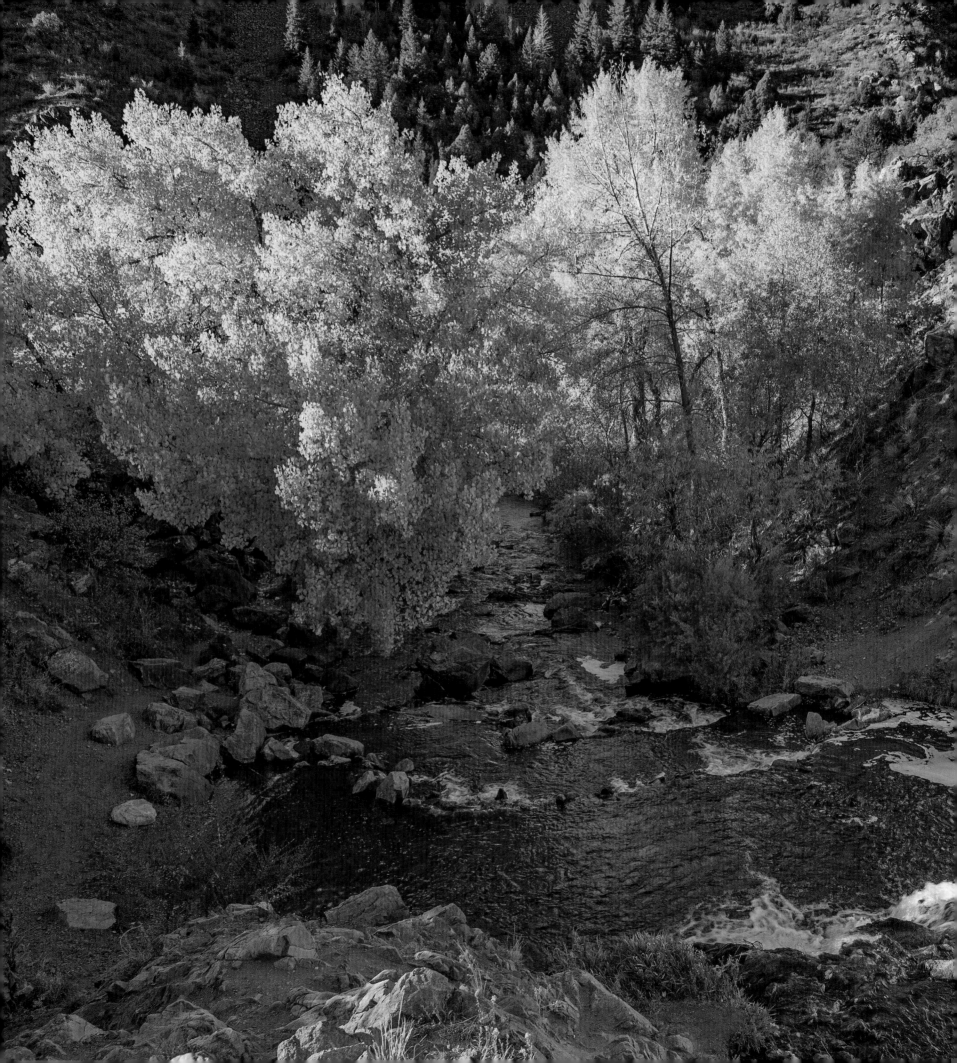

Preface

As soon as I was done photographing and producing two books for my Great Outdoors Colorado project, I got an email from Bart Berger on behalf of the Denver Mountain Parks Foundation. Bart invited me to participate in a book project with the following entreaty:

John Fielder making repeat photos of Red Rocks W. Bart Berger

I would like to bring one [project] forward that might not be onerous, and would have some importance, I believe, in reinvigorating the City of Denver's commitment to its historic mountain parks system.

2013 is the centennial year of the forming of the Denver Mountain Parks, now grown to more than 14,000 acres within 50 miles of the city. The Denver Mountain Parks Foundation and the city department of Parks & Recreation are funding the cost of a centennial book, covering not only the history of the system, but aimed directly at the future of these places, and their important role in outdoor education for Denver citizens and their visitors.

I'd like to have this book feature a photo by someone (you) whose appreciation for the natural world is undeniably infectious. Moreover, I'd like that guy to write a short intro or foreword, which would recharge the vision of the city that made them happen in the first place. I'd like you to speak to how the mountain parks fulfill Denver's obligation to its citizens by providing places of quiet, and preserving important habitat, watersheds, and viewsheds.

Note the reference to one photo! Herein you will find 50 scenic images and 25 then-and-now photo pairs that I made in 2012 for the book. What happened? First, I prefer to promote important conservation projects in a *big* way, and second, I knew that contributing more than one photo would allow me to see and experience the remarkable Denver Mountain Parks, mostly for the first time. Yes, I had been to concerts at Red Rocks Amphitheatre, skied Winter Park, photographed Summit Lake once or twice, and driven by Daniels Park many times, but I had not seen, nor even known, that there are 42 more parks in between Mount Evans and Denver. Great Outdoors Colorado is the entity that distributes the majority of Colorado Lottery profits to cities and counties so they can build parks and trails, and protect open space and ranches across the state. And what better project to follow one that celebrates statewide protection of parks than one that reminds Coloradans how its Queen City has led the way in building parks for one hundred years?

Within its borders, Denver has created one of the world's great municipal park, open-space, and trail systems. Most recently, foresightful mayors such as Hancock, Hickenlooper, Webb, and Peña have added new city parks to those whose legacy began a century ago. What is exceptional about our forebears was their desire to protect what makes the city truly special: its views of the Rocky Mountains and guaranteed access to the best of its foothills and mountains. And the bonus they could never have imagined is a Denver viewshed to the west without a home on every ridgeline and mountaintop.

As you read Bart Berger's afterword, you will come to understand the historical relationship between economy and ecology in Colorado, and for that matter, all western states. Denver Mountain Parks were created to provide both solace to a burgeoning population and to promote population growth for the sake of the economy. As a capitalist businessman and a devout environmentalist, I too have learned the symbiosis between protecting blue skies, clean water, wilderness, ranches, parks, and trails and a sustainable economy. It's no accident that the environmental and economic future of Colorado lies in preserving our "attractive" assets, not exploiting the extractive ones.

—JOHN FIELDER
Summit County and Denver, Colo.

OPPOSITE: Bear Creek Canyon conservation area

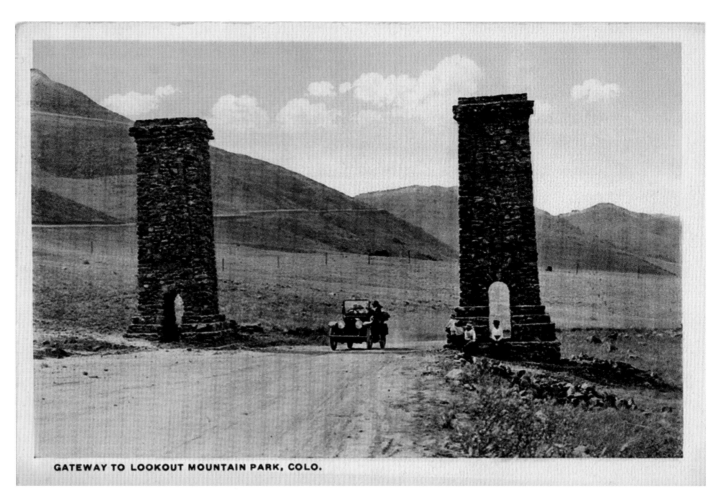

GATEWAY TO LOOKOUT MOUNTAIN PARK, COLO.

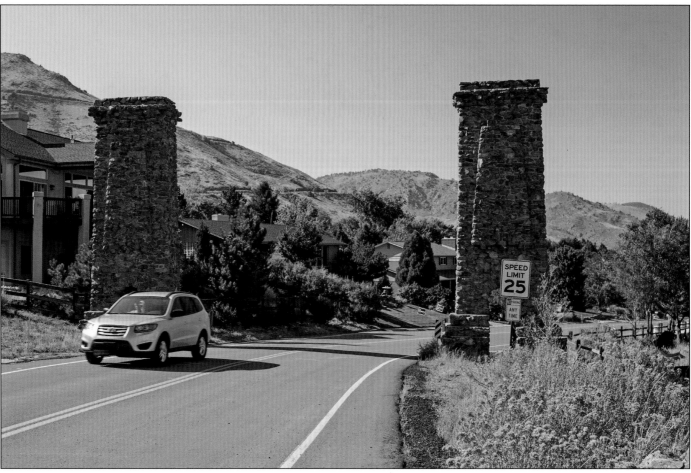

The MacFarland Gateway to the Denver Mountain Parks, donated in 1917 by Findlay MacFarland, still marks the entrance to the Lariat Trail Scenic Mountain Drive (Lookout Mountain Road) at Golden. (**Please note:** As demonstrated here, in the then-and-now photo pairs throughout this book, the historic image appears either above or to the left of John Fielder's contemporary retake.)

Introduction

The most extensive and magnificent system of parks possessed by any city in the world, covering eight square miles and including 41,000 acres, running from Turkey Creek Canon on the south to Mt. Vernon Canon on the north, with Bear Creek Canon about in the center, all within about ten miles of the city. … That is the amazing plan conceived by John Brisben Walker. —The Denver Post, October 30, 1910

The Denver Mountain Parks have inspired visitors for more than a century. The 22 developed parks and 24 conservation areas total more than 14,000 acres and comprise one of the most expansive and unusual park systems in the West. All outside Denver city limits, these parks extend across the mountains and foothills of Colorado's Jefferson, Clear Creek, Douglas, and Grand counties.

From the oak woodlands of Daniels Park, where legendary frontiersman Kit Carson built his last campfire, to the alpine lake near Mount Evans with plants found nowhere else outside the Arctic Circle, the parks showcase an extraordinary variety of settings. In addition to hiking, fishing, golfing, picnicking, or simply relaxing, Denver Mountain Parks' visitors can enjoy a world-class concert at Red Rocks Amphitheatre, ski at the world-renowned Winter Park Resort, and explore significant historic sites such as Lookout Mountain Park, the final resting place of Buffalo Bill Cody.

The visionary founders of the mountain parks were determined to make their dream a reality. Because of their dedication and hard work, some of the most spectacular landscapes in Colorado—and some would say the world—have been safeguarded from development and remain accessible to everyone. Once home to Ute and Cheyenne, trappers and frontiersmen, pioneers and ranching families, these wildlands—now forever protected—will continue to provide a home to the area's earlier residents: elk, eagles, bison, black bears, mountain lions, and countless other wildlife and plants.

In honor of the parks' centennial, *Denver Mountain Parks: 100 Years of the Magnificent Dream* tells the story of these treasured lands.

Part 1: Developing the Mountain Parks, 1910–1940, begins with the early history of the park system. In the years around 1910, men such as John Brisben Walker, Kingsley A. Pence, and Warwick Downing worked to rally public support for municipal parks in the nearby mountains. After passage of the Mountain Parks Charter Amendment in the city election of May 1912, Denver commissioned a comprehensive development plan from the nation's top landscape architect, Frederick Law Olmsted Jr. The story continues through three decades of dynamic development as parklands were acquired, roads built, lodges and amenities constructed. By 1940, the Denver Mountain Park system was largely complete, from the historic Lariat Trail, built in 1913, through the last mountain park the city would develop, the Winter Park ski area.

Part 2: Defending the Mountain Parks, 1941–2012, continues the story through the development of the new master plan, outlines the struggles to maintain the far-flung parks in the face of dwindling budgets, and highlights the triumphs of these later decades. In 1955, the discontinuation of dedicated funding for the parks marked the beginning of decades of financial challenges. Yet, in spite of budget difficulties, World War II, and other challenges, the parks continue as a prized resource for Colorado and beyond.

Part 3: Discovering the Mountain Parks presents up-to-date, detailed information on the 22 developed parks so both first-time and regular visitors can make the most of their visit. Park locations, hours, and amenities such as hiking and biking trails, picnic areas, historic sites, camping information, and more are explained in an easy-to-use format. A map accompanying this text appears inside the front cover.

Part 4: The Future of the Mountain Parks considers what the parks will need to thrive in their next one hundred years. The same visionary leadership that inspired them will be necessary to maintain, develop, and improve the parks in the 21st century. Important questions about funding sources and management will need to be addressed. Denver's mountain parks need our advocacy and renewed commitment to remain the irreplaceable resource they are today.

Throughout the book, historic photographs and documents enhance the text, along with new images by John Fielder that showcase the parks' unparalleled scenery. In addition to his dramatic scenic photos, Fielder captures modern views to match and contrast past and present through then-and-now photo pairs.

Much has changed in the one hundred years since the mountain parks' founding. Today many are surrounded by residential communities, as well as parks and open space managed by other counties and municipalities. In the early years, visiting the parks required an all-day excursion, but now, most can be reached in less than an hour from downtown Denver. The metropolitan population—214,000 in 1912, now almost three million—continues to grow. Homes and businesses multiply as urban development expands into the mountains. Open wildland, something that has defined Colorado and which many took for granted, is becoming increasingly scarce. Suburbs now border some mountain parks, creating the almost surreal experience of watching bison graze within sight of neatly trimmed lawns.

But thankfully, some things haven't changed. The blue silhouette of the Rockies rising above the Great Plains still calls people to Colorado—both to visit and to live. Because of our mountain parks and open spaces, it's still possible to rest on a sun-warmed hillside and watch a hawk ride the pine-scented breeze. For more than a century, the mountain parks have helped make Colorado a very special place—a place where generations could grow and play in the mountains, and share in the magnificent dream of mountain parks.

—ERIKA D. WALKER, Denver, Colo.

Developing the Mountain Parks

We believe the Mountain Park should be more than a picnic place; it should be a summer home for the people of Denver, and indeed for the tourists of the nation.

—Mountain Parks Committee, December 1911

In 1912, the City of Denver embarked on a visionary plan to establish "mountain parks" in the Rocky Mountain foothills west of the city. During the next 30 years, Denver built an extensive system of parks that would protect beautiful mountain landscapes and ensure public access for generations to come. By 1940, the Denver Mountain Parks included 22 developed parks and 24 conservation areas featuring the finest natural scenery in the region, more than 75 miles of scenic mountain roadways, and a host of elegantly rustic amenities and attractions that rivaled the national parks of the day.

A coalition of advocates joined forces to make the mountain parks a reality. Mayor Robert W. Speer made an early call for mountain recreation on behalf of Denver, but Morrison's most charismatic entrepreneur, John Brisben Walker, made the first decisive moves in 1910. Walker gained the support of Denver's commercial organizations, and then a committee

Wendy Rex-Atzet

19

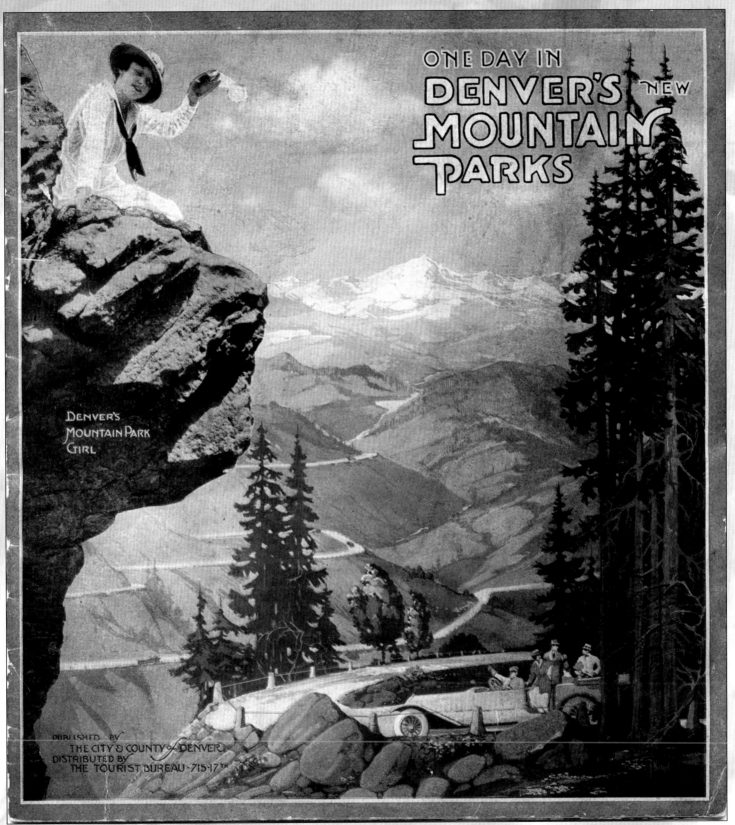

ONE DAY IN
DENVER'S NEW
MOUNTAIN
PARKS

DENVER'S
MOUNTAIN PARK
GIRL

PUBLISHED BY
THE CITY & COUNTY OF DENVER
DISTRIBUTED BY
THE TOURIST BUREAU · 715-17TH

An early tourist brochure, one of
several printed to attract visitors
to the "new" mountain parks
Denver Mountain Parks files

00-1940

led by Warwick M. Downing and Kingsley A. Pence honed the plan and brought it before Denver voters. At the city election of 1912, the Mountain Parks Charter Amendment won wide public support, and voters approved a new mill levy to fund the project.

Soon after the election, Denver engaged the consulting services of Frederick Law Olmsted Jr., one of the most esteemed landscape architects in the country, to design the new parks. Olmsted consulted on the project for two years as the city began acquiring the first parks and building the first roads. His far-reaching plan for mountain parks and roads, completed in 1914, would guide the city's planners for many years.

By 1918, the city had acquired parks and built parkways to form a circle tour stretching from Denver to Golden, up Lookout Mountain, west to Evergreen, then returning to the city via Bear Creek Canyon and Morrison. The roads of the central loop were beaded with parks— Lookout, Genesee, Fillius, Bergen, Corwina, Little, Starbuck—like a necklace upon the landscape. Nature lovers flocked to the parks in numbers that surprised even the most farsighted advocates.

Denver's park planners responded to the mountain parks' popularity with plans for expansion, and the 1920s saw the construction of the Mount Evans Drive, Echo Lake Lodge, and Evergreen Lake. Denver closed the decade with the purchase of the iconic Red Rocks Park.

Thanks to Depression-era federal programs such as the Civilian Conservation Corps (CCC), development in the mountain parks continued during the 1930s. The CCC's role in building the amphitheatre at Red Rocks Park is well known, but Denver also took advantage of federal programs to build trails, bridges, and park structures, and to improve the mountain roads. Denver's municipal ski resort, Winter Park, was the city's last mountain park acquisition in 1939. A host of changes were in store for the mountain parks in the decades after World War II. Yet those who contributed their vision to the system in its early years left a legacy of preserved natural beauty and a tradition of easy access to outdoor recreation that generations of Colorado residents have treasured.

Dreaming the Mountain Parks

The idea of creating a city park in the nearby mountains simmered in Denver for years. After all, by 1900 Boulder had Chautauqua Park, and Colorado Springs was a fashionable summer resort famed for Garden of the Gods and Pikes Peak. The earliest documented proposals for a mountain park in Denver date back to 1901, but momentum gathered slowly.

MAYOR SPEER AND THE CITY BEAUTIFUL

Denver's dynamic and powerful mayor, Robert W. Speer, invited local philanthropists in 1907 to build the city a grand boulevard to the mountains. Speer was inspired by what he had seen on a recent tour of Europe's great cities. As the *Rocky Mountain News* reported that January, the mayor envisioned a broad, tree-lined road to the foothills—nothing less than an Appian Way.

Robert W. Speer

Speer, who served as mayor from 1904–1912 and 1916–1918, was a devotee of the City Beautiful Movement. This sweeping effort to remake the unpleasant urban environments of the early 20th century was changing the face of cities across America. Parks, boulevards, public works, and classical architecture became hallmarks of the nation's City Beautiful tradition, which aimed to improve the quality of urban life by making cities clean, organized, and aesthetically pleasing.

Mayor Speer established new parks, built and landscaped boulevards, started plans for the Denver Civic Center, and remade filthy, flood-prone Cherry Creek into a landscaped greenway. Under Speer's direction, the city paved streets, installed electric streetlights, expanded the sewer system, and built up Denver's urban forest with a popular free tree campaign. In fact, Denver garnered national recognition as an exemplar of the City Beautiful ideal. For many residents, the city's new parks, boulevards, and public buildings became lasting symbols of urban achievement and civic pride.

Speer more than doubled the acreage of Denver's city parks during his first two terms. However, his parks and public works remained within city limits. He believed the city must rely on private benefactors to develop mountain recreation. The municipal government, he explained in a 1910 speech reprinted in the city's news organ, *Denver Municipal Facts,* did not have the authority to go beyond its boundaries.

Mayor Speer accrued a posthumous reputation as the "father of the mountain parks," but his role in making the mountain parks a reality was actually quite limited. Instead, the mountain parks' story involves several imaginative, determined individuals who took the initiative and won the support of a larger public to create a lasting investment in municipal mountain recreation.

JOHN BRISBEN WALKER: The Idea Man

In 1910, the mountain park idea finally coalesced in Denver, prompted in large part by colorful entrepreneur John Brisben Walker. Committed to promoting the beauties and healthy climate of Colorado, Walker was wealthy, charismatic, and known for his ambitious ventures. "There is not a rundown man or woman anywhere who cannot be made over by coming into the dry, bracing atmosphere of Colorado, living in the open air and forcing the oxygenation of his blood by plenty of exercise," Walker enthused in *The Denver Post.*

Walker's influence extended well beyond Denver. His varied enterprises included manufacturing, real estate, amusements, journalism, and—at all times—unflagging promotion. Historian Thomas J. Noel is among those who have helped reconstruct Walker's story. Walker first moved to Colorado in the early 1880s. He introduced alfalfa to the area and prospered as a real-estate developer. In 1887, he opened River Front Park, a popular amusement park on the banks of the Platte that featured a riverboat, thrill rides, entertainment, and a museum called the Castle of Culture and Commerce.

In 1893, Walker moved to Tarrytown, N.Y., where he became editor and publisher of *The Cosmopolitan,* a literary magazine. During

John Brisben Walker

the 12 years he ran the publication, Walker's national stature surged, along with his recognition among literary, political, and social-reform circles. He remade the struggling magazine into a high-quality, affordable, and popular periodical. In the process, Walker almost singlehandedly transformed the American magazine industry, argues sociologist Matthew Schneirov. His unmistakable voice—he often wrote features for the magazine—became part of the fabric of the country's popular culture.

In 1905, J.B. Walker left New York and returned to Colorado with a new venture in mind. He and his eldest son, J.B. Walker Jr., planned to remake sleepy Morrison into a classy resort town and develop the Park of the Red Rocks as a tourist attraction to rival Colorado Springs. The senior Walker arrived in Colorado a millionaire after selling *The Cosmopolitan* to William Randolph Hearst.

Together with his son, Walker would pour his fortune and prodigious energies into the Morrison enterprise.

Between 1905 and 1910, the Walker family purchased more than 4,000 acres of real estate in and around Morrison, including the 720-acre Park of the Red Rocks. The Denver dailies followed the news of Walker's plans and purchases throughout these years. Most of Walker's properties were held within his two development companies, the Colorado Resort Company and the Colorado Power, Water, Railway, and Resort Company; others were held privately. By 1910, the Walker holdings included large tracts on Mount Falcon and Mount Morrison, as well as a few parcels in town.

The Walkers quickly set out to create a destination park at Red Rocks. J.B. Walker Jr. renamed many of the formations after figures of Greek mythology and rechristened the park Garden of the Titans.

They added foot trails throughout the park, carved steps into some of the formations, and installed ladders so visitors could climb to dizzying heights, such as Creation Rock's new observation deck. They also built the first stage in the natural amphitheatre. On May 31, 1906, the Walkers hosted a grand opening of their scenic park, attended by more than 2,500 visitors.

The Walkers also renovated the old Evergreen Hotel. With the Walker touch, this stately building became the Mount Morrison Casino, a luxury resort hotel complete with ballroom, billiards, viewing decks, and a Japanese teahouse. In 1909, Walker opened the Mount Morrison Incline Railway. This funicular offered a thrilling 1,500-foot ascent and expansive views of Morrison, the Hogback, Denver, and the Great Plains beyond.

J.B. Walker's agile promotions would bring three U.S. presidents, including Theodore Roosevelt, to stay at his hotel and enjoy the pleasures of a mountain vacation. He brought esteemed artists—such as opera star Mary Garden in 1911—to perform in the natural amphitheatre, and hosted Sunday concerts atop Creation Rock. Hollywood filmmakers shot early westerns

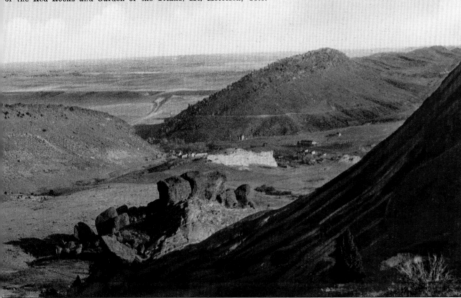

618. View of the Plains, Lakes, Dyke and Hotel. of the Red Rocks and Garden of the Titans, Mt. Morrison, Colo.

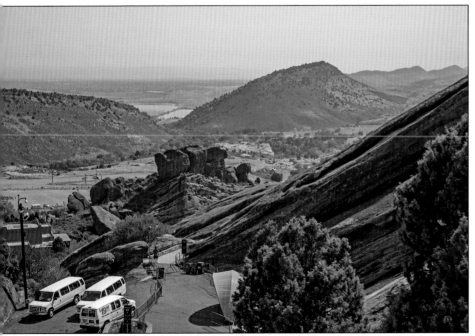

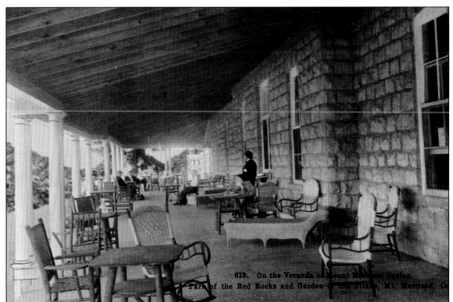

619. On the Veranda at Mount Morrison Casino. Park of the Red Rocks and Garden of the Titans, Mt. Morrison, Co

TOP: This postcard from the Walker era shows a view of J.B. Walker's hotel, the Mount Morrison Casino, from a vantage point in the natural amphitheatre of his Garden of the Titans. Thayer Publ. Co. #618, Denver Mountain Parks files

Presidents and celebrities enjoyed the Walkers' gracious hospitality at the Mount Morrison Casino. As mayor of Morrison, J.B. Walker Jr. persuaded the post office to change the town's name to Mount Morrison in 1908. Thayer Publ. Co. #619, Denver Mountain Parks files

"A splendid opportunity is presented for some one with means to secure and present to the city a ten-thousand-acre mountain park, within twenty or twenty-five miles of the city, with beautiful valleys, canons, streams, cliffs and scenery unsurpassed, where the masses may spend a happy day and feel that some of the grandeur of the Rocky Mountains belongs to them." —**Mayor Robert W. Speer,** February 21, 1910

amongst the red rocks as well. As Noel observes, the Walkers and their "passion for promotion" effectively "put Red Rocks on the map."

It might have been J.B. Walker's dedication to promoting Colorado that prompted him to spur Denver's civic leaders to action on the mountain park question. In a 1910 speech at the YMCA, Mayor Speer made his first public call for a mountain park, marking a significant shift from his earlier hopes for an Appian Way to the mountains. Still, the mayor's conviction that such an amenity must be the work of philanthropy remained unchanged.

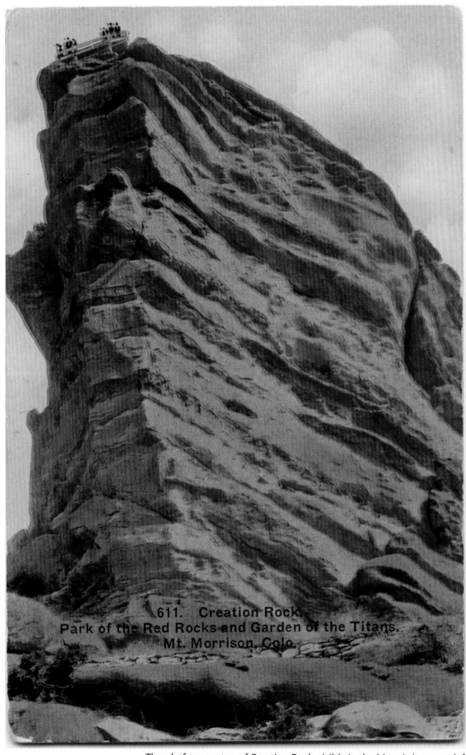

611. Creation Rock.
Park of the Red Rocks and Garden of the Titans.
Mt. Morrison, Colo.

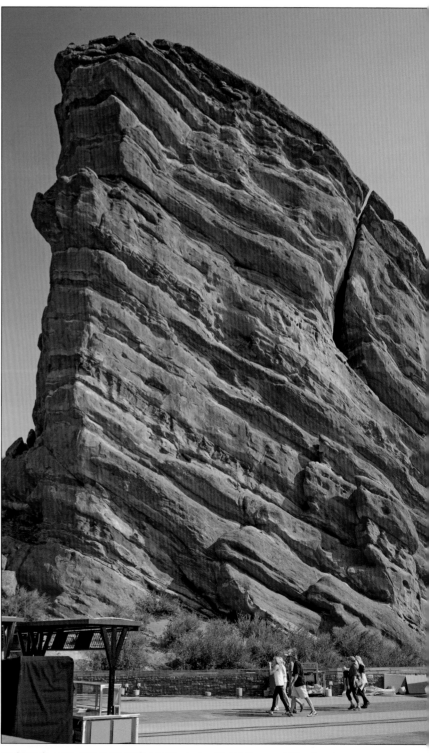

The platform on top of Creation Rock, visible in the historic image at left, hosted Sunday concerts in J.B. Walker's day; today (right) the amphitheatre at Red Rocks is the primary venue. Stairs and ladders that gave visitors access to the stairway to the top are now gone, and climbing on rocks is prohibited.
Thayer Publ. Co. #611, Denver Mountain Parks files

But no donor came forward. Soon Walker took the matter in hand. During the fall of 1910, he approached the Chamber of Commerce and the Real Estate Exchange, pitching his own plan for a large mountain park west of Morrison. The Real Estate Exchange was especially receptive to Walker's "eloquent plea," president Seth Bradley recalled in 1932. Bradley quickly appointed a committee, under the leadership of Kingsley A. Pence, to evaluate the proposition. Pence would play a central role in the success of the mountain parks, a fact that Denver leaders recognized in naming one of the mountain parks in his honor.

Meanwhile, Walker placed a full-page story in *The Denver Post* on October 30, 1910. The feature announced Walker's "amazing" plan for the "most extensive and magnificent system of parks possessed by any city in the world." Walker proposed that Denver purchase 41,000 acres in the mountains west of Morrison, "all within ten miles of this city." He called for "five great boulevards" extending from "the city's prominent thoroughfares," which would allow residents from every part of Denver easy access to the mountains.

Walker argued that a mountain park would entice tourists to "stay here instead of passing us by." He urged Denver leaders to follow the example of Switzerland and Colorado Springs, "where the people have improved the splendid gifts nature has placed within their reach" by furnishing "delightful driveways and swift-moving trolleys and inclined railways to all the places of scenic grandeur and beauty." The plan offered something for everyone: Local businesses would reap the rewards of increased tourism, the city's reputation would be enhanced, and Denver residents would gain access to convenient mountain recreation.

A SUMMER HOME FOR THE PEOPLE OF DENVER

Walker's press piece stimulated a surge of interest in Denver, prompting the Real Estate Exchange to move forward with vigor. In November, the *Post* reported that the exchange had begun surveying on Lookout Mountain and drumming up public support. Soon the Chamber of Commerce and the Denver Motor Club formed investigative committees of their own.

Wick Downing
Warwick M. Downing

On March 2, 1911, the three organizations combined their efforts, forming a single joint committee chaired by K.A. Pence to investigate and promote the mountain parks. Three members from each organization were chosen to sit on the executive committee. Chaired by Warwick M. Downing of the Chamber of Commerce, this smaller group was officially called the Mountain Parks Committee of the Commercial Bodies. With Downing and Pence in key leadership roles, this executive committee shouldered the workload of the project.

In April 1911, the Mountain Parks Committee made a tour to inspect potential mountain park sites, accompanied by city park officials and news reporters from local papers. J.B. Walker hosted a luncheon for the group at his home on Mount Falcon, at which he propounded again his vision for the future mountain parks.

However, concerns mounted that Walker hoped to profit by selling his mountain lands to the city for the parks. *The Chamber of Commerce News Bulletin* soon reported that "no one having any

personal interest in the sale of land for the proposed park should serve on the committee." Walker's influence in the mountain parks movement would grow increasingly tenuous as the committee took the reins. Nonetheless, he continued to develop Morrison and Red Rocks as a resort, and to pursue his plans for Mount Falcon. These efforts would dovetail with the growth of the mountain parks in the ensuing years.

In December 1911, the Mountain Parks Committee presented a detailed mountain park plan to the members of the three commercial bodies. "Our mountains offer the opportunity of the greatest summer resort country in America," the committee argued, confident that mountain parks and new roads to reach them would make Denver "more attractive to tourists than Switzerland." But the mountain parks were not solely intended for tourists: "We believe the Mountain Park should be more than a picnic place," stated the report, "it should be a summer home for the people of Denver."

"A Mountain Park for Denver will be the first step, and, perhaps, the greatest step, in the great movement of making our mountains available for the people. … Such a park will yield untold pleasure to the people of Denver, and as an attraction to visitors will prove a commercial asset worth one hundred times its cost."

—**Mountain Parks Committee,** December 1911

The report called for "a chain or series of parks somewhat in the form of a semi-circle," with parks at Lookout Mountain, Genesee Mountain, Bergen Park, Evergreen, and Turkey Creek. "Each park should be connected with all the others by a well built road, and each end of the chain should be connected with Denver by a splendid drive." Two boulevards leading from Denver would extend to gateways at Golden and Morrison.

The report also outlined the legal actions that would allow Denver to build the mountain parks. Mayor Speer's fruitless appeals to philanthropy had convinced the group that the city must take an active role. Yet early efforts to secure funding from the mayor and from the state legislature had failed, noted the Chamber of Commerce in its bulletin. Downing later recalled how the group realized "that City officials would never lead in such a project; that no City Council would ever appropriate money for its commencement." They also recognized that "it would be difficult to procure continuing appropriations in a region where there would be no votes." The matter, they concluded, must be taken directly to the people.

To do this, the committee drafted an amendment to the city's charter and placed it on the ballot for the municipal election in May 1912. If approved by voters, the Mountain Parks Charter Amendment would vest the city with the necessary authority to acquire and improve land outside the city limits for park purposes. The amendment also established a new property tax earmarked for mountain park development. The tax was set at 0.5 mill per each dollar of taxable property in the city for five years. After five years, the annual assessment might be lowered depending on need, according to the legislation. The amendment also allowed for the issuance of bonds, although this type of debt financing was never utilized to develop the mountain parks. The dedicated mill levy would sustain development and maintenance of the system until 1955.

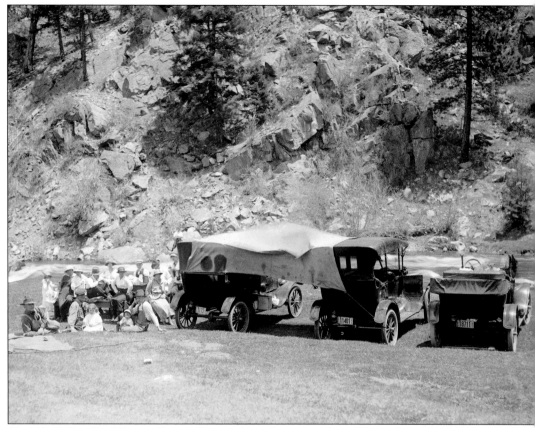

Picnicking in Bear Creek Canyon, Denver's "summer home," was a popular activity made possible by Denver Mountain Parks. Denver Public Library, Western History Collection, MCC-2609

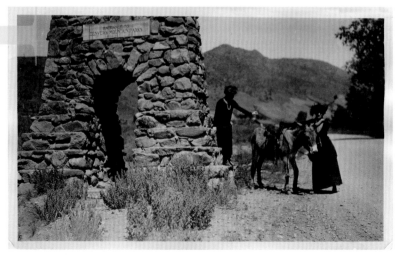

This gateway at Morrison matched the one at Golden (see p. 10), accessing the mountain parks via Bear Creek Canyon and the Garden of the Titans. From 1897 until 1971, the Hebrew family's Gateway Stables, just a short walk from the Morrison train station, offered tours of Red Rocks via burro or pony. Chambers Collection

"VOTE FOR THE MOUNTAIN PARKS"

The committee's plan met with hearty approval from the Real Estate Exchange, Chamber of Commerce, and Denver Motor Club, and leaders set their sights on the May election. As it happened, Mayor Speer was hobbled by a political scandal at the time and the once-popular mayor did not even run for reelection in 1912. Undeterred, Pence planned an elaborate campaign designed to explain to Denver voters "just what a Mountain Park System was, what it would accomplish, and what it would cost."

The committee blanketed Denver with publicity as the election drew near. Maps and posters hung in businesses and trolley cars. Newspaper advertisements explained how the owner of a "modest home" valued at $3,000 would pay just 50 cents per year, allowing the entire family to "forever enjoy the Mountain Parks." Pence wrapped up the campaign with a dramatic touch. On Election Day, "two or more beautiful young ladies" were stationed at each polling location. "Dressed in white with wide blue sashes," the maidens "carried the appeal, 'Vote for the Mountain Parks.'" In Downing's estimation, they were the "most effective feature" of the entire mountain parks campaign. "What voters could resist the dainty miss with her white frock … Nobody!" On May 21, 1912, Denver voters passed the Mountain Parks Charter Amendment by an 8,000-vote majority.

But before the city could take any action, these rights also had to be granted by the state. A bill was introduced in the next legislative session, and in April 1913 Colorado lawmakers confirmed Denver's authority to obtain land for parks and parkways outside the city limits. The state also vested Denver with police jurisdiction over the mountain parks, the power to create ordinances to govern them, and the ability to prosecute violations in the courts.

Launching a Park System

In its annual report for 1913, the Denver Board of Park Commissioners explained that the mountain parks were intended to assure "perpetually to the residents of Denver the sublime scenery of the Rockies, the preservation of native forests and having for all time a pleasure ground in the mountains for the thousands of annual visitors to the city easily accessible." In the heady days following the May election, many in Denver looked with keen anticipation to the time when the city would fulfill this promise.

THE OLMSTED PLAN

After the election the city moved quickly, bringing in the Olmsted Brothers landscape architecture firm, arguably the most respected and influential park professionals of the day. Frederick Law Olmsted Jr. met with the Denver Board of Park Commissioners, the Mountain Parks Committee, and J.B. Walker in July 1912. He toured the mountain region and was impressed with the possibilities. By summer's end the Denver Park Board contracted with Olmsted to develop a plan for the mountain parks, as well as plans for the Denver Civic Center, the Denver Zoo, and other city parks and parkways. During the next two years, Olmsted worked closely with the park board as mountain park acquisitions and road construction commenced.

Olmsted provided critical guidance to the city from the start. In a memo dated July 17, 1912, he offered a primer on developing a park system out of relatively whole cloth. To lay the groundwork for success, Denver needed to foster cooperation with federal, state, and county governments. Olmsted advised the park board to work with state and federal officials to hold potential mountain park lands in reserve for the city.

He also emphasized the importance of collaborating with state and county road authorities as roads were planned and built in the park region, so that "every dollar hereafter spent upon roads within the region may be part of a consistent general plan," and to ensure that future roads in the park region would meet the construction and design standards set by the park board.

Frederick L. Olmsted Jr.

Finally, Olmsted argued that building roads and devising means to protect the scenery should precede acquiring and developing parkland:

> Undoubtedly the three chief things to be accomplished are: First, the provision of a system of first-class roads, giving the public convenient access to the best of the mountain scenery; second, the protection of at least the more important parts of that scenery, by any and every means which may be found expedient; … third the opening to the public for general use of sufficient areas … to provide liberally for resting places, picnic places, camping places, and ultimately for shelters and hotels and other facilities, so situated as to give to the public the fullest possible opportunities for the enjoyment of the mountain scenery.

Olmsted completed his comprehensive plan for Denver's mountain park system in January 1914. Ambitious and insightful, the Olmsted Plan recommended that Denver acquire 41,310 acres of mountain land in Jefferson County. This was a remarkable proposal for the preservation and recreational development of 65 square miles of wilderness land by a relatively distant municipality. Olmsted went well beyond the Mountain Parks Committee's concept, selecting 20 tracts of land, some as large as 9,000 acres, stretching as far

Private benefactors purchased a tract of the forest in what is now Genesee Park in early 1912 to protect the land from logging, thus paving the way for the auto touring that was so central to the early Denver Mountain Parks experience. Denver Public Library, Western History Collection, MCC-2283.

RIGHT: This contemporary image captures the view of Mount Evans preserved at Genesee Park. One historical description of the vista from Genesee Mountain noted, "While the peak itself is not picturesque, the prospect from it is magnificent. Not only does it overlook the great plains to the east, but it offers one an unusual panorama of the Rocky Mountains to the west." W. Bart Berger

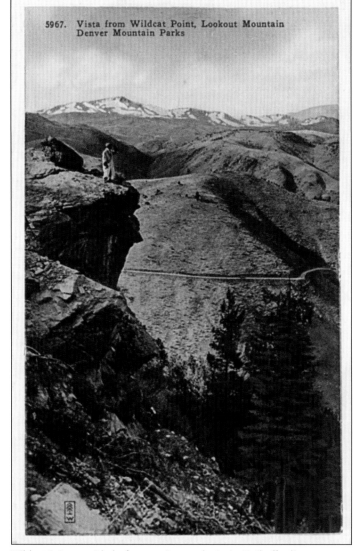

5967. Vista from Wildcat Point, Lookout Mountain
Denver Mountain Parks

Wildcat Point provided a famous vista on the Lariat Trail, affording
"an unsurpassed view of the plains to the east," according to this 1920s
postcard. Today most visitors enjoy a similar panorama from the terrace
at Lookout Mountain Park near the Buffalo Bill Museum. H.H.T.Co. #5967

Architects of the Mountain Parks: The Olmsted Legacy

When the Denver Park Board brought in the Olmsted Brothers firm, it sought the leading talent in American landscape architecture. Principals Frederick Law Olmsted Jr. and John C. Olmsted were scions of the legendary Frederick Law Olmsted.

The senior Olmsted had given direction and definition to the fledgling park movement for four decades. The designer of Central Park in 1858, he helped establish Yosemite National Park in 1862. His work on the Boston park system and the 1893 World's Columbian Exposition in Chicago held tremendous influence. He even did some work in Colorado, including an 1891 plan for a resort (never built) on Lookout Mountain. Olmsted died in 1903.

By 1910, Frederick Law Olmsted Jr. was recognized as the nation's foremost expert in city planning. He had worked with his father on the Columbian Exposition and designed the park and parkway system for greater Washington, D.C. A founding member of the American Society of Landscape Architects, he also launched the country's first undergraduate program in the discipline at Harvard. When the junior Olmsted took on Denver's mountain park project in 1912, he was no stranger to Colorado. He had recently completed plans for Boulder and Colorado Springs. A testament to his skill, Olmsted's plan for the Denver Mountain Parks has retained its significance for a century.

land to Denver for park purposes. Both bills failed dismally. For the 1914 congressional session, Denver forces retooled their appeal, this time with Olmsted's help. In a meeting at the Brown Palace Hotel with Assistant Secretary of the Interior A.C. Miller, Olmsted and the Denver Park Board proposed a compromise that might satisfy both federal and local officials. They thought a "considerable portion of the [federal] land" Olmsted had identified for inclusion in Denver's mountain parks could, instead, be transferred to the U.S. Forest Service, "as it was contiguous and near" the Pike National Forest boundaries.

It made for an inspired plan. On August 25, 1914, President Woodrow Wilson signed the law granting Denver the option to buy 7,040 acres of federal land at the bargain price of $1.25 per acre. Denver eventually purchased some 5,800 acres for its mountain parks from federal holdings. Companion legislation added 9,680 acres identified in the Olmsted Plan to U.S. Forest Service holdings. Olmsted had helped broker a deal that effectively protected more than 15,000 acres of mountain land between Denver and Mount Evans.

FIRST PARKS

As soon as the ink was dry on the state legislation that paved the way for Denver to act, the city stood ready to begin purchasing land and building roads with funds gathered from the first mill levy assessment. Work in 1913 focused on the northern gateway areas of Genesee and Lookout Mountain.

Genesee Park

Genesee Park traces its origins back to 1911. During its initial investigations that year, the Mountain Parks Committee learned that some 1,200 acres on Genesee Mountain had recently been sold and was slated for imminent logging. Rather than allow "that magnificent

west as Squaw Mountain. Olmsted recommended each park based on its "natural charm and fitness" and its accessibility.

The plan called for two primary approach boulevards from Denver to the gateways at Golden and Morrison, and a whopping 200 miles of scenic parkways to connect the parks. Olmsted's road plan was especially influential in its advice on road placement and design to capture the best scenic views and offer a safe, pleasant driving experience. He urged the park board to strive for the highest standards of quality, and to engineer cuts and margins that would allow vegetation to regrow, thus making the roadway seem like a part of the natural scenery.

Denver eventually came to hold 14,000 acres in its mountain parks; of this total, Olmsted had identified about 8,000 in his 1914 plan. Olmsted's vision was further realized in the last quarter of the 20th century, when Jefferson County Open Space acquired much of the remaining land he had identified for the mountain parks.

Olmsted also played a pivotal role in Denver's efforts to secure parkland from the federal government. Colorado introduced bills in Congress twice requesting the transfer of 34,000 acres of federal

forest" to be chopped down, recalled Warwick M. Downing, real-estate man E.W. Merritt solicited donations to buy some of the land preemptively. Contributors to the effort included such notables as F.G. Bonfils, W.G. Evans, E.B. Field, and the Joslin Dry Goods Company.

In January 1912, Merritt purchased several hundred acres on Genesee Mountain, placing the land in a trust to be held until the city could buy it. Denver made its first purchase of Genesee land in September 1913. Over the years, the city painstakingly cobbled together purchases and donations to create its largest mountain park, with 2,413 contiguous acres.

Genesee Park quickly became home to a municipal wildlife preserve. In its 1913 report, the park board announced plans for enclosures on the mountain where elk, bison, deer, antelope, and mountain sheep would be placed to live in natural surroundings. In February 1914, Denver received 31 wild elk shipped by train from Yellowstone National Park. The animals were a gift from Secretary of the U.S. Department of the Interior Franklin Lane, who promised to send bison, too, once the weather improved. Newspapers reported

how the elk had to be housed temporarily in the Denver Zoo while the city built an enclosure at Genesee Park. Later that year, the city placed seven bison and 23 elk in the new preserve. The initial 165-acre enclosure was soon expanded and the Genesee herds grew quickly. Today, the descendants of those original bison graze alongside busy I-70.

Lookout Mountain Park

In April 1913, the city negotiated a crucial deal with real-estate developer Rees Vidler, owner of the Lookout Mountain Resort Company. In connection with the city's construction of the Lariat Trail Road, Vidler agreed to donate 58 acres to the city to create Lookout Mountain Park.

In the summer of 1912, anticipating the success of the city's mountain park plans, Vidler opened a funicular (incline) railway that carried passengers from Golden to the top of Lookout Mountain. This scenic excursion was immediately popular for flower gathering and picnic parties, and carried many visitors to the mountaintop park in the early years. Denver improved this keystone park in 1913 with the first picnic shelter built in the mountain parks. Made of native stone, it was designed by architects W.E. and A.A. Fischer.

Building the Lariat Trail

Roadwork was of central importance in mountain park development from the beginning. On May 8, 1913, the city commenced work on the first road in the mountain parks: the dramatic Lariat Trail Road that winds its way up Lookout Mountain.

Frederick Law Olmsted Jr. played a key role in the design of this road as he was working on his mountain park plan. Superintendent of Parks Frederick C. Steinhauer, a civil engineer, oversaw construction of this and other park roads. The city's landscape architect, Saco Rienk DeBoer, also contributed to the effort. The city hired William "Cement Bill" Williams to manage the day-to-day work. A concrete builder from Golden, Williams had been trying for years to get a road built on Lookout Mountain. The *Colorado Transcript* reported in March that Olmsted and Steinhauer met with Williams, who was already working on some sections of the road in advance of the city.

Two crews tackled the job, one working downward from the top and the other from the bottom up. Workers blasted rock, hauled it away, and leveled the roadbed using picks, shovels, and wagon teams. By fall 1913, the Lariat Trail Road was completed to the summit of Lookout Mountain and opened to drivers.

The Lariat Trail Road was designed to showcase the best views along its route. The designers carefully preserved an "easy" grade, no greater than six percent. The highway was 20 feet wide—excessively wide according to its critics—to allow the free flow of two-way traffic all along its length. These specifications established an important precedent that was followed on future Denver Mountain Park roads.

Cement Bill gained notoriety the following May, when he famously blocked Denver drivers at the entrance to the Lariat Trail. He was angry that the city had been slow to pay him for his work on the road. Denver paid its bill, and Bill let the drivers through.

Construction of the Lariat Trail signified the first of many instances in which Denver would collaborate with state and county

Genesee's Historic Bison Herd

Public interest in restoring wildlife ran high in the early 1900s, in response to the near extermination of bison and other wildlife during the 19th century. Denver tried repeatedly to obtain purebred bison for its zoo in City Park and, in 1903, purchased five cows from the famed Flathead herd in Montana. The city acquired two bulls, one named "Goodnight," from the Goodnight herd in Texas in 1905. For the next several years, these animals and their offspring at City Park were the only purebred bison in Colorado.

Two bulls shipped from Yellowstone National Park to Denver in 1914 were placed in the Genesee Game Preserve with cows from the City Park herd, which by then numbered about 20. By 1925, the Genesee herd had reached 40 and several animals were returned to the zoo for display. By that time, bison populations were recovering nationwide, with more than 14,000 purebred animals in North America, all but one-tenth of which lived in public and private captive herds, according to records of the American Bison Society. In 2007, the U.S. Department of Agriculture reported 220,000 bison in managed herds in the United States alone, nearly half of all the bison in North America.

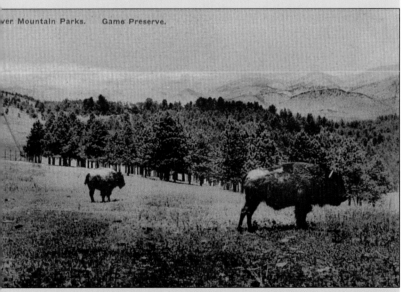

...ver Mountain Parks. Game Preserve.

Hand-colored postcard, circa 1915 Kendrick-Bellamy Co.

1918-1918

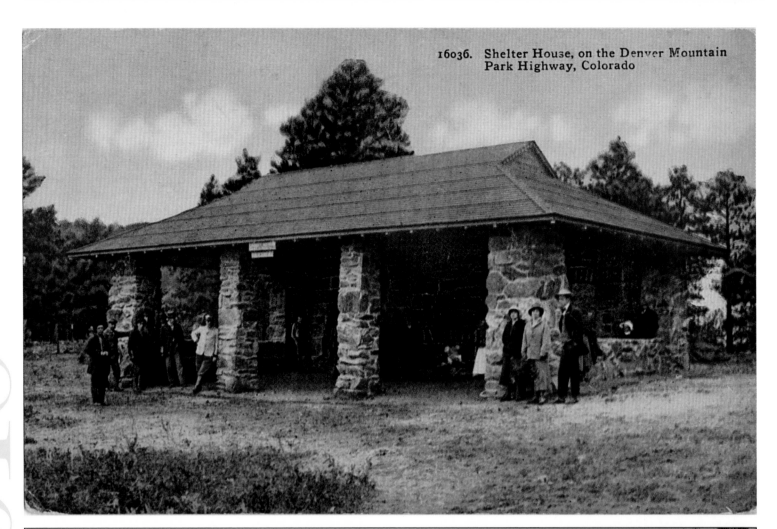

16036. Shelter House, on the Denver Mountain Park Highway, Colorado

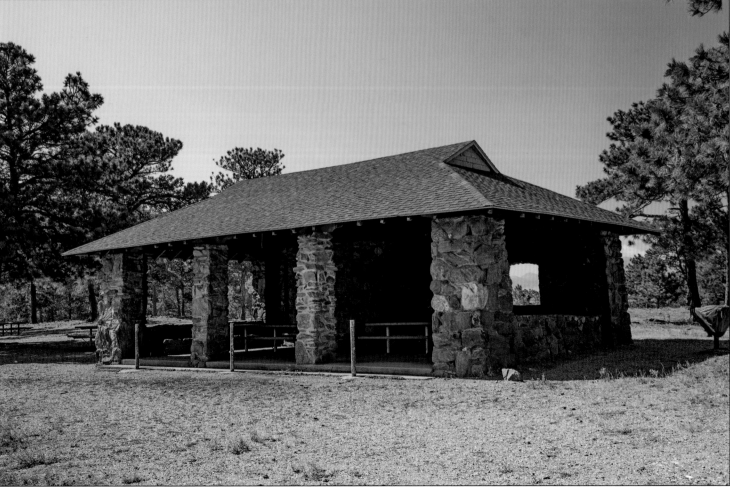

TOP: Built in 1913, the shelter at Lookout Mountain was ready to welcome visitors when the park system formally opened that year. This first shelter house in the mountain parks set the character for those that would follow. H.H.T. Co. #16036

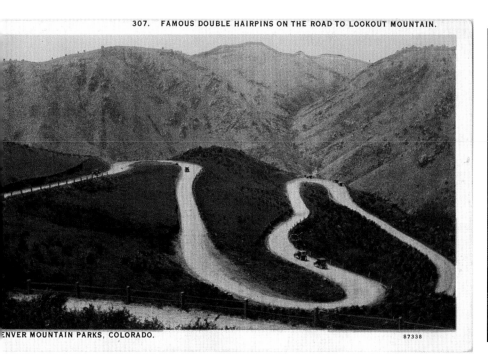

307. FAMOUS DOUBLE HAIRPINS ON THE ROAD TO LOOKOUT MOUNTAIN.

ENVER MOUNTAIN PARKS, COLORADO. 87338

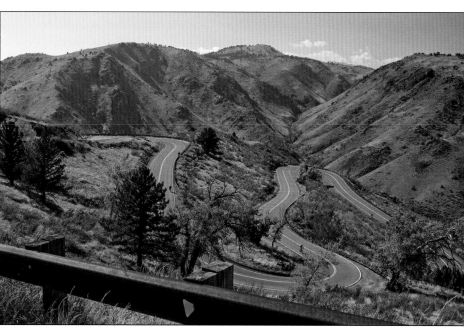

Once a primary route to Idaho Springs, the Lariat Trail has been replaced by I-70 for most commuters. This "splendid mountain boulevard … winds its way around and over the hills like the loops of a far flung Lariat," a circa 1930s postcard proclaimed. Thousands of cars still travel the historic Lariat Trail daily, but drivers and cyclists must share the road. Sanborn Souvenir Co. #307

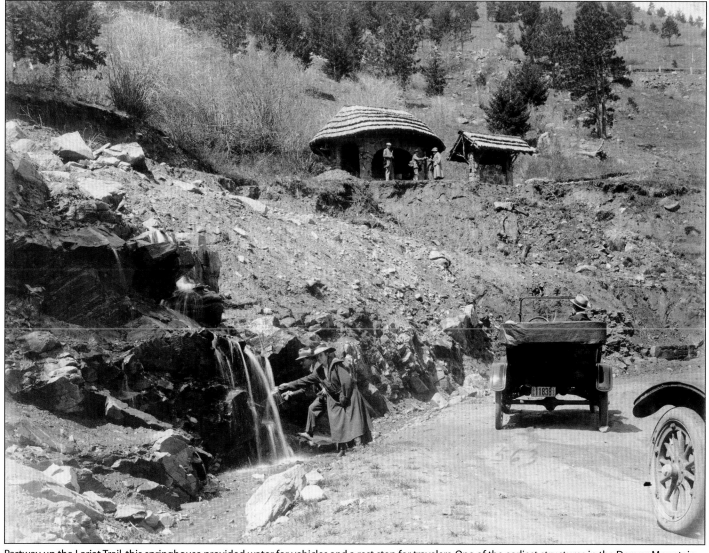

Partway up the Lariat Trail, this springhouse provided water for vehicles and a rest stop for travelers. One of the earliest structures in the Denver Mountain Parks, it was removed in the late 1990s because of its unsafe condition. Denver Public Library, Western History Collection, Z-6219

governments to fund road-building and, later, maintenance in the mountain park region. The park board reported that construction costs totaled $32,500 in 1913 alone. Of this total, Denver contributed $7,500 out of its mountain park fund, Jefferson County paid $7,500, while the State Highway Commission underwrote the largest share of $17,500.

The Lariat Trail would become one of the most recognized attractions in the mountain parks. This iconic roadway quickly gained fame for its sheer drops, stunning views, and remarkable design. "All the tricks of the scenic engineer" were employed in building the impressive drive, historian W.F. Stone observed in 1918. "At Sensation Point, the road hangs on the face of the cliff and is prevented from dropping into Clear Creek, 500 feet below, by a concrete retaining wall." The upper and lower hairpins compared

"favorably with any of the scenic road-building in the Swiss Alps." Climbing 1,500 vertical feet in just five miles, the road "twists and curves like a serpent," reported the Denver Park Board, "verging on the edge of precipices and constantly unfolding views of surpassing splendor of mountains and valley and of the plains that stretch away to the skyline in the east."

THE MOUNTAIN PARKS OPEN TO THE PUBLIC

In August 1913, the Denver Park Board introduced its two mountain parks and new parkway with great fanfare in the pages of *Municipal Facts*. On August 27, the city marked the official opening of the Denver Mountain Parks by hosting 150 members of the American

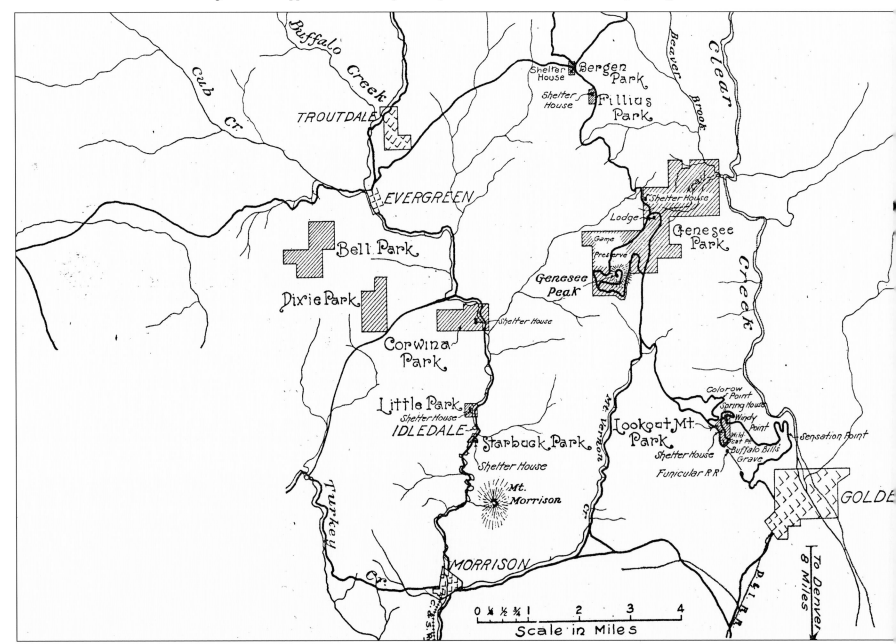

This 1918 *Municipal Facts* map illustrating the popular Circle Trip west of Denver shows that by then, the city had completed the primary loop of mountain parks and roads that would anchor the system even today. From Golden (bottom right), the Lariat Trail curved its way up Lookout Mountain. From there, scenic parkways led to Genesee, Fillius, and Bergen parks. The route continued past Evergreen and back to Denver via Bear Creek Canyon, with Bell, Dixie (now Pence), Corwina, Little, and Starbuck parks along the way. The map showed travelers where to find the Lookout Mountain funicular, Buffalo Bill's Grave, Lariat Trail springhouse, Genesee game preserve, Chief Hosa Lodge, and the city's seven mountain park shelter houses. *Municipal Facts*, April 1918

Association of Park Superintendents on an all-day tour. The group traveled in 35 autos up the new Lariat Trail Road to Lookout Mountain Park. There they tarried, taking rides on the funicular, "strolling among the pines and over the cliffs," and enjoying "a most excellent mountain trout fry." After another stop at Genesee Park, they went on to view the sites of future parks in Bergen Park, Evergreen, and Bear Creek Canyon. This auspicious event left the superintendents enthusiastic and confident that the mountain parks would enhance Denver's "prestige as a tourist center and a desirable place to live." A few weeks later, the Lariat Trail Road opened to public traffic.

The mountain parks were off to a strong start. In hiring the Olmsted firm, making the first mill levy assessment, and beginning road construction and land acquisitions that first year, the Denver Park Board had enjoyed the hearty support of Mayor Henry J. Arnold. The former county assessor had won the office in the 1912 election that saw passage of the Mountain Parks Charter Amendment, and Arnold's support of the parks was evident in both word and deed. But Denver's political scene soon took a turn that would threaten the embryonic parks. In June 1913, Denver voters approved an experimental form of city governance, replacing Arnold with five elected commissioners. The commission government lasted only three years, but this change came at a critical moment for the mountain parks. Determined to bring frugality to the municipal pocketbook, the new City Commission soon proved itself at odds with the Denver Park Board, the Mountain Parks Committee, and the Olmsted firm.

In June 1914, the Denver dailies trumpeted the resignation of the entire Denver Park Board. This left Commissioner Otto F. Thum in charge of the all of the city's park matters, including mountain park development, the Civic Center plans, urban park supervision, and dealings with Olmsted. Overwhelmed, Thum soon invited the Mountain Parks Committee to accept a formal appointment as an advisory commission to the city. Reconstituted in late 1914 as the Mountain Parks Advisory Commission (MPAC), the longstanding committee led by Warwick M. Downing took over "the active charge and management of the mountain parks."

The group faced a difficult task. Within weeks the City Commission refused to assess the mountain parks mill levy for 1915, forcing the MPAC to file a lawsuit against the city. Court victories over the city confirmed the constitutionality of the Mountain Parks Charter Amendment and the dedicated mill levy. Thereafter, through a succession of mayors and park appointees, the MPAC steered the mountain parks through tumultuous political waters, remaining active in park development for many years.

THE CIRCLE TRIP

Crews completed the road connecting Lookout Mountain Park and Genesee Summit in 1914. That summer, the Denver Tramway Company and the Seeing Denver Company, which operated private automobile tours, advertised a combined fare of $1 for a round trip to the new mountain parks. Passengers traveled by electric rail to Golden, then rode in a hired car up the Lariat Trail to Lookout Mountain and Genesee parks, returning to Denver by the same

Henry J. Arnold

Nathan Dankwardt of Morrison was one entrepreneur who took advantage of new opportunities in the Denver Mountain Parks. As this circa 1916 image shows, visitors could hire his "bus line" to Morrison and Bear Creek Canyon for $1 or go all the way to Evergreen for $2.50. Morrison Historical Society, Horton Collection

route. Alternatively, one could take the Tramway to Golden and then ride the Lookout Mountain Funicular Railway to and from Lookout Mountain Park. Travelers lucky enough to have access to an automobile could make the entire trip themselves. In the parks' early days, fewer than 10 percent of Denver households owned a car, but that number would rise steadily in the coming decades. By any route, a visit to the Denver Mountain Parks was quite an excursion.

In 1915, the city opened the first loop of park roads, known as The Circle Trip. The loop consisted of well-built roads connecting Golden, Lookout Mountain, Genesee Park, Bergen Park, Bear Creek Canyon, and Morrison. This was no small feat. Indeed, road construction claimed by far the highest share of park funding throughout these years. W.F. Stone reported that in the first five years of mountain park development, Denver invested $225,000 in road construction alone, with additional funds contributed from the state and Jefferson County. By comparison, the city only spent $34,000 on land purchases and $30,000 on shelter houses, fences, and other improvements.

At the 1916 municipal election, Denver voters returned the city administration to a mayoral system and elected Robert W. Speer to the office for his third term. Speer appointed William Fitz Randolph Mills as his Manager of Parks and Improvements, a powerful position that included oversight of the mountain parks. Speer also reappointed the MPAC as the city's official advisory board to the mountain parks.

However, Speer would serve as mayor over the mountain parks for just two years. His death in May 1918 cut short his third term in office. In the wake of Speer's passing, W.F.R. Mills served as deputy mayor until an election could be held. During his tenure managing the city's parks under Speer, and as interim mayor, Mills played an important role in mountain park development.

W. F. R. Mills

GENESEE: A Home in the Mountains

Between 1915 and 1918, improvements at Genesee Park made it a highlight of the system. Chief Hosa Lodge, designed by Denver architect Jules Jacques Benois Benedict and opened in 1918, was the city's first mountain lodge. The lodge was named for a Southern Arapaho leader known as a peacemaker by the settlers of Colorado. Benedict used native stone from the immediate area for the walls, and natural logs for the railings, roofing, and details. "It remains rock and red bark like its setting," he explained in *Municipal Facts.* He designed the building to blend into the hillside. The spacious veranda invited guests to "stir their hearts" contemplating the distant peaks. A restaurant offered hot meals. The interior featured stone walls, timber beams, and a fireplace. On a maple-wood dance floor, guests could dance for free— if they wound the Victrola themselves.

Also in 1918, the city opened a campground. Denver residents could rent a furnished tent for $2.50 a week, announced *Municipal Facts,* allowing those "of moderate means" to enjoy a summer holiday in the mountains. Sites for car campers were free.

The Genesee campground was akin to the automobile camps that Denver operated at City Park and Rocky Mountain Lake Park during these years. As cars became increasingly affordable during

Architects of the Mountain Parks: Jules Jacques Benois Benedict

One of Denver's most preeminent architects, J.J.B. Benedict created a distinctive style of mountain architecture in the buildings he designed for the Denver Mountain Parks. Notable for its use of native stone and wood, Benedict's work did much to define the rustic yet civilized character of the park system.

Born in Chicago in 1879, Benedict trained in Paris. He moved to Denver in 1909 and quickly became known for the many Beaux Arts homes, churches, and public buildings he designed throughout the city. The Alpine style Benedict developed for his mountain structures drew inspiration from the nearby landscape.

Benedict designed more than 10 structures for Denver's mountain parks, more than any other single architect. The picnic shelters and well-houses he created for Genesee, Fillius, Bergen, Corwina, Starbuck, Little, and Daniels parks showcase the naturalistic style he developed. Although these simple structures could have become rote, each building is unique.

Chief Hosa Lodge, built in 1918, remains Benedict's best-known work for the mountain parks. This was Denver's first mountain lodge, and the only such building Benedict would design for the city. He aimed to have the structure blend seamlessly into its surroundings, to appear as though it grew from the very place on which it stood.

J. J. B. Benedict

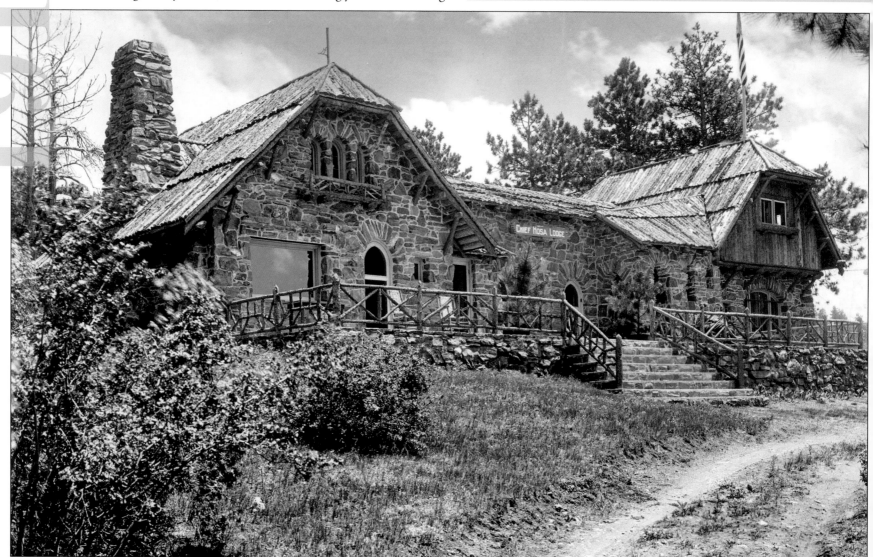

Chief Hosa Lodge was built in 1918 to serve as a restaurant for campers and tourists. An addition in the 1920s housed a museum of World War I memorabilia. By 1990, the impressive stone structure had become an event center, and it still hosts weddings and other celebrations. Restoration of the original railing enhances Chief Hosa Lodge's exterior; other improvements have modernized this substantial structure by renowned architect J.J.B. Benedict. Denver Public Library, Western History Collection, Z-6321

Bergen Park, a popular wayside picnic and rest stop between Genesee and Evergreen, became the connection to Squaw Pass Road and the new Mount Evans Drive. The shelter and well-house by J.J.B. Benedict are built entirely of white quartz. Sanborn Souvenir Co. #87332

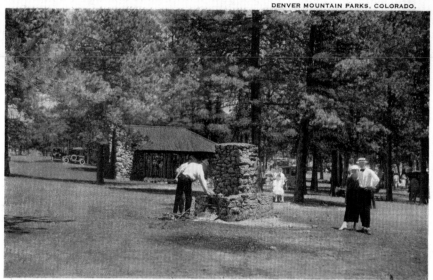

DENVER MOUNTAIN PARKS, COLORADO.

BERGEN PARK, JUNCTION OF MOUNT EVANS, IDAHO SPRINGS AND EVERGREEN — LOOKOUT ROADS.

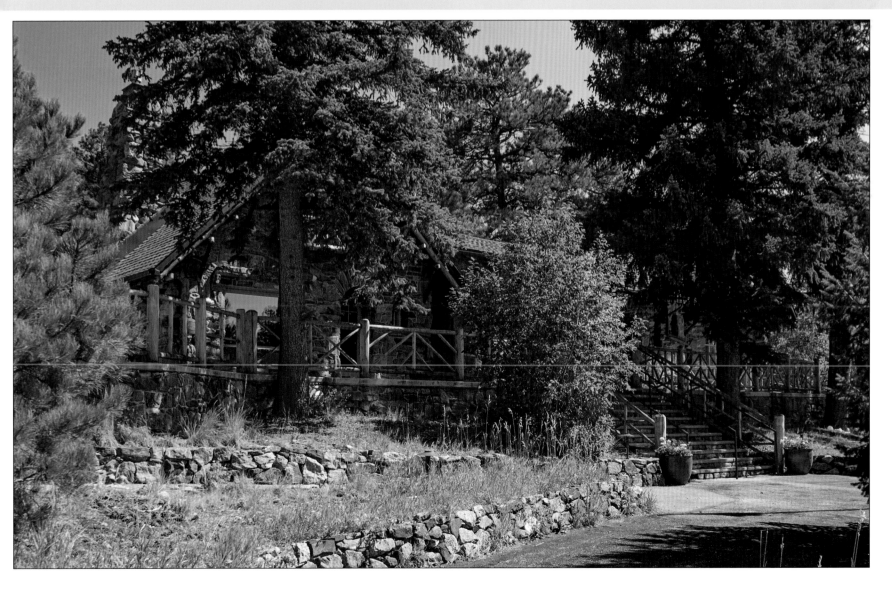

the 1910s, the new pastimes of automobile touring and car camping boomed in popularity. Colorado became a favorite destination for tourists from the Midwest and California, and Denver eagerly catered to this annual migration. Using the Denver autocamps as a base, these "motor gypsies" made day trips into the mountains.

The city began work on the Beaver Brook Trail in 1917. The first section started at a rail station in the bottom of Clear Creek Canyon. Those with strong legs and stronger lungs could hike from the river bottom all the way up to Genesee Park. One could make the entire trip without a car by taking the train to the trailhead,

hiking into the park, spending the night at the municipal campground, and returning the same way.

The trail system was extended over the years with the help of the Colorado Mountain Club, which completed the Colorow Trail from Genesee to Windy Saddle on the Lookout Mountain Road. The connecting trail from this point via Chimney Gulch into Golden gave hikers trolley access to yet another trailhead. This trail system offered hikers the opportunity to travel through "virgin and unfrequented" wilds where, touted *Municipal Facts,* "one never hears the sound of an automobile horn."

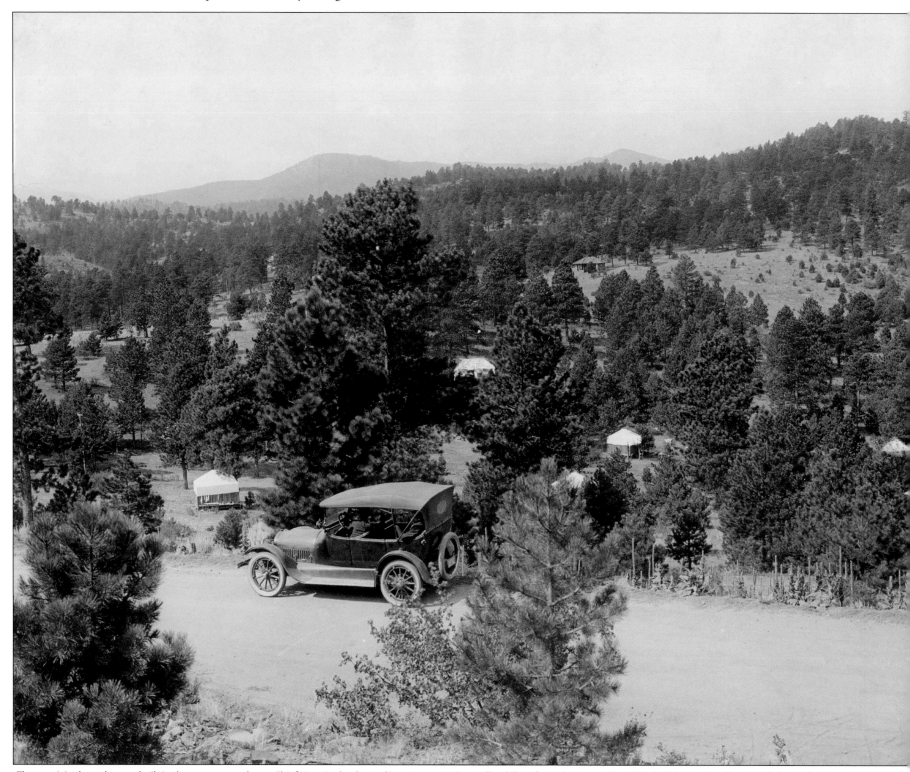

The municipal tent houses built in the campground near Chief Hosa Lodge hosted "motor gypsies" as well as hikers from the Beaver Brook Trail. With wooden floors and electric lights, these structures provided a vacation home for $2.50 a week. Denver Public Library, Western History Collection, Z-6316

Architects of the Mountain Parks: Saco Rienk DeBoer

Dutch-born Saco Rienk DeBoer served as Denver's landscape architect from 1910–1919, and as the city's chief landscape and city planning consultant from 1920–1958. DeBoer consulted extensively throughout the Intermountain West, serving on the National Resources Planning Board as well as the state planning boards for Utah, New Mexico, and Wyoming.

In his home city, DeBoer is still recognized for his gifted design of city parks such as Alamo Placita, Cheesman Park Esplanade, Sunken Gardens, and Speer Boulevard. He also helped to found the Denver Botanic Gardens. His tenure coincided perfectly with the development of the Denver Mountain Parks, of which he was a great supporter. He was a contributing designer on the Lariat Trail Road in 1913, and created landscape plans for Lookout Mountain Park, Chief Hosa Lodge, Echo Lake Lodge, and the Summit Lake shelter house.

Talented and thoughtful, DeBoer spent a lifetime "planning for beauty," observes Denver historic preservationist William A. West, weaving a tapestry of big trees, gardens, parks, and parkways into the fabric of Denver and beyond.

Saco Rienk DeBoer

BUFFALO BILL COMES TO LOOKOUT MOUNTAIN

In 1917, Lookout Mountain Park became the final resting place of the legendary William F. "Buffalo Bill" Cody. The renowned frontiersman and performer passed away at the Denver home of his sister, May Cody Decker, on January 10, 1917. He had stopped there in December, feeling worn-out and ill, at age 71. As his condition declined, family and friends gathered at his bedside. His wife, Louisa, and daughter, Irma, arrived on a midnight train. Admirers hung on the daily newspaper reports of Buffalo Bill's last days.

After Cody's death, his family announced that the Colonel had asked during his final days to be buried on Lookout Mountain. He had visited Lookout Mountain Park in 1914 and been impressed by the view. This news came as a surprise to some, especially in the town of Cody, Wyo., which the Old Scout helped to found, and where he had at one time planned to be buried. However, new research by Steve Friesen, curator and author of *Buffalo Bill: Scout, Showman, Visionary,* documents Buffalo Bill's request. "Motivated by reasons known only to the Old Scout," Friesen observes, Cody's "change of heart" would become the subject of lasting controversy between Wyoming and Colorado. Threats to take the body led Cody's foster son, Johnny Baker, to have several tons of concrete poured over the grave in 1927.

On January 14, 1917, Denver hosted a public funeral to honor Buffalo Bill. "Farewell, Pa-has-ka!" intoned *The Denver Post,* as Cody's body lay in state under the State Capitol dome. "For to-day the good-bye must be said; the last glimpse taken of him who laid the foundations of the West." On that wintry day, 25,000 mourners paid their respects to the Old Scout. Afterward, a grand procession of Elks, Masons, Knights Templar, and American Indians in full regalia escorted the caisson through the city streets to the Elks lodge, where the funeral ceremony was held. On June 3, 1917, Denver's Masons led another solemn procession, this time up the Lariat Trail. Buffalo Bill was laid to rest in a tomb blasted out of solid rock in Lookout Mountain Park.

In collaboration with the Cody family, plans were soon under way to build a museum honoring Buffalo Bill at the gravesite. In 1921, Denver proudly opened Pahaska Tepee, the William F. Cody Memorial Museum. The distinctive structure featured "gnarled and curved logs and branches, stumps, and roots of trees" to create an effect that was "unique and typical of the West," *Municipal Facts* explained. The rustic yet refined lodge in its picturesque setting was thought a fitting tribute to the man.

Johnny Baker managed the museum, often giving daily lectures to guests, until his death in 1931. Baker's wife, Olive, continued to oversee the site until she died in 1956. Pahaska Tepee quickly proved a world-class attraction. More than 70,500 people visited the museum in its first six months of operation. "Every state in the Union, the District of Columbia, Alaska, the Canal Zone, Hawaii, and the Philippine Islands sent their quota," reported *Municipal Facts.* In addition, guests from 40 foreign countries signed the registry.

A POPULAR EXCURSION

Five short years after work began on the mountain parks, the high hopes of early advocates such as Pence, Downing, and Walker had been more than fulfilled. In 1918, Denver owned 10 mountain parks, comprising a total area of five square miles and spread over a region roughly 150 miles square, reported Stone. The Lariat Trail Road from Golden carried visitors past the Colorow Point overlook and on to Lookout Mountain. From there, the road wound westward to Genesee, Fillius, and Bergen parks. Between Morrison and Evergreen, motorists traveled an improved Bear Creek Canyon Road, dotted with Starbuck, Little, and Corwina parks. Near Evergreen, Bell and Dixie (later renamed Pence) parks offered yet more places to picnic, fish, and play. Travelers could make the entire circle trip from Denver in a day.

The stunning numbers of park visitors confirmed the foresight of early park proponents. From June through August 1917, more than 300,000 daytime visitors passed through the mountain park gates at Golden and Morrison in some 69,500 cars. This was more, Stone boasted, "than the combined attendance at all of the Federal national parks in the country" during the same period.

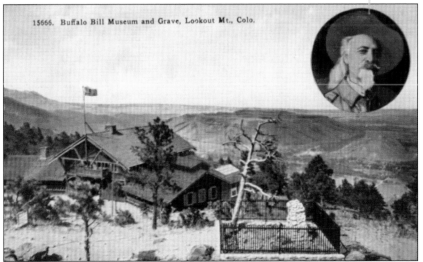
Opened in 1921, Pahaska Tepee sits beside William F. "Buffalo Bill" Cody's gravesite on Lookout Mountain. Visitors came from every corner of the nation to see the museum's large collection of Buffalo Bill's weapons, artworks, and memorabilia donated by the Cody family. The grave and museum boast expansive views across the Great Plains. H.H.T. Co. #15666

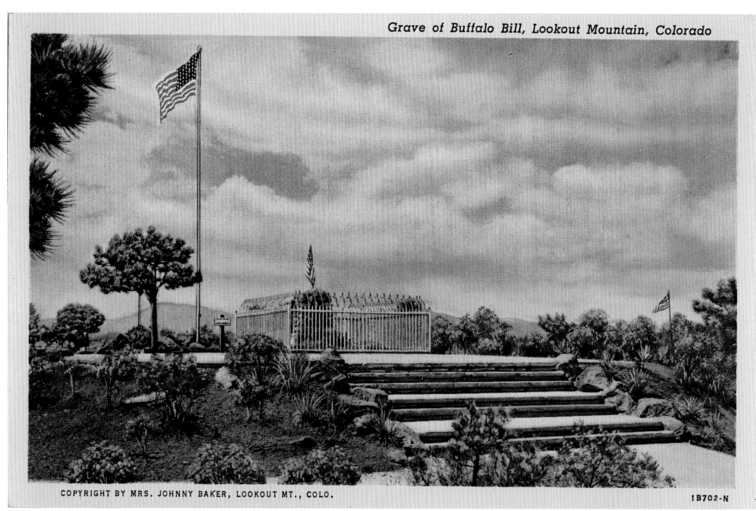

Grave of Buffalo Bill, Lookout Mountain, Colorado

COPYRIGHT BY MRS. JOHNNY BAKER, LOOKOUT MT., COLO.

1B702-N

Colonel William F. Cody was laid to rest on Lookout Mountain in 1917. Louisa Frederici Cody was buried in the same tomb with her husband, in 1921.

Johnny Baker #1B 702-N

Beyond the Circle

In May 1919, Denver voters elected Dewey C. Bailey mayor. Bailey asked W.F.R. Mills to return to his post as Manager of Parks and Improvements because, *Municipal Facts* reported, Mills was familiar with and committed to the mountain parks. Bailey also reinstated the MPAC as an official advisory body to the city and then appointed Mills to serve as its chair. However, by 1922, the Bailey administration had cut the mountain parks levy to just "two one-hundredths of a mill," a tiny fraction of prior years, reported *Municipal Facts.* The Mountain Parks Charter Amendment had allowed for the levy to be adjusted in the future, but this retraction came at a challenging time for the mountain parks. By 1918, the sheer number of visitors to the mountain parks had begun to exceed the system's capacity. On weekends, traffic jammed the scenic drives, motorists choked on dust and exhaust, and picnickers overwhelmed the park spaces.

NEW CORRIDORS, NEW PARKS

Mills, the MPAC, and the city's park officials agreed that further development was needed to accommodate the high number of visitors, announcing their plans in *Municipal Facts* in 1919. Planners aimed to develop new corridors in Mount Vernon, Turkey Creek, and Deer Creek canyons to help disperse the crowds. New parks included Deer Creek (1919), Cub Creek (1922), Turkey Creek (1927), and Bear Creek Canyon (1928).

The city acquired its first and only prairie park in 1920, when Ms. Florence Martin and MPAC member Charles MacAllister Willcox donated just under 40 acres on Douglas County's Wild Cat Mountain. Long a popular spot for evening picnics and sunset viewing, Daniels Park offers ridgetop views of the Continental Divide from Pikes Peak north to Wyoming. Seventeen years later, Daniels Park was expanded significantly when Florence Martin donated just over 960 acres of family ranchland to the city. Denver would soon establish its second bison herd there to alleviate crowding at the Genesee preserve.

Benjamin Stapleton

With the development of Mount Evans, Evergreen Lake, and Red Rocks Park, this decade saw the acquisition of some of the system's most beloved parks. The pace of development quickened dramatically on the heels of the 1923 city elections, when Benjamin Stapleton was elected for the first of an eventual four terms. As mayor, Stapleton supported strong investment in the popular, successful mountain parks, Warwick M. Downing recalled.

OPENING THE MOUNT EVANS REGION

Between 1916 and 1918, the MPAC and the Chamber of Commerce devoted considerable energy to having the Mount Evans region designated the "Denver National Park." At 14,264 feet, Mount Evans is one of the three "sentinel peaks" that characterize Denver's western skyline, along with Longs Peak and Pikes Peak. Longs Peak formed the centerpiece of the new Rocky Mountain National Park, established in 1915 after years of effort on the part of Enos Mills. Pikes Peak had been developed long before as a summit destination from Colorado Springs. Of the three, Evans was nearest to Denver,

and the city's mountain parks and roads already bridged some of the distance toward the sentinel.

A new form of tourism bloomed with the motor age: Americans were taking to the road in search of nature. In Colorado, the flood of auto tourists from the Midwest each summer continued to grow. *Municipal Facts* explained in 1918 how out-of-state visitation to Rocky Mountain National Park, Denver Mountain Parks, and Denver's autocamps already threatened to exceed the capacity of these parks. Advocates of the proposed Denver National Park believed the Mount Evans area's scenic qualities and proximity made it ideally suited to help absorb tourist traffic. The proposed national park embraced roughly 152 square miles and more than 15 peaks exceeding 11,000 feet in elevation.

Colorado introduced legislation in Washington for Denver National Park in 1915, without success. Advocates stepped up their campaign in 1918, this time lobbying a new federal bureau: The National Park Service had only been established in 1916. For decades, the national parks—which at the time included Yosemite (1862), Yellowstone (1872), Mesa Verde (1906), Glacier (1910), and Rocky Mountain—had been managed by different federal agencies with highly varied results. Resource development schemes, from dams to grazing, increasingly threatened the integrity of many national parks. The National Park Service finally provided centralized administration and protection of the federal parks.

In October 1918, Horace M. Albright, assistant director of the new agency, inspected the Mount Evans region and found it "eminently fit for permanent reservation" as an extension of Rocky Mountain National Park. Denver backed up its appeals to the

This late 1920s view of unpaved Squaw Pass Road at Witter Gulch in Clear Creek County shows the rocky outcrop of Snyder Mountain, one of Denver's "wilderness parks," today known as conservation areas. The U.S. Forest Service carried the road west from this point to Echo Lake.
Denver Public Library, Western History Collection, MCC-2721

1919-1931

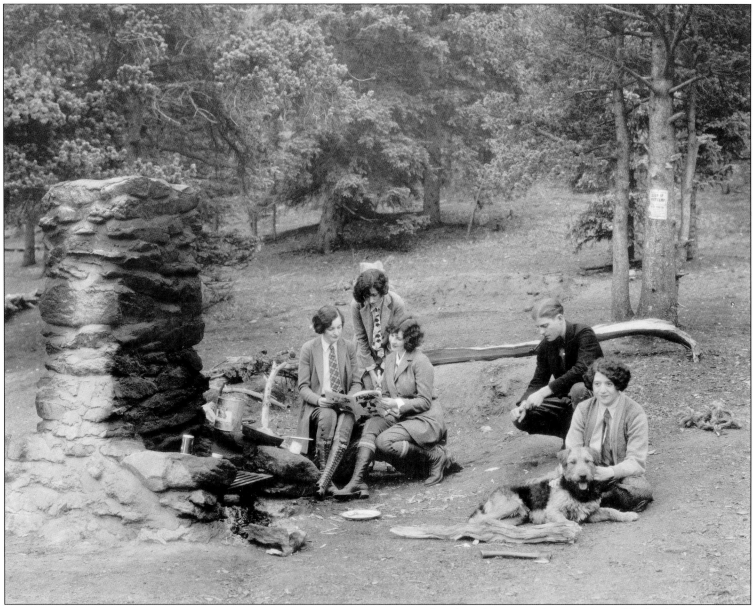

Campers at Echo Lake in the 1920s gather around one of the fireplaces typical of early mountain parks. In 1927, *Municipal Facts* raved: "Against the velvet curtain of the falling night are gathered happy groups of people, and at all the city fireplaces of the mountain parks they are cooking steaks and bacon and coffee.... These are the simple pleasures, that cost little, and linger longest in the mind. These are days when everyone is rich—endowed with all that the days and nights spent in the Colorado open have to give." The sign on the tree reads, "Clean up your camp."

Denver Public Library, Western History Collection, Z-7608

National Park Service with a commitment to partner in developing the region for mountain tourism.

The famed Mount Evans Drive had its origin in the Denver National Park effort. From 1916–1919, Denver invested some $85,000 to build an 11-mile stretch of highway, in the faith that the federal government would continue the road toward the peak. The project was controversial: Even Mayor Speer questioned the plan at first, Downing recalled. Beginning at Bergen Park, already a popular mountain park on the circle tour, Denver crews cut and finished the road as far as Squaw Pass.

However, the Denver National Park proposal ran into opposition from the U.S. Forest Service, which already held and managed Mount Evans and its surrounds within the Arapaho and Pike national forests. In 1919, Chief Forester Henry S. Graves proposed that his agency develop Mount Evans for recreational use rather than cede it to the Park Service. He pledged to continue the Mount Evans Drive from Denver's terminus at Squaw Pass to Echo Lake. Denver accepted the offer, in this way entering a long partnership with the Forest Service to open the Mount Evans region to camping, fishing, hiking, and driving.

In addition to building the first leg of the Mount Evans road, Denver also agreed to acquire key tracts of land including Echo and Summit lakes. Both lakes were at the time private inholdings within the national forest. Denver purchased Echo Lake in 1921 as the Forest Service road approached the site. Mayor Bailey championed the acquisition in the pages of *Municipal Facts.* Proponents believed a park at the picturesque lake would signify the "crowning triumph" of the mountain park system, providing a point of access to the Mount Evans summit, Chicago Lakes, and other scenic destinations.

Debate ensued as Denver forces urged that the drive be carried on to the summit of Mount Evans. Unlike Longs Peak, the approach to Mount Evans was well suited to automobile passage. A road to

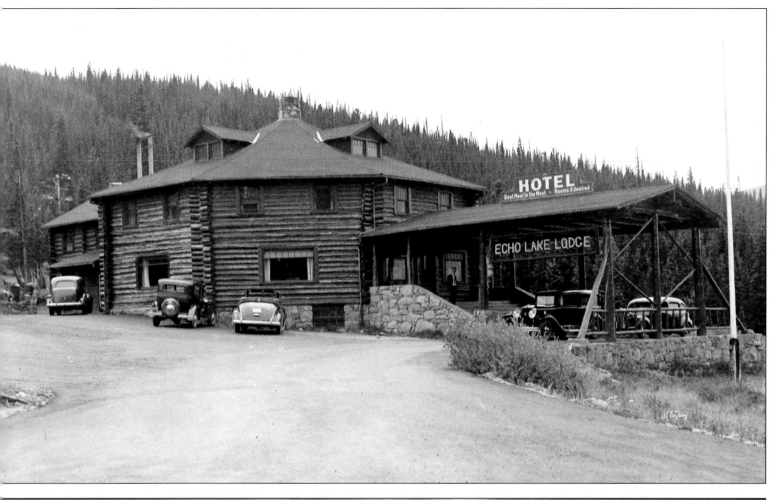

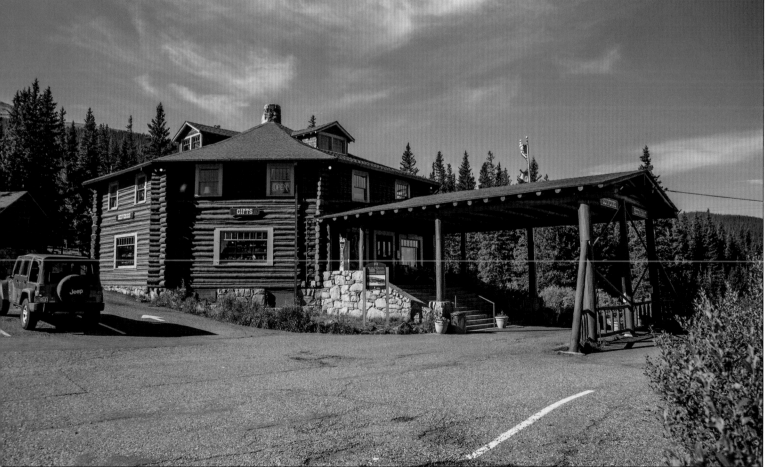

Despite renovations, Echo Lake Lodge retains its 1926–1927 appearance. Log restoration in 2011 supported by a State Historical Fund grant helped stabilize the exterior. Open seasonally, the lodge no longer serves overnight guests. Denver Public Library, Western History Collection, X-20403

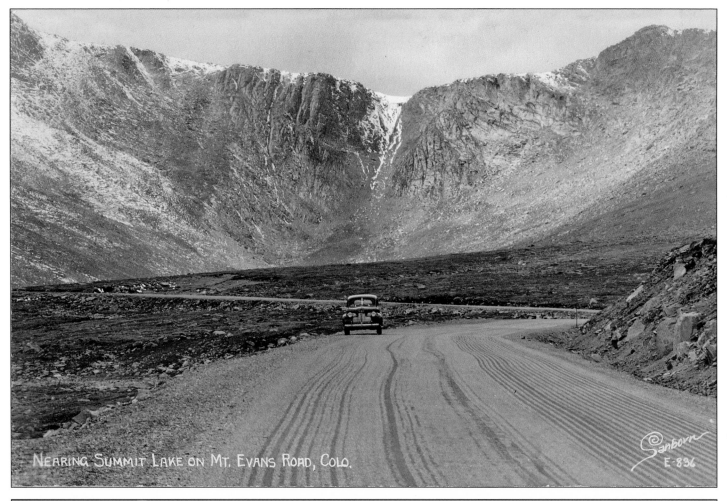

Nearing Summit Lake on Mt. Evans Road, Colo.

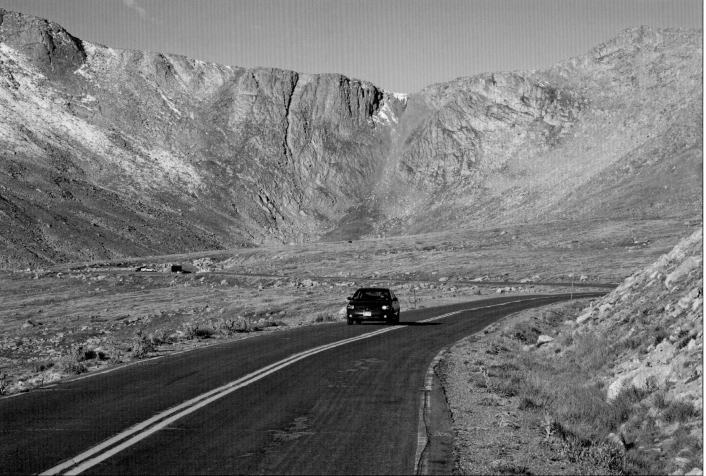

The approach to Summit Lake Park shows little change since the 1930s other than the paving of the road. The U.S. Forest Service manages the surrounding wilderness area. Sanborn Souvenir Co. #E-836

the peak, *Municipal Facts* argued, would offer a rare chance to experience the sublime environs of a 14,000-foot summit for patrons too old, weak, or infirm to make the journey on horseback or by foot. The State Highway Commission stepped in, helping to fund construction of the final section of the road to the summit, as well as the highway from Echo Lake to Idaho Springs. In 1924, Denver purchased Summit Lake and made plans to build a shelter house there. Colorado's highest road reached Summit Lake in 1925 and arrived, finally, at the summit in 1930.

The city also took responsibility for developing its holdings on Mount Evans. Echo Lake Lodge, which opened in 1926, was the most impressive of these amenities. Designed to harmonize with its surroundings, the rustic stacked-log inn represented "a place that is as picturesque as its setting," observed *Municipal Facts*. Overnight accommodations allowed travelers the opportunity to "view the sunsets and sunrises on lofty Mount Evans," to hike or ride to and from Summit Lake "at any hour of the day or night," and the leisure to "thoroughly absorb all that this vicinity has to give." Expanded in 1927, the fine lodge featured a massive stone hearth, restaurant, dance hall, and comfortable bedrooms. Denver aimed to provide "the highest type of mountain hospitality" at Echo Lake Lodge.

Dedisse Park:
The Heart of Evergreen

Today as part of the heart of Evergreen, Evergreen Lake counts among the major mountain park projects of the 1920s. The present lake was built on the site of the historic Dedisse Ranch. Homesteaded in 1869 by French immigrant Julius Caesar Dedisse and his wife, Mary Ann, the 400-acre ranch covered a broad, flat meadow astride meandering Bear Creek.

Among the first residents of Evergreen, the couple were respected as town pioneers. They raised their six children in the lovely mountain valley, making their living raising hay, grain, potatoes, and livestock. After J.C. passed away in 1909, Mary Ann stayed on the ranch while son Jerome ran the outfit.

In 1916, Denver attempted to acquire the ranch, planning to dam Bear Creek and create a lake on the site. The city made an initial offer of $15,000, which the family turned down. Mrs. Dedisse was in her late 70s and had lived on the ranch nearly 50 years. She "could not bear to consider the question," reported *Municipal Facts*.

Three years later, as part of the city's mountain park expansion program under Mayor Mills, Denver initiated condemnation proceedings to acquire the ranch. A panel of court-appointed appraisers from Evergreen—neighbors who knew the Dedisse family—set the fair market value of the property at $25,000, substantially more than the city's initial offer. Denver officials agreed to pay the higher price.

Although Denver used condemnation proceedings to acquire other tracts for the mountain parks, the Dedisse case was perhaps the most controversial. After the transaction's completion in 1920, Mrs. Dedisse moved to Denver to live with her daughter. She died in 1922, still remembered in Evergreen as "a fine old lady," wrote the *Colorado Transcript*.

The dam was built during 1927 after Mayor Stapleton's administration made the long-delayed project a priority. Evergreen Lake filled to its capacity with the spring runoff in 1928. *Municipal Facts* explained that the dam contained rock quarried from nearby

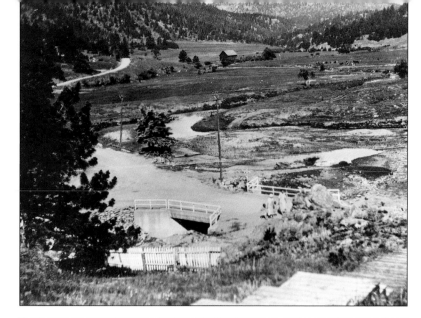

TOP: Denver acquired the 400-acre Dedisse family ranch through condemnation proceedings in 1919, with plans to build a lake for recreational use. History Colorado (F-9056, #10030474). MIDDLE: The dam was built during 1927 on land donated to the city by John S. McBeth. *Municipal Facts*. BOTTOM: Completed in 1928, Evergreen Lake created a "mirror of the mountain parks," and soon became a year-round destination for fishing, boating, picnicking, golf, and winter sports. The lake is now an Evergreen icon.

Cub Creek, 15,000 barrels of cement, eight tons of steel, and 11,617 cubic yards of concrete. The dam cost $214,375 to build, reported City Auditor George Begole in the newspapers that spring.

Set above the quaint village of Evergreen, the 65-acre lake in its beautiful mountain setting soon became the town's defining feature and one of the system's most beloved parks. Denverites and tourists flocked there year-round, enjoying boating, fishing, and picnicking during summer, and ice-skating, tobogganing, and skiing in winter.

By 1925, the city had acquired the nine-hole Evergreen Golf Course next to the future lake, according to reports in *Municipal Facts.* The land including the golf course was donated by the owner of the fashionable Troutdale-in-the-Pines Hotel on the condition that the site always remain a golf course. The city quickly added another nine holes to the popular links. In 1925, Denver built the rustic, stacked-log golf clubhouse designed by F.W. Ameter. The original octagonal building was expanded over the years and currently houses a restaurant.

The Civilian Conservation Corps in the 1930s developed the wooded area north of the lake as a picnic area with a shelter house with views of the lake, restrooms, and several sites for picnicking.

As part of the Olmsted Plan, the view behind Evergreen Lake is preserved by several of Denver's conservation areas, including Elephant Butte (center, in Jefferson County); Hicks Mountain, Mount Judge, and Snyder Mountain (Clear Creek County); and Bergen Peak (Jefferson County). To the left in this view are Dedisse Park and an outcrop of Jefferson County's Alderfer/Three Sisters Park. W. Bart Berger

DENVER MAKES RED ROCKS ITS OWN

By 1920, J.B. Walker—who in the preceding 15 years had helped launch the mountain parks movement in Denver and developed Park of the Red Rocks and Morrison—had fallen on hard times.

His beloved wife Ethel died in 1916. Two years later, a fire destroyed the majestic Walker home on Mount Falcon. By this time, the Summer White House project also had failed and Walker's commercial operations at Red Rocks were declining. He began to look toward selling off some of his holdings.

In 1923, Walker offered to sell Red Rocks to the city for $100,000, reported *The Denver Post.* Walker approached officials a year later, asking $60,000. The MPAC favored the acquisition, calling Red Rocks "a scenic and recreational center overshadowing the remainder of her mountain park system," and "outrivaling" Garden of the Gods at Colorado Springs, described the *Rocky Mountain News.* Mayor Stapleton, known for his support of the mountain parks, was open to the idea.

Beginning around 1925, banker Frank Kirchoff bought up J.B. Walker's Mount Morrison Casino and Mount Falcon properties at "fire sale prices," writes coauthor Sally White, some as foreclosures and others for taxes. By 1927, some 2,400 acres previously held by Walker—including Park of the Red Rocks and Mount Morrison— had been purchased by local developer John Ross.

Denver finally purchased Red Rocks from Ross in 1928. The city paid $50,000 for 640 acres containing the main sandstone formations, and an additional $4,000 for water rights to Bear Creek. Condemnation proceedings to complete the transaction dragged on until finalized in 1937.

J.B. Walker left Colorado as his enterprises crumbled. He married again, this time to feminist Iris Calderhead. He spent time in Texas and eventually returned to Tarrytown, N.Y., where he died in July 1931. Walker passed away just a few years before Red Rocks Park once again began to accrue the elusive fame he had sought for so long. Although Walker watched his Colorado dreams slip through his fingers, he was prescient about both the promise of tourism and the value of parks and outdoor recreation to Denver's future.

The city soon began making improvements at Red Rocks to bring the site up to the mountain parks' high standards. New amenities included water stations, fireplaces, and new picnic tables. To throw "a strong right arm around the climbers who are often so ready to risk their necks in a spirit of daring," noted *Municipal Facts,* the city replaced broken ladders and installed railings among the rocks. Workers tore down the Walkers' old funicular; its mark is still visible on Mount Morrison today.

Building a new scenic drive through the park claimed top priority. This "dynamite road" required blasting and moving tons of rock with power shovels before the road could be graded. Finished in 1930, the "spectacular five-mile drive" wound "in and out among the sights" of the park, raved *Municipal Facts.* The new drive created access points to Red Rocks at three different entrances: Bear Creek, Morrison, and Mount Vernon Canyon.

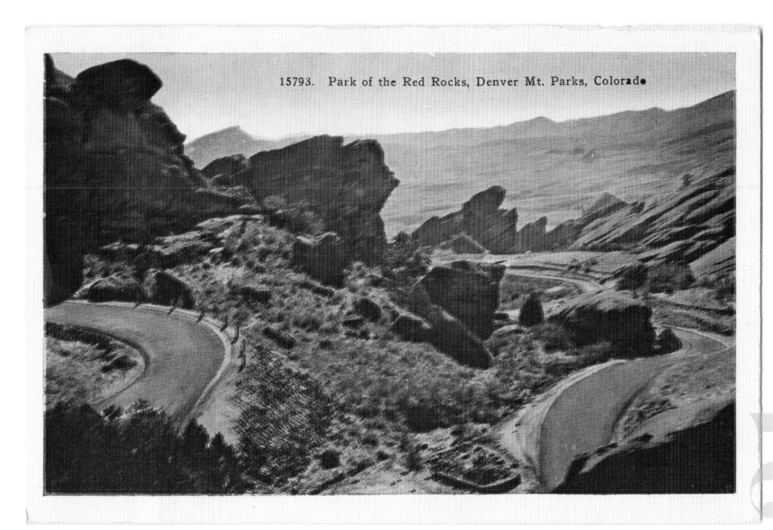

15793. Park of the Red Rocks, Denver Mt. Parks, Colorado

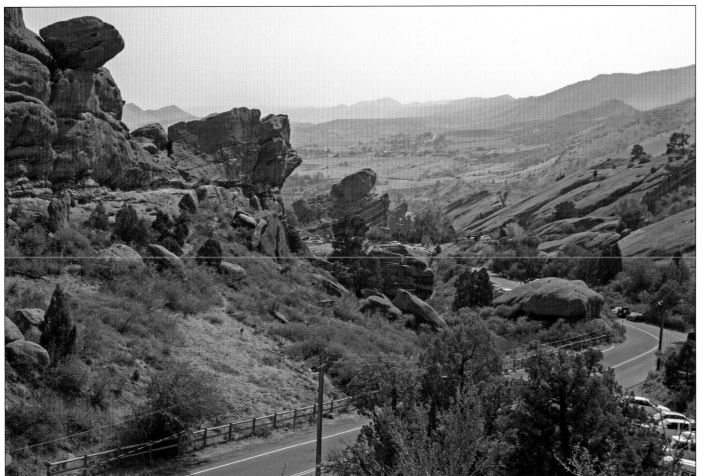

TOP: An early "Photoshopper" enhanced the view of Denver's new "dynamite road" in Red Rocks in about 1930 to emphasize the scenery and touring opportunities, adding not just color but an entire road to the picture. H.H.T.Co. #15793

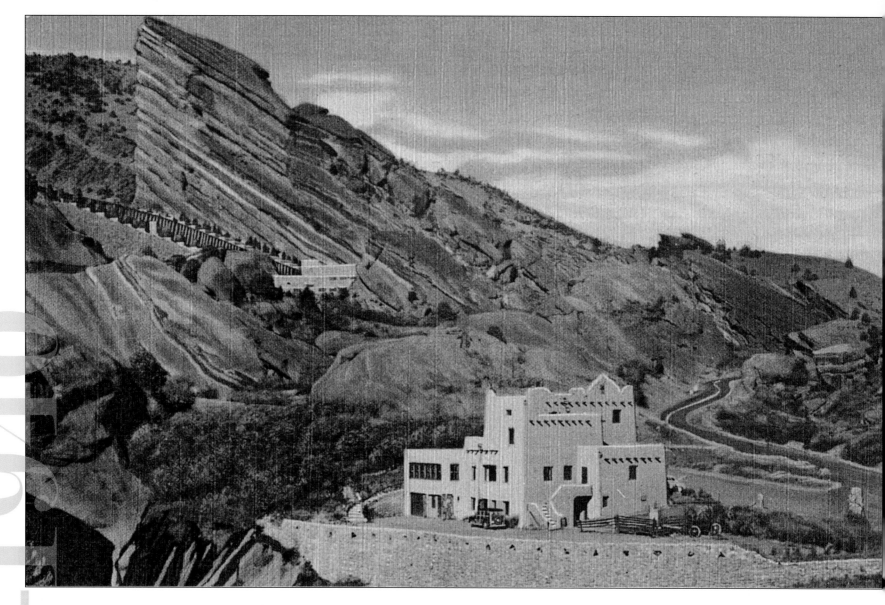

In 1931, Denver completed the adobe-style Indian Trading Post (formerly Indian Concession House) at Red Rocks Park. To help design a visitor center to suit the distinctive site, the city formed a committee of local experts in American Indian culture, anthropology, art, and architecture. The resulting Pueblo Revival building, designed by architect W.R. Rosche, featured red stucco surfaces, a log ladder to the roof, blunted corners, and a bell-tower facade. The interior continued the Pueblo theme with sandstone floors and exposed log beams in the high ceilings. The Trading Post housed a museum, restaurant, and souvenir shop. To better accommodate audiences at open-air events, in 1931 the Begole administration made initial improvements to the natural amphitheatre at Red Rocks. But the famed classical amphitheatre that would come to define Red Rocks Park still lay several years in the future.

At the municipal elections of May 1931, Mayor Stapleton failed to win his bid for a third term. During his first eight years in office (he would return to the job in 1934), Stapleton supported substantial investments in the Denver Mountain Parks. His administration oversaw a doubling of mountain park holdings, including the acquisition, development, or both, of Echo Lake and Echo Lake Lodge, Summit Lake, Evergreen Lake, Red Rocks Park, and the Red Rocks Trading Post—still some of the system's best-known features.

Depression and Dynamism

The phenomenal growth of the mountain parks under Stapleton wound down as the Great Depression tightened its grip on Colorado. Unemployment in the state topped 30 percent by 1932 and continued to rise; little aid came from government sources and private relief fell far short of alleviating the suffering. As the economic crisis drained Denver's coffers, it might have signaled an end to the city's mountain park story. However, the New Deal, coupled with dynamic leadership, would bring renewed vitality to the mountain parks.

When President Franklin D. Roosevelt took office in March 1933, he promptly introduced a slate of federal programs designed to provide relief for the unemployed, stimulate the economy, and pave the way for recovery in the business and agricultural sectors. Through such programs, Roosevelt's New Deal would prove a wellspring for the Denver Mountain Parks, ushering in a burst of energy, development, and commitment in spite of the lingering depression.

Natural resource conservation formed a key component of the New Deal. In April 1933, Roosevelt established the National Emergency Conservation Work (ECW) program, more popularly known as the Civilian Conservation Corps (CCC).

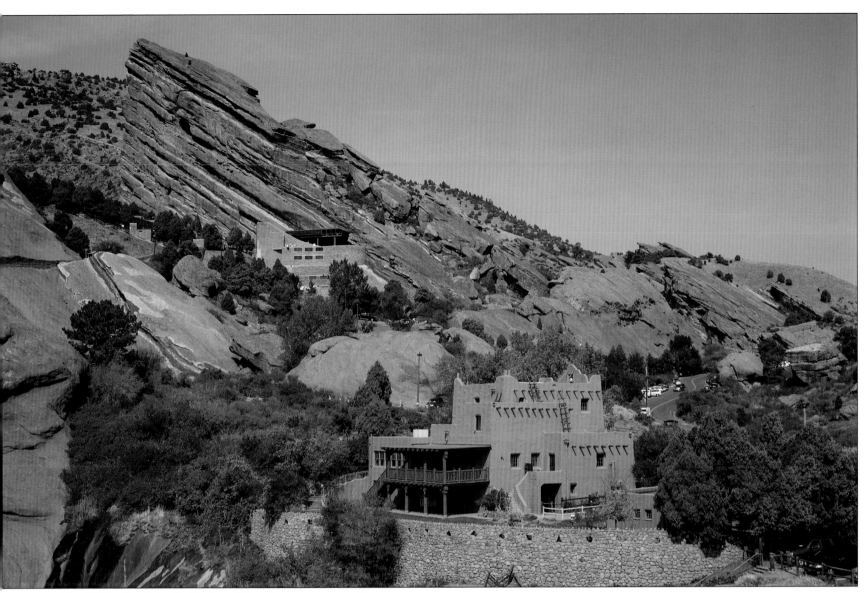

The 1931 Trading Post, a Red Rocks building of many names over the years, was built by Denver in Pueblo Revival style to house a restaurant and gift shop. ABOVE: Today it also serves as a Colorado Welcome Center, with information for the thousands who visit this flagship park.
1940s postcard: Sanborn Souvenir Co. #2059

This innovative agency operated from 1933 to 1942, in 10 years putting more than 3 million unemployed young men and World War I veterans to work on hundreds of conservation, erosion control, and development projects in the nation's forests, prairies, and parklands. The program provided room and board, educational and cultural opportunities, and $30 per month in cash; $25 of this income was sent to the enrollees' homes to support families and stimulate local economies. In Colorado, some 32,000 men would serve in the CCC at more than one hundred camps across the state. For many, their service in the corps marked a defining period in their lives.

Although the CCC is perhaps the best known of the New Deal programs that offered work in Depression-era Colorado, it was not the only relief agency that supported the Denver Mountain Parks. The Federal Emergency Relief Administration (FERA) and its successor agency, the Works Progress Administration (WPA), employed more than 8 million people nationally during the program's 10 years in a wide variety of occupations, from manual labor to the arts. The Civil Works Administration (CWA) offered short-term work relief to the unemployed as well. Denver's park administrators would take advantage of all of these federal programs.

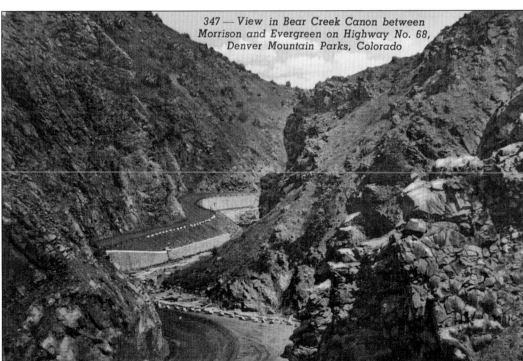

347 — View in Bear Creek Canon between Morrison and Evergreen on Highway No. 68, Denver Mountain Parks, Colorado

WPA workers built stone walls in 1939 to support an elevated Highway 74 after disastrous floods in the 1930s. The lower four-mile stretch of canyon, designated the Bear Creek Canyon Scenic Mountain Drive, is Denver's Bear Creek Canyon Park, acquired in 1928. Sanborn Souvenir Co. #347

MOUNTAIN PARK IMPROVEMENTS OF BEGOLE, LOWRY, AND AILINGER

George D. Begole served as Denver's mayor from 1931–1935, coming to the office after serving three terms as city auditor. He led a city with shrinking resources and little federal assistance. Begole established a municipal relief agency to administer charity work, but the Denver Emergency Relief Committee was quickly overwhelmed by the need. To make matters worse, even after Roosevelt rolled out his New Deal programs, Colorado's state legislature refused to authorize the matching funds needed to receive much of the aid. By the close of 1933, federal officials threatened to cut the state off entirely and Denver teetered on the brink of bankruptcy.

George D. Begole

In spite of these challenges, Begole's administration managed to take what advantage it could of federal aid. Manager of Improvements and Parks Walter B. Lowry and Mountain Parks Superintendent Walt Ailinger secured several New Deal projects that began in the mountain park region during 1934.

In 1934 and 1935, crews of FERA workers widened roads and reduced curves in Bear Creek Canyon on the park highways. "Curves that once were right angles," noted the *Rocky Mountain News* with appreciation, "are now sweeping and allow 75 per cent more vision ahead." Bridges for autos and pedestrians were built in Bear Creek Canyon, providing access to parklands and fishing grounds across the stream.

On Genesee Peak, FERA crews built a viewing area using blocks and columns reclaimed from the Denver courthouse. Just below the peak, "steps that saw years of service at the old courthouse are arranged around the columns," the *Rocky Mountain News* reported, while benches crafted of stone were positioned "in comfortable disorder." Newly installed steps and a ramp to the top brought visitors to an "altar" made of short columns "topped by a huge block of native stone." From the altar, panoramic views spread out in every direction. At Red Rocks Park, FERA projects included 50 new stone fireplaces, road improvements, trout ponds, and flood mitigation along Bear Creek.

The Begole administration also sought CCC funding for work in the mountain parks. In December 1934, parks manager Lowry secured approval from the National Park Service for two CCC camps in the mountain parks: one slated to make improvements in Bear Creek Canyon and the second at Red Rocks Park, where construction of a large new amphitheatre topped the list of projects. Lowry had begun initial development of the natural amphitheatre as a performance venue in 1931, using workers from the local Citizens Employment Committee. The *Post* reported that crews built steps and ramps in the hopes of offering summer entertainment at Red Rocks in 1932.

However, by the time approval for the CCC camps was secured, city elections were fast approaching. Begole did not pursue reelection, and in June 1935, Benjamin Stapleton returned as Denver's mayor, a post he would hold until 1947.

Genesee Camp SP-14, at Katherine Craig Park, demonstrates the military layout and regimen of a typical CCC camp. Each camp housed 150 to 200 men, who mustered for roll call each morning before heading out to the day's work. Denver Mountain Parks files

CRANMER AND THE MOUNTAIN PARKS

Stapleton brought with him new leadership for the city's parks, naming George E. Cranmer his Manager of Improvements and Parks. With cunning and creativity, Cranmer would capitalize on the New Deal to take the Denver Mountain Parks in new directions.

A well-connected Denver native, Cranmer attended East High School and Princeton University. After returning to Colorado, he became a successful stockbroker. Fortuitously, he sold his brokerage just before the crash of 1929. Possessed of an agile mind and exceptional promotional talents, Cranmer served as Benjamin Stapleton's campaign manager during the 1935 election. He entered public service as Manager of Improvements and Parks that summer, at the helm of the city's largest department. In six short years, in the face of continuing economic depression, Cranmer's gift for thinking big, his promotional drive, and his shrewd approach to financing would bring Denver three new mountain parks—Katherine Craig, O'Fallon, and Newton—as well as a major expansion at Daniels Park, Winter Park Ski Resort, and the peerless Red Rocks Amphitheatre.

George E. Cranmer

Designed to keep people employed, the CCC program emphasized physical labor by large groups of young men. Here, men are working at Dedisse Park. Denver Mountain Parks files

THE NEW DEAL ARRIVES IN THE MOUNTAIN PARKS

Events moved swiftly the summer Stapleton and Cranmer took office. On May 16, 1935, Company 829 arrived at Chief Hosa Camp P-204 in Genesee Park. As chronicled in L.A. Gleyre and C.N. Alleger's *History of the Civilian Conservation Corps in Colorado,* the men "felt it a signal honor" to be chosen for the work. Company 829 would do forestry and flood control work, build roads and trails, and improve campgrounds and picnic areas for the Denver Mountain Parks.

On June 30, 1935, Company 1848 arrived at Mount Morrison Camp SP-13. Made up of young men aged 18–25, this cadre had come "to furnish man power for the construction of a huge amphitheater in the Park of the Red Rocks," wrote Gleyre and Alleger. But that work would wait a year as the architectural plans were completed. Meanwhile, the boys kept busy building picnic tables, parking areas, roads, bridges, ovens, and trails, and banking exposed slopes in the mountain parks.

On the last day of October 1935, Veterans Company 1822 arrived at Genesee Mountain Camp SP-14. It took responsibility for a variety of improvements including "guard-rail construction, road construction, … beetle control and weed eradication, sign work, fireplace construction, and the construction of picnic benches and tables."

Veterans Company 1860 arrived at the Morrison camp in 1937, bringing older men skilled in the construction trades to work on Red Rocks Amphitheatre. In addition to the CCC's signal presence in the Denver Mountain Parks, the city continued to benefit from other New Deal programs. In 1939, WPA crews repaired Bear Creek Canyon Road and installed several miles of retaining walls following severe flooding the previous autumn.

Altogether, these New Deal programs changed the face of Denver's mountain parks dramatically. Healthier forests, safer roadways and riverbeds, and a host of new bridges, trails, and facilities graced the mountain parks by the time the CCC era had come to a close. Noteworthy among these accomplishments were the log boathouse at Evergreen Lake, the rustic picnic shelter at Genesee Park, and a new shelter house and picnic area at Dedisse Park, all built by CCC workers. But the best-known New Deal project in the Denver Mountain Parks was George Cranmer's grand endeavor at Red Rocks Park.

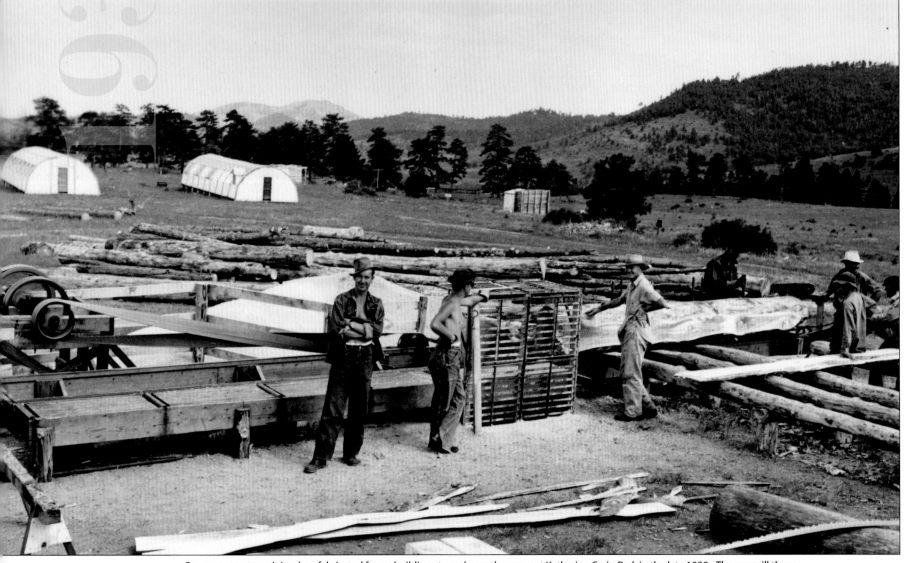

Quonset structures joined prefabricated frame buildings to make up the camp at Katherine Craig Park in the late 1930s. The sawmill these men are operating provided materials for shelters, latrines, picnic tables, and other structures in the mountain parks. Denver Mountain Parks files

TOP: True to the manual labor of the 1930s, Civilian Conservation Corps workers rehabilitated Little Park by hand. Denver Mountain Parks files.
ABOVE: The National Park Service directed the removal of the cupola from the 1918 well-house/shelter, but plans for restoration are being developed.

RED ROCKS AMPHITHEATRE

Several years before becoming involved in city politics and park administration, Cranmer had visited the ancient Greek theatre in Taormina, Sicily. This classical example would deeply influence his vision for the natural amphitheatre at Red Rocks, which had seen modest development by J.B. Walker and the Begole administration. Cranmer hired respected Denver architects Burnham Hoyt and Stanley E. Morse

to design a public venue that would match the natural setting's grandeur while taking advantage of its rare acoustic properties.

The project was anything but simple, as historian Thomas J. Noel has shown. The designers worked with the asymmetries and slope of the bowl nestled between Creation Rock and Ship Rock. After Hoyt came up with original schematics, he and Morse completed more than 125 drawings from the earliest plans in 1935 through completion in 1941. Many in Denver—including Mayor Stapleton—worried that Cranmer's project would disturb the natural appeal that drew picnickers and hikers to the park.

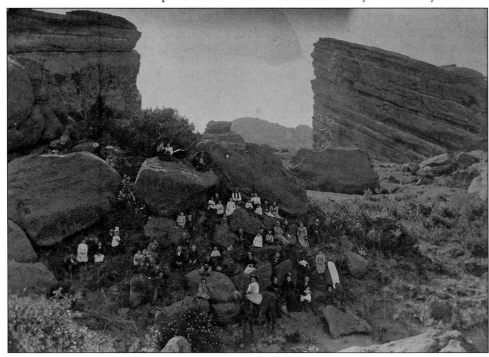

"I am especially proud of having had a part in building the Red Rocks Amphitheatre, a masterful monument that will be there for centuries for people to enjoy. … We did not have power machinery, so all the work was done with pick and shovel. I operated a jackhammer. Sometimes in carving out the side of a cliff, I was suspended by a rope attached to my belt and held by three men. Sometimes it was dangerous but mostly it was hard work and we Colorado boys loved it." —**Demas Atencio,** CCC Company 1848

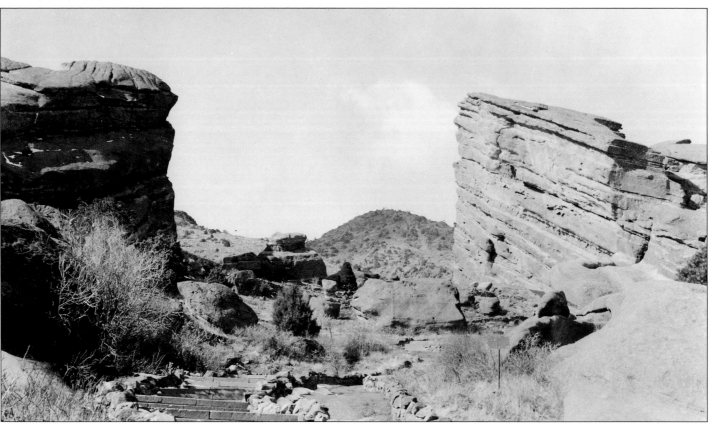

TOP: Long before today's amphitheatre, Red Rocks was a popular spot for sightseeing. Along with other groups, the family of Anderson Gage Pike—nephew of Zebulon Montgomery Pike—enjoyed picnicking in the "natural amphitheater" in what was then the Garden of the Angels on May 31, 1893. C.S. Lilliebridge, courtesy the Pike Family Collection. ABOVE: Stairs and pathways reflect improvements built in 1931–1932 after Denver acquired Red Rocks Park. Denver Mountain Parks files

Architects of the Mountain Parks: Burnham Hoyt

A Denver native, Burnham Hoyt was the city's most respected architect in the 1930s and 1940s. Hoyt opened his private practice in Denver in 1919 with his brother, Merrill. In 1926, he moved to New York after accepting a commission from John D. Rockefeller to design Riverside Church on Morningside Heights; during this time, he also joined the faculty of the New York University School of Architecture. Hoyt returned to his Denver practice in 1936.

Burnham Hoyt

Denver Public Library

Hoyt's sensitive design for Red Rocks Amphitheatre proved his greatest work. His concept earned National Park Service support and secured federal funding for the massive project. Hoyt understood that the task demanded a restrained hand, so that the architecture would "preserve in full … the view and the extraordinary acoustic properties" of the amphitheatre in its natural setting, reports Thomas J. Noel. The result: a gently sloping, asymmetrical bowl that followed the shape of the surrounding formations.

Working from Hoyt's original concept, partner Stanley E. Morse handled much of the daily supervision. Red Rocks Amphitheatre won national accolades during the 1940s, when the New York Museum of Modern Art selected it as one of the decade's top examples of American architectural excellence.

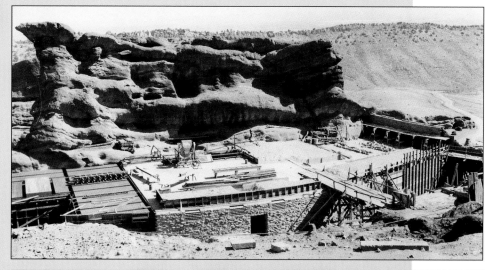

Much of the clearing and carving of benches into the seating area at Red Rocks Amphitheatre was done by hand after the initial blasting. Denver Mountain Parks files

TOP: Stage construction, here in progress in the late 1930s, was completed ahead of the seating. Denver Mountain Parks files. ABOVE: Redwood was used in the original bench seats of Red Rocks Amphitheatre. The city replaced the worn seats with ipĕ, a tropical hardwood, in 2003. Denver Public Library, Western History Collection, X-20508

Still, Red Rocks Amphitheatre would become one of the country's most distinctive and monumental CCC projects, earning international acclaim for its architectural design and unique setting.

On May 9, 1936, the boys of CCC Company 1848 began excavating, backfilling, and grading the bowl area to provide a consistent slope for the auditorium seating. Workers moved some 50,000 cubic feet of dirt and rock, the vast majority of it with only hand tools and brawn, Noel writes. One year later, Company 1860's veterans were brought in for the more skilled labor required. Taking a great deal of pride in their work, and being fully aware of the project's significance, the CCC men would work for five years to build the amphitheatre.

Cranmer also took advantage of WPA labor to build parking areas, widen Alameda Avenue, and build a new road from CO 93 to Red Rocks.

Scores of New Deal workers—most of them Coloradans—built a modern masterpiece at Red Rocks Park. These hardworking men built redwood bench seating for 9,450 patrons; set hundreds of stone steps and railings; laid 90,000 square feet of sandstone; built the stage, dressing rooms, and orchestra pit; installed an electrical lighting system in the theater area; and completed landscaping, parking, and road work. Although the project cost $473,164 for materials and labor, the lion's share was federal money paid to CCC and WPA workers.

THE LAST MOUNTAIN PARKS

George Cranmer's commitment to developing the mountain parks did not stop with the amphitheatre. During his tenure, some 2,400 acres joined the system. Cranmer was adept at promoting philanthropy, and under his leadership the Denver Mountain Parks received four significant land tracts as gifts, including Katherine Craig, O'Fallon, and Newton parks. O'Fallon Park connected Corwina and Pence parks to create a contiguous 1,478-acre tract. Newton Park was a gift from the father of future Denver mayor James Quigg Newton Jr. In 1937, Cranmer accepted just over 960 acres from Florence Martin to expand Daniels Park.

Cranmer was also the originator of Winter Park, Denver's municipal ski resort. After pulling together financing and support for the project with the aid of the Chamber of Commerce, Cranmer purchased 89 acres for the lodge and ski tow in 1939. The remaining 5,511 acres of the ski area was leased from the U.S. Forest Service. Development of Winter Park would stretch many years into the future, but in some ways the ski area—the city's last purchase of a new mountain park site—represented the end of an era.

THE PARKS AND THE PEOPLE

From 1912–1940, Denver invested deeply in land, roads, and infrastructure to create a system of mountain parks that captured the essence of the Rockies. The parks offered patrons a diverse array of activities in an equally diverse range of picturesque settings. Denver residents as well as tourists came to the mountain parks to enjoy picnicking, hiking, fishing, camping, boating, and golf; pleasure driving through the scenic region; and one-of-a-kind attractions including Pahaska Tepee, Mount Evans, and Red Rocks Park. In 1938 alone, activity logs tracked more than 1.2 million cars passing through the four entrances to the mountain park region between Memorial Day and Labor Day.

In the years before World War II, the mountain parks proved an integral part of life for thousands of Denver residents. Every year, hundreds of local children participated in Girl Scout, Boy Scout, and other outdoor programs. Denver families celebrated major and minor milestones with a mountain park gathering, some of which became traditions passed down from generation to generation. Community events such as the annual Genesee Park flag-raising drew hundreds to the mountains.

True to the vision of their earliest proponents, the mountain parks bequeathed to Denverites a legacy of accessible, low-cost nature recreation. The parks also protected the most stunning mountain landscapes near the city from extensive development, preserving the foothills' scenic beauty and setting the stage for further open-space protections later in the century. For more than 30 years, a dedicated corps of imaginative planners, designers, engineers, promoters, and municipal officials saw in the mountain parks a grand opportunity for the city and its people—a promise that was, they believed, well worth public investment.

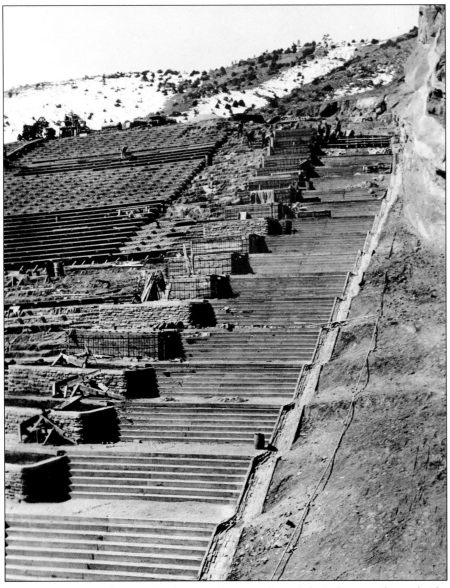

Construction of the seating area, stairs, and planter boxes on the north side of Red Rocks Amphitheatre. Denver Public Library, Western History Collection, X-20505

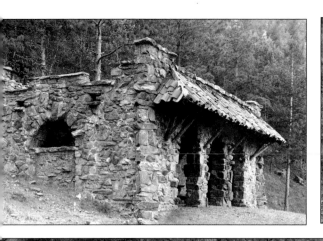 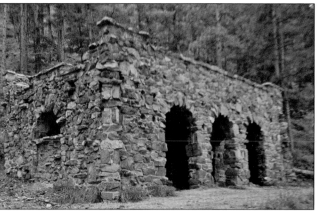 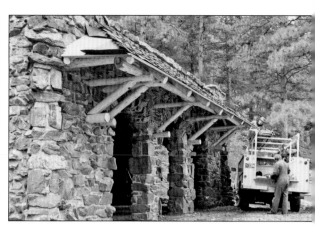

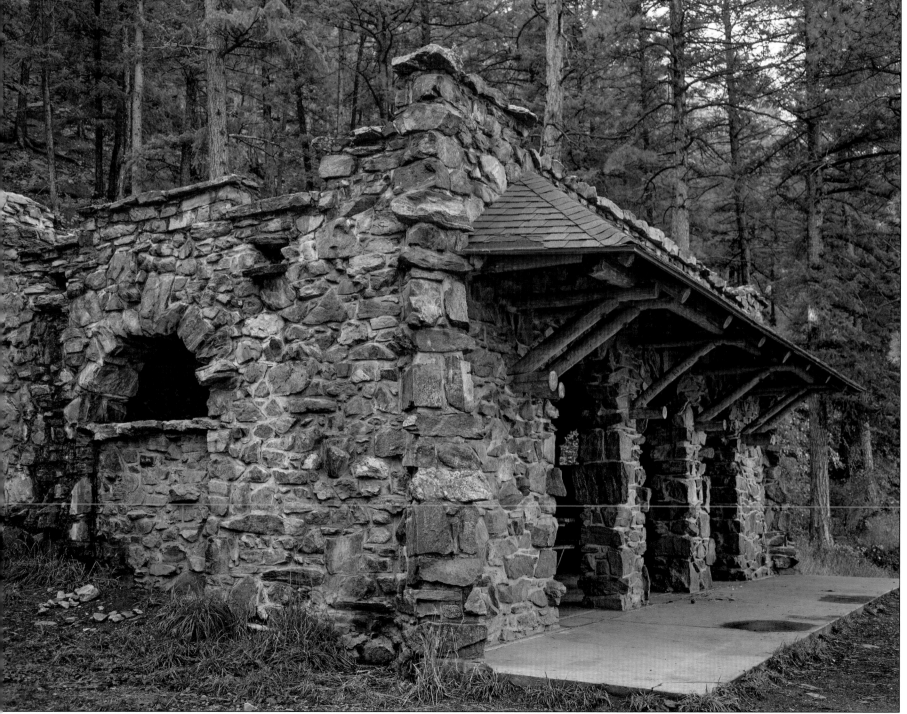

The original awning roof of the shelter at Corwina Park (seen in the image at top left) had deteriorated and been missing for years when staff rehabilitated this shelter in the early 1990s using city funds. Timbers were harvested on site, and a fireplace was added. TOP LEFT: Denver Public Library, Western History Collection, X-20462. MIDDLE and RIGHT: Denver Mountain Parks files

Defending the Mountain Parks

That early planners accurately predicted the population growth of the region and the demands and impacts of that growth continues to astound today's users. ... Denver is the regional forerunner in open space preservation and will continue to maintain an active leadership role in providing for a wide array of activities appropriate in a mountain park setting."

—Denver Mountain Parks Strategic Plan, 2000

Challenges arose for the Denver Mountain Parks in the second half of the 20th century as budgets declined, demographics changed, and the park system struggled to preserve what had been built in the early years. Park managers responded to this chronic uncertainty with determination and creativity. By the 1990s, a renewed commitment to the historic mountain parks had dawned.

A municipal reorganization in 1955 removed the dedicated mill levy that had long funded mountain park development and maintenance. These changes also put the mountain parks in a political tug-of-war with city parks and soon triggered calls for divestiture. As the parks strove to maintain themselves in spite of funding losses, pressures on the parklands grew exponentially during the period of massive foothills population

Sally L. White

Part 19

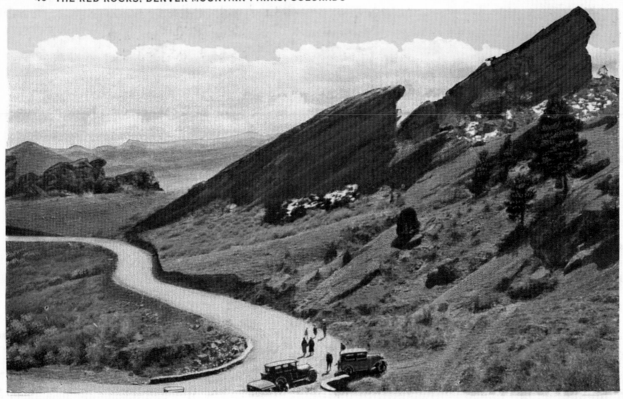

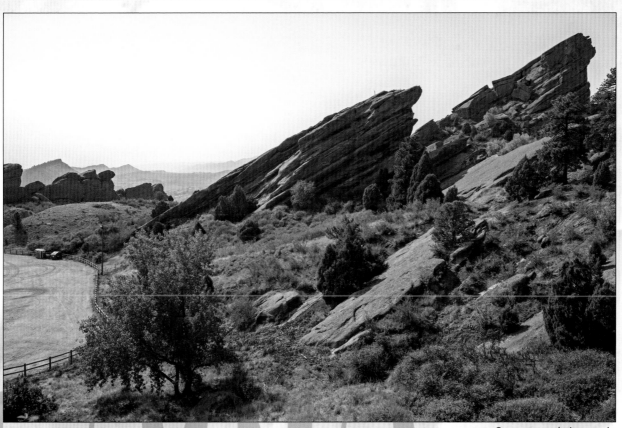

Once a meandering scenic road (top), this corner now has a large parking lot that fills up with concertgoers during events but remains empty at most other times.

E.D. Bowman News Co. #46

growth. The rise of suburban Jefferson County revealed the parks' inherent value but also threatened their existence.

By the 1970s, environmental consciousness increased public awareness of land protection, inspiring foothills citizens to create for themselves the kind of legacy Denver enjoys. The Jefferson County Open Space initiative, passed by voters in 1972, gave that new system dedicated sales tax funds, enabling acquisition of more of the lands identified in the original Olmsted Plan. Movements championing open space and environmental protection expanded Denver's opportunities to find new partners and outside support for park improvements, and enhanced focus on the system's natural resources, including better management of forests and fisheries.

During these years, efforts to preserve landmark buildings and structures gained public support. The perspective and foresight of managers such as Carolyn and Don Etter, along with work by planners and historical consultants, helped to earn the Denver Mountain Parks designation in the National Register of Historic Places during the 1990s. This national recognition of the parks' historical value enables Denver to tap programs such as the State Historical Fund for planning and restoration.

At the Denver Mountain Parks' centennial, Denver Parks & Recreation is reevaluating the role of the mountain parks in a changing region in terms of serving public needs for recreation while protecting the natural landscapes, scenic corridors, wildlife, and watersheds that civic leaders originally placed in trust for the people. As this park system continues to evolve, the challenge will be finding ways to move into the future without losing sight of the parks' distinct character and the variety they offer in the regional public landscape.

The Last Boom

With the accomplishment of the grand dream of Red Rocks Amphitheatre, Denver and its mountain parks were poised to enter a new era. Unfortunately, the amphitheatre's formal dedication on June 15, 1941, came just months before the United States entered World War II, when many plans and dreams changed as the country mobilized around new goals.

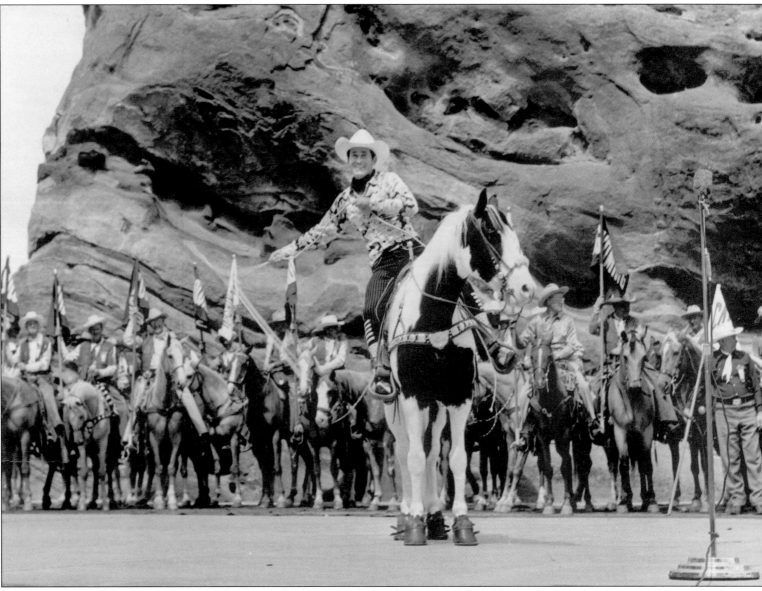

In July 1952, Hollywood star Montie Montana performed at Red Rocks as part of a show by Roundup Riders of the Rockies. A year later, he attracted headlines when he threw his trick lariat around President Dwight D. Eisenhower during Eisenhower's inaugural. Denver Public Library, Western History Collection, Z-3770

A Rocky Start for the New Amphitheatre

The 1941 dedication was a double feature. The city held an "unofficial event" on June 8 with 3,000 in attendance. Parks manager George E. Cranmer served as master of ceremonies, reported *The Denver Post*. On that Sunday afternoon, the Denver Junior Symphony orchestra played, presaging the amphitheatre's future performances. The *Jefferson County Republican* called it a "dress rehearsal for the 10,000 Rotarians who will gather next Sunday to hear Miss Helen Jepson." Their international convention had the honor of being the true grand opening.

The fortunes of the new amphitheatre waxed and waned through the 1940s, its primary use being by the Denver Symphony Orchestra and its offerings guided by Cranmer's love for classical music. The public rebelled, showering Cranmer with scorn during a crowded ceremony held on August 3, 1946, to celebrate what would have been the hundredth birthday of Buffalo Bill Cody. The *Post* reported that traffic tie-ups marred the occasion. The *Rocky Mountain News* joined in criticizing Cranmer's highbrow choices, looking for something more "down to earth."

Despite that critique, homegrown entertainment abounded in those early years, and performances in the 1940s and 1950s, announced regularly in the *Post,* demonstrated variety. The KOA orchestra played on Sundays in 1941, vespers were sung regularly in 1942, the city band played in August 1946, and the *Denver Post* sponsored concerts. Square dancers took the stage often after 1947, "Koshare Indians from La Junta" (Boy Scout Troop #2307) danced annually, and ballet dancers also performed. After Denver banned free use of the theatre in August 1947, use became more formalized. The Denver Symphony Orchestra organized a summer festival beginning in 1946 that lasted until 1962, despite frequent reports that its seasons were less than profitable.

Easter Sunrise: A Tradition Takes Shape

The first watershed event came to the amphitheatre six years after its dedication. The Easter Sunrise Service of April 6, 1947, launched a tradition that continues as a highlight today. The event also revealed a flaw that would plague the facility indefinitely: Wedged between two megaliths, the amphitheatre had, and always would have, a limited capacity of 9,450.

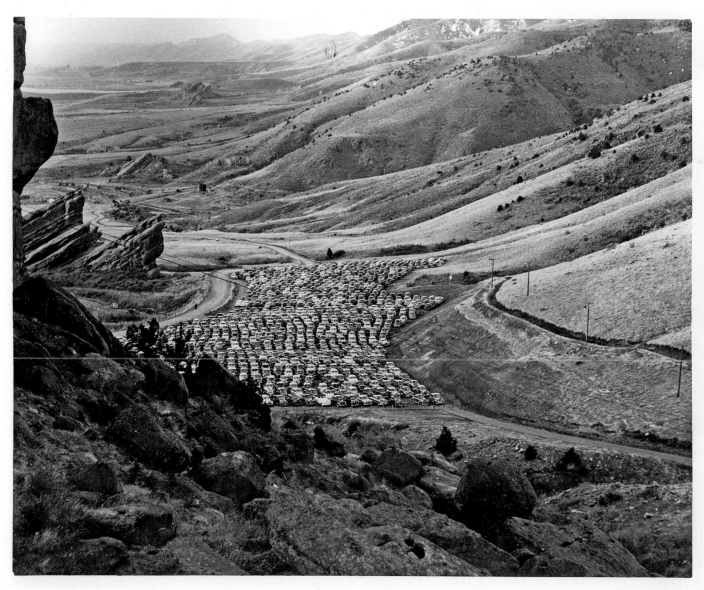

With cars packed in this tightly, early concertgoers must have had an orderly—and patient—exit from Red Rocks. Denver Mountain Parks files

1941–1955

Tens of thousands flocked to the event, far more than could be accommodated. Despite visitors being trapped for hours in their cars or in a standing-room-only facility, the amphitheatre's charms apparently won over even the unlucky, and the people's enthusiasm for the venue went untarnished. By the Easter service in April 1949, 5,000 autos cleared the park in 47 minutes, the *Post* crowed, despite the estimated crowd of 15,000.

Improvements Get a Boost from the Cold War

Few remember that Red Rocks was contemplated for use as a civil defense shelter, at least by Mayor James Quigg Newton Jr. and his city council, as the Cold War heated up in the mid-1950s. City officials appointed a committee to develop plans and began receiving state grants-in-aid for civil defense, including some $1,200 in 1954. By July 1955, the *Post* reported that a control center would be located "beneath the stage at Red Rocks." A year later, the center was ready for operation, said the *Post*, and the *News* noted that "City Hall can use Red Rocks 'in case.'" Other improvements to the park and facility at that time, including the new South Ramp built across the face of Ship Rock and a new water well at Entrance 2, may have been paid for partly with civil defense funds. For years, schoolchildren learned to "duck and cover" under their desks, but city officials would have a safe retreat among the rocks.

Fortunately, the feared attack failed to materialize. New parking lots were graded, and minor improvements continued through the late 1950s, but plans for more serious remodeling began about 1958; the work started in March 1959 and was completed that summer. Lighting towers flanking the stage were built of the same Lyons Sandstone as the original amphitheatre features, and backstage facilities and dressing rooms saw an upgrade.

Denver Public Library

James Q. Newton Jr.

Planter boxes with native junipers separate the seating area from the stairways at both sides of the amphitheatre. The lighting towers flanking the stage, at left in this 1998 photo, were added in 1959. Denver Mountain Parks files

The Winds of Change

Not until 1988 did the stage receive a much-needed roof, providing performers, if not audience members, with protection from the elements after decades of open-air concerts and events. From the memorable 1957 occasion of the opera *Die Walküre*, to the impressive storm, highlighted in Thomas J. Noel's *Sacred Stones*, that marked the legendary U2 performance in 1983, weather played a conspicuous role in the Red Rocks concert experience.

"The wind started to come up during Wotan's final song, and was fierce by the time he started the fire. As he sang … the wind was in almost hurricane blast. The Walküre were hanging onto the rocks for dear life. The fire was blown into the orchestra pit, and we could hear the dropping of instruments as the musicians panicked. Saul Caston was yelling 'come back, come back' and Brunhilde was gamely holding on so that she wouldn't be blown into the fire. Wotan was trying desperately to look heroic, while at the same time trying to keep his cape down and his skirt from going up.

"Caston got the orchestra back, they began playing and Wotan finished his aria. It was a grand finale."

—**Ray Koernig,** eyewitness to *Die Walküre* in 1957

DENVER'S LOVE AFFAIR WITH SNOW

Rhapsodies in *Municipal Facts* suggest that Denverites had long been enamored of water in its crystalline form. The Denver Mountain Parks proved the perfect outlet for exercising this infatuation. As early as 1914, *Municipal Facts* touted the joys of charging up the unplowed Lariat Trail in an automobile. Editor Edith Sampson fawned over winter picnicking in 1929. Denver citizens apparently couldn't get enough snow.

Winter Fun: Skating and Sledding

Denver residents found ways to enjoy snow in the city, but the filling of Evergreen Lake in 1928 immediately drew ice skaters to the hills. The city administration and the Figure Skating Club oversaw skating six days a week during freezing weather, with music wafting over the lake from 10 a.m. to 10:30 p.m. From the 1940s through the mid-1980s, city staff at the CCC-built warming house rented skates and offered hot cocoa to skaters as they rested on the long benches of its rustic interior.

Denver Mountain Parks staff groomed the ice nightly using a jeep with a scraper, then a Massey tractor with a broom on the front. Using a fire hose, they pumped water from a hole in the ice and

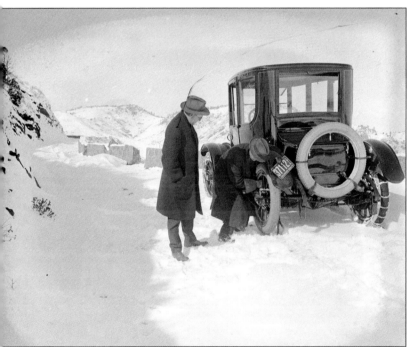

TOP: Ice skating continues to be a popular pastime at Evergreen Lake, as it has been since the 1930s. Today the Evergreen Park and Recreation District operates recreational activities at the lake. Denver Mountain Parks files

LEFT: Even in the Lariat Trail's early days, snowstorms did not discourage adventurous travelers, who packed shovels and chains to cope. This 1916 photo demonstrates the joys of winter outings on the unplowed Lariat Trail. Denver Public Library, Western History Collection, Rh-453

BELOW: Alpine tundra in winter is an inhospitable place, as this November 1948 photo at Summit Lake Park suggests, but the Army Air Forces Training Command found the area perfect for arctic training in 1943–1944. Denver Mountain Parks files

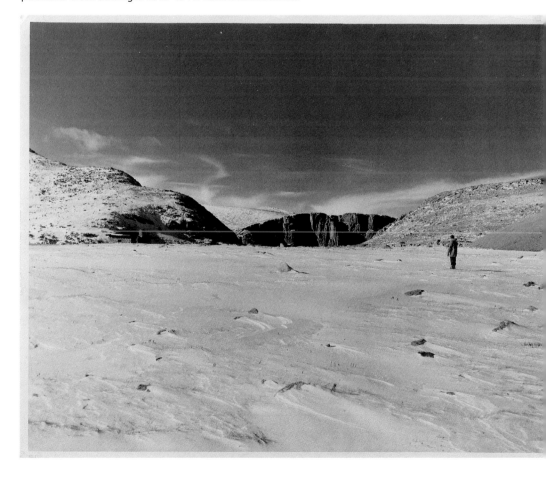

hand-sprayed the surface every night. Once the ice grew thick enough to support a truck with a water tank and spray bar, the work went faster, except for stops to thaw the spray bar.

Skiing and tobogganing officially occurred at "Twin Forks Ski Course" in today's Turkey Creek Park, wrote the Denver Chamber of Commerce in 1942. In a 1965 report on "sledding in the Mountain Parks," Superintendent Patrick Gallavan said, "[W]henever there is sufficient snow, sledders will be found in all parks where there is a slope to sled on." He estimated that up to 20,000 people went sledding in Pence, Fillius, and Cub Creek parks on nice Sundays. Gallavan submitted a plan in 1960 to improve sledding areas, but with liability an issue, the city's legal staff vetoed his ideas for creating safe areas for winter sports in the mountain parks.

Regardless of risk, popular use continued, watched over by signs that noted, "This area not supervised for winter sports." Winter

The Warming Hut, built at Evergreen Lake by Civilian Conservation Corps enrollees in 1939, is headquarters for winter skate rental and serves as a boathouse and nature center during the summer. Denver Mountain Parks files

fun in the mountain parks came to an abrupt halt in February 1978, when a young girl was killed at Pence Park, prompting new signs: "Park Closed for Winter Sports." That tragedy brought a 60-year tradition of informal winter recreation to an official end.

Skiing the Mountain Parks

Inspiration Point at 49th Avenue and Sheridan Boulevard marked the edge of the city and its first view of the mountain parks. The blizzard of 1913 made a ski attraction of this unlikely site; at 200 feet above Clear Creek, it was the only prominent height that promised a good drop.

"The Denver Rocky Mountain Ski Club, a spin-off of the Colorado Mountain Club, had held ski jump competitions at Inspiration Point, down in dusty Denver. The search for better snow led them to build a jump next to Denver Mountain Park's first purchase Genesee Mountain. ... Tournaments were held there for several years, but the view of snowblanketed hills to the west, so prominent from the brink on Inspiration Point, eventually drew the skiers' ambitions westward," wrote local journalist John McMillin in *Historically Jeffco* magazine in 1997.

The Genesee ski area, despite the name, was on private property, not in Denver's mountain park. This, and a few other Front Range

sites, kept ski enthusiasts happy from 1920 until the opening of ski areas farther west. Some skiers credited Genesee with "putting Colorado skiing on the map."

In January 1935, Denver used relief workers to launch a sports center at Echo Lake Park, the *Denver Post* reported. Twenty men were put to work, soon completing ski trails. The area included downhill runs, ski jumping, a cross-country trail, ice skating, hockey, and skijoring. Dedicated during a snowstorm on February 25, the center seemed to have it all; however, it faded into oblivion.

Winter activities at Echo Lake, at least for a select few, were resurrected during World War II, when the Army Air Forces Training Command took over in search of "hell freezes over" temperatures. In 1943, men were training in giant ice boxes at Buckley Field but needed something more rigorous: true alpine conditions. The road to Summit Lake and Mount Evans closed to the public for almost two years as trainees tested their mettle camping at Echo Lake Park. Meanwhile, officers enjoyed the rustic comforts of the Echo Lake Lodge.

Colorado's passion for skiing truly blossomed in the wake of the 1932 Winter Olympics in Lake Placid, N.Y., the first winter games

hosted in North America. With improved access to the high peaks and the enthusiasm and promotional skills of the Colorado Arlberg Club, the time was ripe for Colorado skiing. George Cranmer noticed.

FROM WEST PORTAL
TO WINTER PARK

As his amphitheatre was on the drawing board back in 1935, Cranmer was envisioning his next "gift" to Denver citizens: a winter sports mecca in Winter Park. Winter sports fans already enjoyed skating at Evergreen Lake, and the 1935 winter sports center at Echo Lake briefly offered thrills and spills on downhill runs, cross-country trails, and lake ice. But the mountains beckoned, and development at Winter Park began by 1937, when Denver had nothing more than a lease on Forest Service acreage.

From its early days as a hangout of the prestigious Colorado Arlberg Club, West Portal was a hotspot for Colorado skiing. Club members established a base in the old mining cabins at Mary Jane. With the 6-mile Moffat Tunnel completed in 1927, westbound trains conveniently delivered skiers to West Portal, at the base of the mountain. Formed to promote the sport in Colorado, the club introduced Cranmer to the site, firing his early enthusiasm.

"Directly west of Denver, we have absolutely everything essential to the ideal winter playground. The new high speed trains make it possible for easterners to come out here Saturday, spend a weekend in the mountains, and be home again on Monday. But to get them out here we must have something to offer in the way of accommodations and some kind of winter program. We can't expect them to come out to sit on the [side] of a mountain just to view the scenery."

—**George Cranmer** to a reporter, 1937 (cited in *Westword*, 2002)

West Portal, in the late 1930s, was a small ski area at the base of Vasquez Mountain where trains exited the Moffat Tunnel. Parks manager George E. Cranmer's vision for the site made it a favorite ski area, now operated by Intrawest Corporation. Denver Mountain Parks files

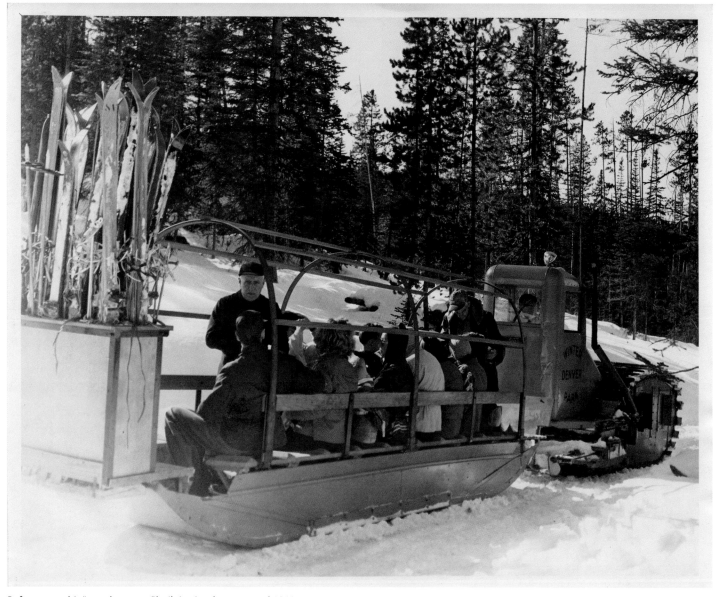

Before tows, this "people mover," built in city shops around 1940, transported skiers up the mountain for several years. A motor mounted in the cab drove a roller on the front to move the contraption; people rode in the sled behind. Denver Mountain Parks files

Winter Park was, and is today, chief of Denver's winter sports areas. The 89 acres the city purchased at West Portal in 1939 enhanced lands leased from the Forest Service. In August 1939, Cranmer wrote to the mayor of Granby in search of volunteers to help clear ski runs, smoothing the request by noting that "one Grand County woodcutter is worth five Denver people" in accomplishing such work.

Without the ski tow, introduced in Quebec in 1933, the fortitude required for skiing at Colorado elevations would have limited participation. However, by 1939, the popularity of Colorado winter sports equaled that of New Hampshire and Vermont combined. Winter Park's second season, in 1940–1941, was twice as long as the first, reported the manager; from December to mid-April, it attracted some 112,000 skiers.

In 1942, when the Denver Chamber of Commerce extolled the "limitless opportunities for cross-country skiing" at Winter Park, the area included a 2,300-foot tow, a warming shelter, "many ski trails," a 1,700-foot slalom run, a 700-foot practice slope, a 35-meter ski jump, and a junior jump. A tractor tow operated on weekends. Early on, all of it was managed by mountain parks staff, whose ranks swelled with seasonal hires to handle the extra load.

It made for a far-flung system. The mountain parks crew often stayed in cabins to reduce the commuting cost; former CCC buildings moved from Katherine Craig Park also became bunkhouses for seasonal employees at Winter Park.

Winter Park became Denver's favorite ski area, a homegrown place where generations of residents learned to ski. In 1950, the Winter Park Recreation Association (WPRA) took over its management. This nonprofit organization acted as the city's agent, paying $7,000 per year for the opportunity. With profits going into development, Winter Park expanded rapidly through the 1950s and 1960s. A new lift was added in 1953, and Mayor Will Nicholson dedicated two more in 1958. The Denver & Rio Grande Western Railroad ran specific "ski trains" to deliver enthusiasts to the mountain. The popular Ski Train operated until 2009.

Will Nicholson

By the time Snoasis, the resort's new restaurant and warming house, opened in February 1968, the growing ski industry's climate had changed. Destination skiing was the new wave. Winter Park needed housing and facilities at the mountain base to cater to skiers from distant states. Denver refused to spend public funds on further development, and Winter Park fell behind flashier resorts, including Vail and Aspen. Loyal Denverites

retained a nostalgic affection for Winter Park, whose family-friendly resort offered children's programs, junior ski jumping, winter carnivals, handicapped skiing, and other enticements.

Winter Park's origins as part of the Denver Mountain Park system were all but forgotten as the ski area flourished under WPRA. In 1993, the organization offered to buy Denver's interest for $53 million as the city slowly realized that Winter Park must adapt to new realities. Mayor Wellington Webb at first entertained the proposal, but backlash from Denver's public led instead to a renegotiation of the lease. WPRA agreed to pay the city $2 million a year, money earmarked for capital improvements in Denver's park system.

From 1994 to 1999, Denver parks received some $13 million in income from Winter Park, but in 2000 and 2001, WPRA defaulted, citing poor snow seasons in 1999 and 2000. Mayor Webb appointed a committee to evaluate options "to preserve and protect Winter Park as a first-class ski mountain." This time he refused to be known as "the mayor who sold Winter Park," *Westword* reported, so the city searched for a partner, evaluated bids, and finally contracted with Intrawest Corporation in 2004. Currently Denver receives at least $2 million annually from Intrawest's operation of the ski resort, supporting development projects citywide and within the mountain parks. The resort once supported by mountain parks staff today helps support repairs to the historic system.

Postwar Changes, New Challenges

The Denver Mountain Parks began at a time when the foothills west of the city largely remained undeveloped country, although private owners already held much of the land. Jefferson County, where the most parks lie, had fewer than 15,000 residents in 1910 but, by the 1950s, population there had boomed to 56,000, just 10 percent of its present level.

In the years between World War II and the environmental "revolution" of the 1970s, Denver Mountain Parks provided the primary opportunities for public outdoor recreation in the metro area. As funding from Denver diminished in the postwar decades, permanent residents replaced the earlier seasonal population in the foothills, creating a demand for near-urban levels of service, thus fueling further development. This growth changed the dynamic for Denver's mountain parklands, which were increasingly surrounded by subdivisions and commercial properties.

LIFE WITHOUT THE MILL LEVY

In 1948, a "Manual of Operations" outlined the personnel required to maintain the mountain parks, including 23 permanent and 25 seasonal employees. The superintendent reported directly to the director of parks, oversaw six "districts" of mountain parklands, and had an accountant, a clerical assistant, two parks police, and a dedicated engineer at his office in downtown Denver. Laborers and equipment operators used 30 pieces of heavy machinery and motor vehicles that were housed and serviced at nine garages in Morrison, Genesee, Winter Park, Deer Creek Park, and Daniels Park. Many of these locations had at least one employee stationed on-site.

Albert Stromberg served as superintendent through the 1950s, assuming oversight of a system that included all of this, but that would soon change. In 1954, the mill levy for Denver Mountain Parks brought in $95,666, wrote a former city councilman; personnel costs were about $70,000 per city records. That amount was 2 percent of all special levies, and little more than 0.5 percent of all property tax receipts.

In 1955, the city administration underwent a major reorganization. The Department of Improvements and Parks split into a new Public Works Department and a Parks Department that was now combined with Recreation. The Mountain Parks Division, previously separate from the city parks, moved within that larger entity, and the mill levy that had funded operations since 1913 quietly vanished. Denver's mountain parks were now a single outlying district competing with several urban park districts, and the system's role diminished as budgets tightened downward from the decades when they were funded by the mill levy.

"THIS WORK IS ALWAYS WITH US"

Patrick Gallavan assumed the role of mountain parks superintendent in 1960 and wrestled with the implications of the growing foothills population and resulting pressures on the parks. Near the top of his July 1963 report on mountain park operations and projects, Gallavan's observation that "this work is always with us" captured the essence of the job. The staff spent much of its time on routine maintenance of buildings, roads, forests, and the parks themselves.

With a dwindling staff of about 12 men supplemented by "20–25 prisoners from county jail and 8–10 boys from Juvenile Hall," the season promised to be a busy one. At mid-year, Gallavan

During his tenure, Mountain Parks Superintendent Patrick Gallavan worked with Denver's Department of Corrections to pioneer the use of juvenile and honor crews for work projects ranging from forestry and sign-making to shelter construction. At the 1966 dedication of Dillon Park, a picnic area built by the juvenile crew in Cub Creek Park, Gallavan (in dark suit) stands behind probation officer Frank Dillon, who helped create the work program. Courtesy Patrick Gallavan

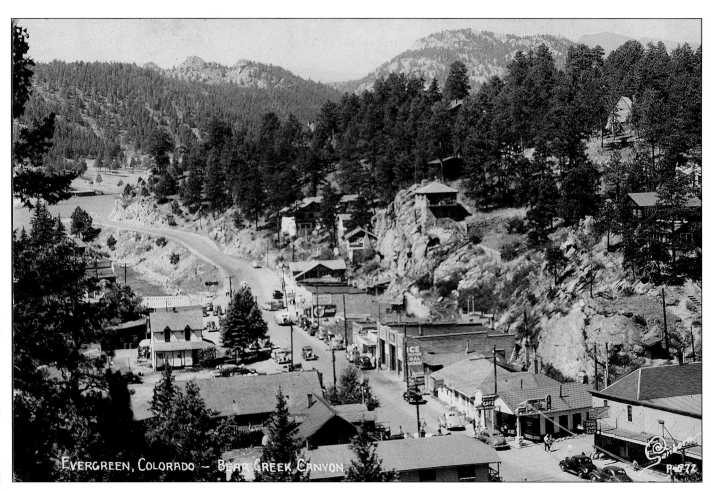

EVERGREEN, COLORADO — BEAR CREEK CANYON

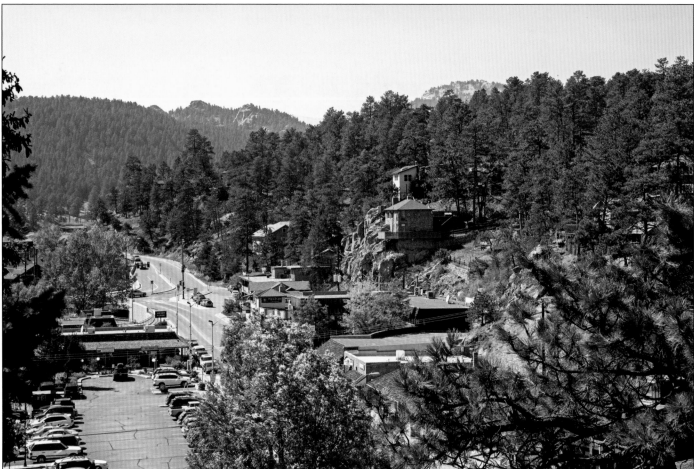

Bustling with tourists, the "charming mountain resort" of Evergreen was considered "the hub of the Denver Mountain Parks System" after the creation of Evergreen Lake, praised this circa 1940s postcard (top). Tourism dwindled after World War II, but the area's permanent population expanded in following decades. Sanborn Souvenir Co. P-872

observed it was already "one of the worst" fire seasons on record; even maintaining the fire ban postings became a challenge, he wrote, as "the thoughtful public [use] the 'No Fire' signs to start their fires."

This 1963 season found three historic buildings "leaking like sieves" and needing new roofs; they were not expected to last if heavy storms occurred. Heavy use was causing erosion in Fillius and Bergen parks, and Gallavan thought better planning of facilities and parking could alleviate some of the problem and prevent the parks' closure.

Control of the mountain pine beetle, or Black Hills beetle, engendered concern, although the "epidemic buildup in 1961" had been checked by the following hard winter. Mountain parks crews removed about 3,000 infested trees in 1962, and state forestry crews assisted with follow-up surveys and treatment in 1963. The prisoners and juvenile offenders also worked on the growing pine beetle problem. Gallavan and staff kept busy overseeing these extra crews as they built toilets at Genesee Park, constructed parking areas, and built or installed picnic tables, grills, and signage—all in a summer's work.

Gallavan's 1963 report seems almost playful as it reveals the frustrations that generations of park superintendents have faced in maintaining public facilities. Regarding fencing and barriers, he wrote, "This is a major problem since many of our fun loving citizens want to see what's on the other side of the fence. ... These measures deter the majority, however, we have not as yet devised a barrier that will stop some of the winch equipped jeeps and power wagons."

In addition to such routine matters, Gallavan pleaded for thoughtful park planning:

> This area is in my opinion one of our most pressing needs. While we are on primarily a conservation and maintenance budget the need for planning is still great. From observation I have seen where some of our efforts in the past have gone astray for lack of planning. ...Conservation in its greatest meaning is wise use of our resources. ... We have many areas that were ... considered wilderness areas that are now adjacent to mountain subdivisions with paved roads. Once these areas are accessable [sic], people are going to use them in spite of efforts to keep them out. This is particularly true of the small destructive element of our society who seem to shun areas that are open and in use by the general public.

The four superintendents who have followed Patrick Gallavan would share those sentiments through the ensuing decades. Gallavan's 1963 report documents the largely invisible effort that the Mountain Parks District routinely handled in managing the park system for public use, its work complicated by vandalism and petty pilferage.

PARKS NEED TLC

Public disrespect for parklands reached such a level in 1974 that columnist Joanne Ditmer devoted one of her *Denver Post* columns to it, echoing Gallavan's concerns. "And isn't it sad," she wrote, "that we treat our public lands as public dumps, rather than public treasures. ... We need a great deal of education and commitment on all our parts ... to start treating these lands as a personal responsibility." In this era, highway litter pickup cost Colorado taxpayers $750,000

annually. Ditmer's comments stemmed from conversations with Mrs. Pru Grant of the Park People, who said she was "appalled by the amount of litter and vandalism evident in the Denver mountain parks." That summer marked the first time the Denver group, formed in 1970 to advocate for parks through fundraising and specific projects, became involved in the mountain parks with a trail rehabilitation project at O'Fallon Park.

For the Parks & Recreation bond issue that went before voters in 1964, Superintendent Gallavan detailed the need for $990,000 for mountain parks, of which $500,000 would fund urgently needed repairs and redevelopment of facilities, including roads, toilets, parking areas, and picnic units. The remainder would go toward more visionary developments intended "to serve the increasing population." It was just 9 percent of an $11 million request from the Parks & Recreation Department. Although his bond request was reduced to a mere $60,000, some items found their way into capital improvement budgets in later years. In time, three shelters and picnic areas would be built at Newton Park, and grass greens would replace the sand "greens" on Evergreen Golf Course's front nine holes. Most of the other items Gallavan requested 50 years ago could be moved intact and unfinished to a similar request in 2014.

Gallavan brought professionalism and creativity to the superintendent's job. He also quickly took advantage of the new federal Land and Water Conservation Act passed in September 1964, which established funding for matching grants to state and local governments for recreation planning, acquisition, and development. Gallavan sought and received critical funding that helped rebuild

This 1960s photo suggests the popularity of Evergreen Lake, in Denver's Dedisse Park, as a fishing spot. Preserving the view behind the lake are several of Denver's conservation areas, including Elephant Butte and Bergen Peak. Denver Mountain Parks files

Staff replaced the roof on the Dedisse Shelter in the late 1970s, but used modern materials rather than logs similar to the original. This shelter needs restoration to historic standards. The image at right is from the 1930s. Denver Mountain Parks files

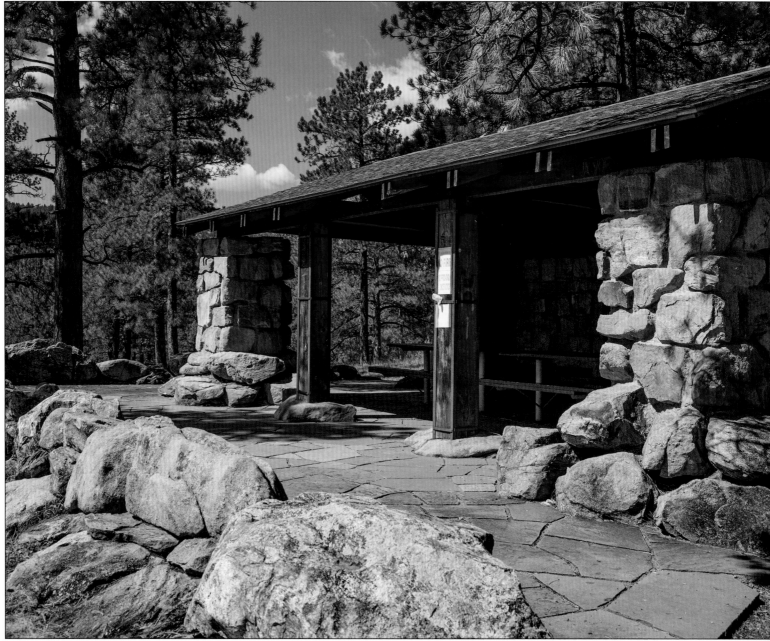

toilets and rehabilitate shelters across the system, compensating, in part, for the money requested but not received from the 1964 Denver bond proposal.

PARK RECOGNITION REACHES NEW HEIGHTS

The designation of Summit Lake Park as a National Natural Landmark in 1965 marked a turning point in mountain park recognition. This widespread park system, conceived in 1910, had reached a significant milestone in turning 50, a standard indicator of historical value. New programs launched as the nation approached its bicentennial. The National Natural Landmark program took shape in 1962, administered by the National Park Service, as was the earlier National Historic Landmark. Passage of the National Historic Preservation Act followed in 1966, creating the National Register of Historic Places and establishing state historic preservation offices. As public awareness rose, local historical societies and programs developed, and the Denver Mountain Parks began to gain new recognition and support from inside and outside the city.

The proposal to designate Summit Lake Park under the new national landmark status came from outside the city. Dr. William A. Weber, curator of the University of Colorado Herbarium at Boulder

and foremost botanist of Colorado through the latter half of the 20th century, had made many trips to study Summit Lake's alpine flora. During several years of hosting tours of visiting botanists on Mount Evans, especially experts from Europe, he came to recognize the unique nature of the plant communities, as well as the threats the area experienced from visitors who didn't respect the delicate tundra ecosystem and saw the park only as a place to picnic, fish, and pick wildflowers.

"The lake is regularly stocked with fish, which are an attraction to local fishermen, who commonly drive their vehicles to the lake shore, cutting tire tracks into the tundra, which soon become sandy barrens. In the absence of established picnic areas, picnickers commonly pull together stones and build their cooking-fires on the tundra, thereby destroying small parcels of land each time the process is repeated. … One of the best ways to accomplish the conservation of the lake would be by stopping the practice of stocking the lake with fish."

—**William A. Weber,** manuscript for 1965 excursion

Botanists from the Colorado Native Plant Society, Denver Botanic Gardens, and Colorado Natural Heritage Program conducted surveys of rare plants at Summit Lake Park in summer 2012. Here, David Anderson leans in for a closer look. The lake and wetlands at the park form the headwaters of Bear Creek and harbor several rare plants and tundra communities similar to those in the Arctic. S.L. White

To Weber, Summit Lake signified a place where "students of the flora and fauna would be able to make a vicarious excursion to the Arctic at a fraction of the cost and time." Weber saw that "nearness to the urban center of population at Denver results in a constant threat to the survival of its unusual flora." In the fall of 1964, he enlisted Jack Evans, manager of Parks & Recreation, and Superintendent Gallavan to support his cause and his nomination for Natural Landmark status. They erected boulders to eliminate vehicle access to the lakeshore, posted signs, and considered asking the Colorado Game & Fish Department to cease stocking.

Park Service biologist Walter Kittams completed his favorable review of Weber's application in February 1965. The Park Service sent word in May that Secretary of the Interior Stewart Udall had approved its recommendation. The dedication was set for September 2 and invitations went out to dignitaries nationwide. Some officials sent regrets, but hundreds of people, including international scientists attending the VII Congress of the International Association for Quaternary Research, attended what Gallavan described as a "brief but impressive ceremony" on a blustery day. Vandals promptly stole the bronze plaque, but Weber wrote in 1991 that "a new one was in place for the dedication," to be unveiled by Rocky Mountain National Park Superintendent Granville Liles.

DENVER'S HISTORIC BISON HERDS

The effort to restore elk and bison, once threatened with imminent extinction, enjoyed such success that the city soon had a surplus. In the 1920s, numbers of animals were reported regularly in *Denver Municipal Facts*, the city's public information vehicle, as citizens awaited news on each crop of calves. Mountain sheep, antelope, and other animals had not fared well at Genesee, but by 1929, the bison population boomed to 59. Hard times would turn the herd into a different kind of resource during the Great Depression. In the fall of 1932, the *Denver Post* reported that the city would "slaughter 25 buffalo and 25 elk for the poor," and in 1935, a bull elk was given to the poor farm, providing victims of the Depression fresh meat for a time.

By 1938, the Genesee bison herd had grown so large that a second herd was established at the new "High Plains" park near Sedalia, 1,001-acre Daniels Park. This expansion doubled bison-watching opportunities for regional residents and tourists. About 800 acres of Daniels Park are still used only by the bison, which are watched over, as at Genesee, by a resident caretaker. Denver's popular bison herds have endured, but their home on the range has not been secure.

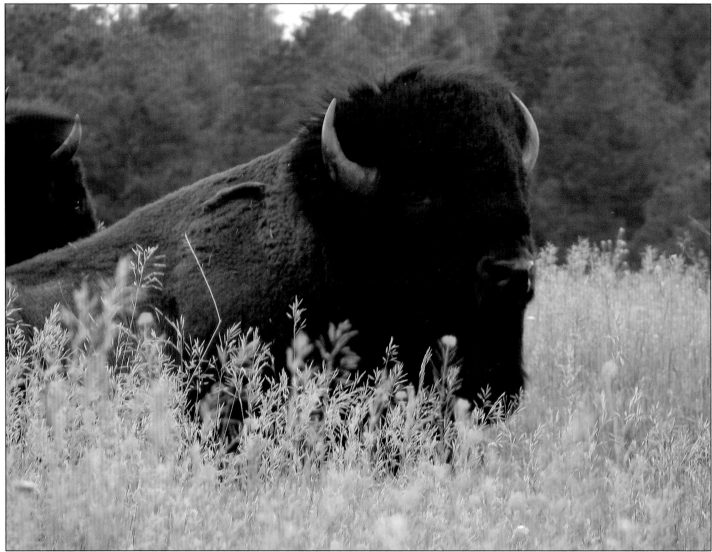

The herd bull at Genesee Park is master of his domain. Each herd has two bulls and about 20 to 25 cows. Calves are born in spring, temporarily increasing the herd size. S.L. White

A File Cabinet with Horns?

In 1938, the *Denver Post* reported that bison had multiplied "into a nuisance. … The total count now is sixty-five at Genesee mountain, twenty at Daniels park in Happy canon and five at the City park zoo—all … descendants of the original herd." The beasts continued to breed so successfully that, between November 1945 and February 1946, 48 were butchered at Daniels Park, reducing the herd there to 58, according to records on file.

Throughout 1956, bison were sold, one or a few at time, totaling nine from the Genesee herd and 36 from Daniels Park and adding $4,300 to the city revenue stream. Buyers included the Southern Ute Tribal Council, the Disabled American Veterans Club, and the Junior Chamber of Commerce, in addition to more than a dozen individuals from Colorado and as far away as Nebraska.

For many years, management of excess stock fell to Denver Mountain Parks staff. At first, bison calves were simply sold now and then to parties who expressed interest. With no organized process, casual sales helped keep herd numbers from booming, and the occasional bison went to slaughter for a downtown restaurant or hotel, or a backyard barbecue.

The City of Denver no longer allows the sale or disposal of city property through casual means. By 1985, even the competitive bidding introduced in the 1940s seemed unceremonious, and the bison were deemed official "city surplus" property, just as if they were old file cabinets or obsolete typewriters. Denver's Purchasing Department formalized management of the annual auction, ensuring that costs are recouped before the proceeds reach the city's general operating fund.

The bison herds weren't just nice to have for the enjoyment of park visitors. In fact, Denver Mountain Parks was in the livestock business. Bison and elk could be scenic park amenities, but as they came under the purview of Department of Agriculture and Division of Wildlife regulations, they also began to be viewed as a commodity.

After researching handling facilities and talking with ranchers, in 1993–1994 mountain parks staff designed and built an innovative corral system, dubbed "Elkatraz," to handle elk and bison. In preparation for the annual bison auction, calves are sorted and tagged in four round corrals and related chutes. Extra calves are sold to help maintain herd size at a level the park system's pastures can support. Here, a bison cow bolts from the loading chute after being separated from her calf. Dean Panos

Denver was operating ranches at Genesee and Daniels parks, and the city had to comply with the same rules as any other rancher. Individual bison and elk were numbered, tagged, and recorded on ledgers. Their transfer to new ownership required the kind of paperwork that might accompany transfer of a registered vehicle. Now, at the roundup in late winter, mountain parks staff, along with a veterinarian and assistants, carefully record each 10-digit USDA tag number, and make sure the associated animal is ear-tagged and tattooed for permanent tracking, as well as tested or vaccinated for brucellosis and tuberculosis.

Managing for Better Bison

A bison-management plan, developed in the 1990s, aimed to improve stock through selection of the best animals and to maintain the herds at a level the range could support. At first this selection was done by observation of traits and behavior. DNA testing has made selection more scientific; calves with fewer genetic "cattle markers" can be kept for breeding while others are sold. As a result of both methods, the herds have improved continuously in recent decades.

Today, just as 30 years ago, management goals include: providing an educational opportunity to Colorado residents and an attraction to visitors by maintaining public herds; managing to improve animal quality, maintain pasture quality, and to be economically self-sustaining; and following guidelines of relevant authorities.

At Genesee Park, descendants of the original herd now roam about 740 acres, wandering freely from the middle pasture south of I-70 to the north pasture on the other side of the interstate highway through their private tunnel, originally completed by 1917.

Through the winter months, they traditionally feed in the north pasture, and are visible to sightseers. With the elk herd phased out at the end of 2010, the bison occupy all the pasture space at Genesee, about one-third of the park area.

The Denver Mountain Parks staff's years of experience in bison management give them expertise sought after by other public entities. When Denver International Airport was built, officials entertained a proposal to graze bison on the extensive prairies there. From 1996 to 2001, Superintendent A.J. Tripp-Addison and others consulted with DIA officials about that project. More recently, staff was contacted to advise the City of Boulder when Ted Turner offered to donate bison as the nucleus of a new herd there. In both cases, the hurdles and cost of starting up an operation, from adequate fencing and handling facilities to land and staffing concerns, led to decisions that the proposals were not practical.

Fortunately, the Denver herds' establishment came at a critical time for the protection of the species, when conservation considerations outweighed the challenges. Like the mountain parks system, these treasured public herds represent an idea from another time that has survived to benefit all.

I take all of my visitors to Daniels Park and they are shocked that only five minutes from my house they can see bison, elk, coyotes, eagles, and pronghorn with the mountains as a backdrop.

—**Ed Kramer,** Highlands Ranch resident living near Daniels Park

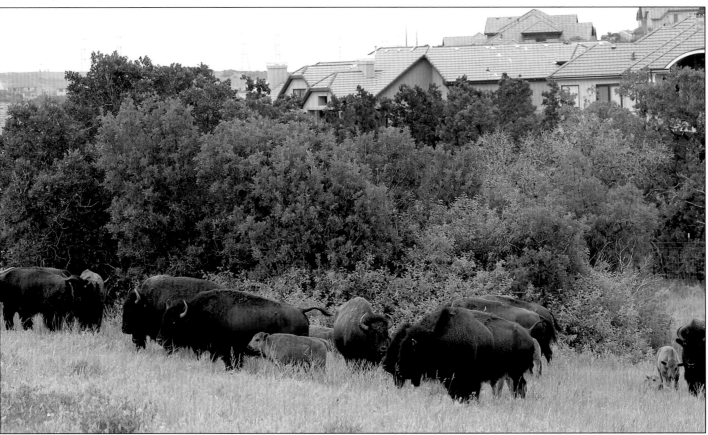

Daniels Park bison cows and calves graze in pastures adjacent to the Castle Pines subdivision, juxtaposing the Old and New West. Reddish in color at birth, bison calves weigh about 50 pounds but grow rapidly into replicas of their parents. Denver Mountain Parks files

Staying the Course

Between 1950 and 1970, the population of Jefferson County, or Jeffco, multiplied by a factor of four. By 1980, it rose to more than six times the 1950 level of 55,687. Land in the mountain region was at a premium. A proposal to host the 1976 Winter Olympics in and around mountain parks in the Jeffco foothills raised awareness of threats to the semirural area and was defeated by the people of Colorado in November 1972. In the same election, Jeffco residents, fearing the loss of remaining open spaces, created an open-space program funded by a 0.5-cent sales tax, and passed it by a significant margin.

Rapid development of this program gradually eclipsed that of the mountain parks, and the recreational balance shifted from sightseeing, hiking, and picnicking, to hiking and mountain biking. The two programs remain complementary today, as Jefferson County Open Space helped fill gaps in the circle of mountain parks envisioned by Denver civic leaders and F.L. Olmsted Jr. in the 1910s. Denver Mountain Parks—a recreational asset that goes largely unrecognized amid the highly visible Jefferson County Open Space parklands—still provide about 15 percent of Jeffco's nonfederal parks and open spaces.

As the semirural population grew, Denver's parklands became patches in a quilt of private and other public management. The parks gained new users, and the city new constituents, whose concerns lay outside its usual scope. Many of them had moved west for the high-quality foothills environment, and they expected that environment to be respected.

RESOURCES AND RESOURCEFULNESS

Challenges facing mountain parks budgets lessened somewhat as the 1970s took hold. Pat Gallavan was promoted to deputy manager of parks; he continued to oversee mountain parks activities, which now fell under the direct management of Superintendent Jennings "Jim" Dixon. Up from a park district in downtown Denver, Dixon was not much attached to downtown management, but focused on getting the job done. He was the first superintendent to move his office into the Morrison field headquarters, where his men were based.

Jim Dixon oversaw a period of relative affluence and stability during his tenure as superintendent from 1970 to 1983. His 1973 budget of $308,700 equates to $1.6 million in 2012, almost double the actual 2012 operating budget and about the same present worth as 1914's mill levy appropriation of $67,500, according to the U.S. Bureau of Labor Statistics.

The staff complement averaged 20 to 25. As with the CCC, labor was available in the mountain parks, but heavy equipment often was not. Part of the reason for large crews in those decades was a lack of other means of doing the job. Workers dug holes for fenceposts—in fact, holes of any kind—by hand; in-house carpenters, blacksmiths, and welders fabricated needed parts.

"When I first came up here in 1970, there was nothing the guys couldn't do! They could pull almost anything out of a scrap pile and fix whatever needed fixing," reports Marty Homola, who became the resident caretaker at Genesee Park when he was barely out of his teens and holds a 40-year record in the role. It was an era

FROM LEFT: Superintendents Jim Dixon (1970–1983), Lee Gylling (1983–1996), and A.J. Tripp-Addison (1996–2009) collectively managed almost 40 years of the 100-year history of Denver Mountain Parks. "I get notes of thanks from people I've never met who enjoy the parks," said Gylling in 1993. "That's where our hearts are; that's what we do." Denver Mountain Parks files

of skilled labor, and the frugality and work ethic of the Depression persisted in the mountain parks long after the rest of the country had returned to normalcy. The variety of demands put a high value on the willingness to learn and the flexibility to work wherever necessary.

As the foothills population expanded, no markers existed to tell residents where their property ended and undeveloped parklands started—a situation ripe for abuse and encroachment, whether innocent or intended. A garage lapped onto Cub Creek Park, and a garden of antennas sprouted on a 40-acre parcel near Marshdale. Current park staff and Denver surveyors continue to deal with similar issues; unless carefully watched, park property slips into private use.

FIGHTING THE BARK BEETLE

Although efforts to combat the pine beetle extended back to the 1930s with the CCC, the 1970s brought a recurrence of pine beetle activity that made Gallavan's "epidemic buildup" of 1961 look sparse. Between 1969 and 1976, the number of beetle-killed trees along the Front Range multiplied by a factor of 75, Barbara and Gene Sternberg reported in *Evergreen, Our Mountain Community*. Citizens and neighborhoods rallied, especially in the Evergreen area. Throughout the mid-1970s, the Colorado State Forest Service (CSFS) helped foothills residents cope with the beetles. According to the Sternbergs, tensions ran high: "Private owners of lands bordering the Parks watched in helpless fury as their own efforts to deal with the beetles were rendered ineffective by Denver's inaction" in the face of budget woes. CSFS crews were, in fact, also working in mountain park forests, removing diseased trees and thinning neglected tracts. Neighboring property owners were relieved to see work under way.

The mountain parks crews got relief from a new source: the Comprehensive Employment Training Act (CETA), passed by President Richard Nixon in 1973. As with the CCC and WPA, the program provided federal funds for on-the-job training, work experience, and transitional public service employment to the unemployed. President Jimmy Carter expanded CETA funding to a peak of 725,000 workers in 1978. From the late 1970s until

1971-1990

The 1860 Patrick House, a residence that served as a toll station on the Genesee Wagon Road, is home to the Genesee Park caretaker, who oversees the property and its historic bison herd. Since its acquisition by Denver in 1913, the Patrick House has served as Genesee Park headquarters. Renovations have preserved the character of the Patrick House, shown at top as it was in the 1930s. It is the oldest structure in the Denver Mountain Parks system.

Denver Public Library, Western History Collection, X-20419

Mountain parks forester Andy Perri continues a long tradition of efforts to maintain Denver's forests in a healthy condition to aid pine beetle control and reduce risk of wildfire. He often supervises Youth Corps or NCCC teams. Max Bader, Denver Mountain Parks files

1982, as many as eight CETA workers—assigned to pine beetle efforts in the mountain parks—complemented the parks staff of 25.

In November 1979, Denver City Council voted to shift $200,000 earmarked for mountain parks to the urban parks. Parks manager Joe Ciancio successfully countered that the cutback would hamper beetle control and might force the closing of popular picnic areas in foothills parks.

Wildfire and the mountain pine beetle still threaten park properties. Using grant funding, Denver hired its first full-time forester in 2010. Although subsequent grants have continued to support forest mitigation work, the future of these efforts is uncertain with no consistent funding base and some 10,000 acres of forested parkland yet to be treated.

THE WORK AND THE WORKERS

In Denver, petroleum was big business, and ripple effects from the oil embargo of 1982 meant tough times all around. The city had 2,500 unemployed workers just in former geologists. One of them, John Hickenlooper, left geology and took up the brewing business, eventually becoming mayor of Denver and, today, governor of Colorado. Nationwide, unemployment hit 10.8 percent, the worst recession since the postwar contraction of 1945. Former mountain parks superintendent A.J. Tripp-Addison suggests that calls for disposing of the mountain parks generally track these cycles of the national economy.

The 1982 recession became a textbook case. As it gripped the city, the budget axe again fell on the Denver Mountain Parks. CETA workers were among the first to go. Along with the forestry crew went a half-dozen equipment operators and utility workers, as well as all three park police, who had served in lieu of rangers. Superintendent Jim Dixon had one foreman left, Lee Gylling, and just eight on-the-ground crew. More cuts came in 1983, leaving Dixon with just five workers. Of necessity, and not content to sit in an office, he helped man the garbage truck some days.

The idea that this outlying system was an unnecessary drain on city budgets soon followed the bust of 1982. That fall, city councilman Ted Hackworth—whom the *Post* described as a "staunch fiscal conservative" and who had led the drive for the 1982 cuts—initiated a plan to sell or lease the mountain park system to Jeffco in an effort to direct more money to the urban park system. It was perhaps the most serious divestiture attempt to date. Months later, the discussion foundered, partly because Denver and Jeffco couldn't agree on which parks to transfer to Jeffco management.

PARTNERSHIPS FOR THE PARKS

As budgets shrank, the mountain parks district soon found it had friends. More than ever, partnerships with federal, state, and county entities helped the struggling parks survive. Today, many agencies and organizations assist operations in the Denver Mountain Parks through legal agreements and informal partnerships. Throughout this book, stories of cooperative efforts highlight park history and, in fact, those efforts make that history possible. From the counties where the parks are located, to nonprofits and nearby residents, mutually beneficial partnerships support roads, fire and police protection, resource management, trail construction, and much more. Within the city, too, joint efforts and support inside and among departments play a critical role.

With half the budget, Superintendent Lee Gylling, who succeeded Dixon in 1983, had little choice but to reach out. One partnership—with the growing Jefferson County Open Space program—started in the 1980s and continues to enhance the mountain park system today. With proceeds from sales tax funding, that program began to purchase properties near the existing Denver parklands. Trails connecting county lands to and through city

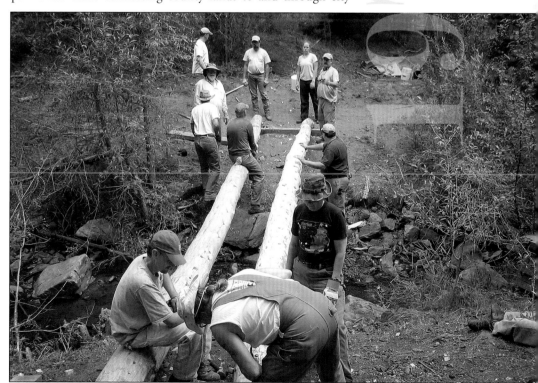

Volunteers construct a footbridge on the Braille Trail in Genesee Park in the 1990s. Denver Mountain Parks files

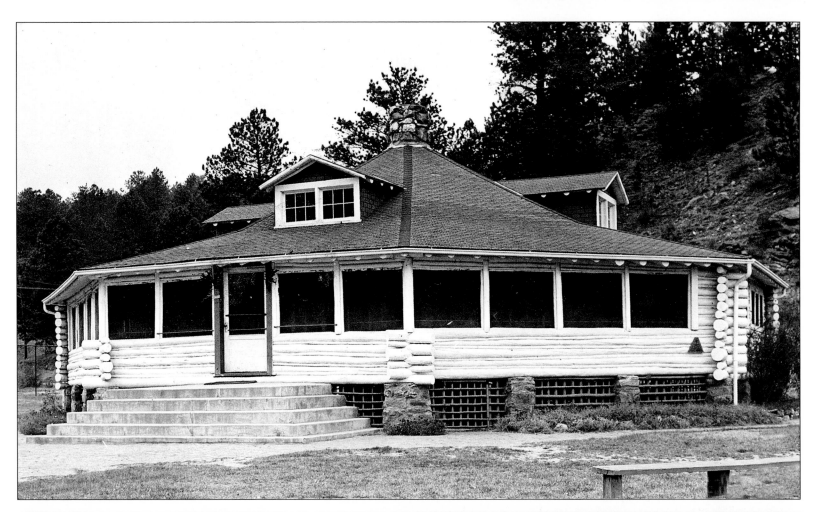

Some historic park buildings have been so modified to provide for new functions (as seen in today's image, at bottom) that they are no longer likely to be restored to their original integrity. This octagonal log clubhouse at Evergreen Golf Course was designed by F.W. Ameter and built in 1925. Denver Public Library, Western History Collection, X-20436

properties were implemented, and the partnership between these two systems has benefited park and open-space users in Jeffco ever since. In addition to connecting adjacent parks, joint trail agreements have opened mountain parks properties that would otherwise be inaccessible. Similar programs in Douglas and Clear Creek counties, launched in the 1990s, enhance partnerships there as well.

In 1982, Denver entered an intergovernmental agreement with Evergreen Metropolitan Water and Sanitation District for maintenance of Evergreen Dam, which needed repair. Denver kept its golf course but reassigned its management to Denver Golf, an enterprise fund within the Parks & Recreation department. "To the great surprise—and delight—of Evergreen residents, the same City and County of Denver that could not find $200,000 to repair the dam managed to rustle up a reported $1,000,000 for a total upgrading of the golf course in 1983–84," noted the Sternbergs. "Sand greens were replaced by carefully tended grass. The entire 5,103-yard course was redesigned. …" Denver Golf could find and deploy such capital funds, but basic operations dollars continued to elude the Denver Mountain Parks District.

Through a series of agreements, the city turned Evergreen Lake's popular skating and boating concessions over to the Evergreen Park and Recreation District, which still oversees recreation programs and manages facilities at the lake. Denver Mountain Parks currently retains responsibility only for the park properties surrounding the lake. In partnership with Denver Mountain Parks, Evergreen Park and Recreation built the Dedisse Trail from Evergreen Lake, connecting Dedisse Park to Alderfer/Three Sisters Park.

BUFFALO BILL GETS A NEW MUSEUM

Pahaska Tepee, built somewhat casually in 1921 near Buffalo Bill Cody's grave, featured concessions and a museum from its earliest days. After decades of management by Cody's foster son, Johnny

Baker, and later Baker's widow, Olive, Helen Stewart became the curator and manager following a building renovation in 1957–1958.

By 1967, the log and frame structure was showing its age and proved inadequate to house the collections of artifacts while serving as a café and souvenir shop to the site's one million annual visitors. Funding for a new museum was pieced together in 1976, and the building's dedication followed in February 1980. Today the museum introduces about 60,000 annual visitors to the exploits and accomplishments of William F. Cody, a fraction of the number of

In Business for Life: H.W. Stewart Co.

Bill Carle and sister Barbara Carle Day were born into the family business in the 1950s and grew up in and with the Denver Mountain Parks in the latter half of the 20th century. Their grandmother, Helen Stewart, assumed management of Pahaska Tepee in 1957. In 1963, she added to her responsibilities Red Rocks Trading Post, and, in 1965, Echo Lake Lodge. Although trading post management went to ARAMARK in 2002 along with the new Red Rocks Visitor Center, Stewart descendants continue to operate concessions at Lookout Mountain Park's Pahaska Tepee year-round and at Echo Lake Lodge during summer.

Barbara Day bakes dozens of pies at Echo Lake Lodge each summer day and oversees a staff of seasonal employees. The upstairs of the historic lodge provides accommodations to the crew, who greet, serve, and sell memorabilia to as many as 1,000 visitors daily.

Many of the half-million annual visitors to Buffalo Bill's grave stop by Pahaska Tepee, where Bill Carle and staff serve buffalo burgers and fudge, as well as shopping opportunities, to tourists from distant lands, road bikers from nearby towns, residents with visiting relatives, and other enthusiasts of the view and the celebrity buried nearby.

During all those years, now 125 in total, the roofs of the various buildings leaked for all but about 40. Tarring Red Rocks Trading Post's flat roof was a spring ritual, Bill Carle says, and they got the buckets out every time it rained at any of the sites. "Not until the late 1990s," he reports, "did I ever work in a Denver building with a tight roof!" At that time, capital improvement funding replaced the roofs on all three buildings.

Like their ancestors, Bill and Barb are valued members of the Denver Mountain Parks family. Their service has enhanced the park experience for generations of visitors.

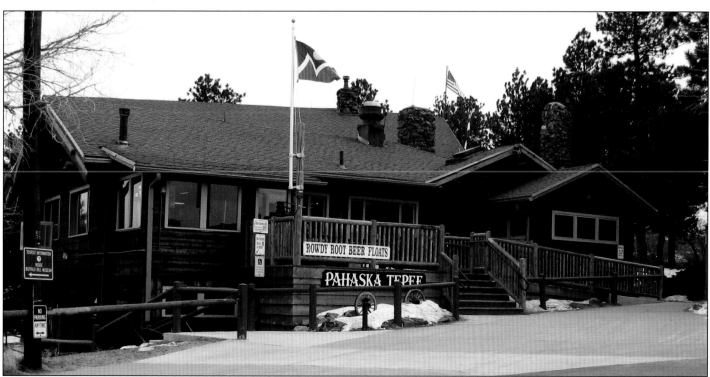

Pahaska Tepee has undergone several episodes of remodeling and restoration since it served as the Buffalo Bill Museum from 1921 until 1979. The original entrance faced the grave, but this is now the main entrance. Denver Mountain Parks files

tourists who visit the grave. Improvements have also been made to Pahaska Tepee, a contributing structure to Lookout Mountain Park's National Historic Register listing.

With the new millennium, the museum again began to outgrow its home, which also no longer met contemporary museum standards. In 2010, efforts to create a master plan for Lookout Mountain Park were launched. The plan's goals include a new, larger museum building and relandscaping to take better advantage of the views.

Youth Corps teams built the arbor surrounding and providing shade for participants at powwow events in the Tall Bull Memorial Grounds. The arbor is circular with openings to the east and west. Tall Bull Memorial Council

A GATHERING PLACE FOR THE AMERICAN INDIAN COMMUNITY

In October 1974, the White Buffalo Council obtained Mayor Bill McNichols's support for an American Indian cultural park, which the Colorado Centennial-Bicentennial Committee endorsed enthusiastically. An agreement with the city was signed in June 1977 for the use of a 70-acre parcel in Daniels Park, designated as the Tall Bull Memorial Grounds, set aside by Denver and managed for the use of a consortium of organizations known later as the Tall Bull Memorial Council.

Establishing the site represented "a gesture made in the spirit of the nation's bicentennial," reported the *Rocky Mountain News* in 1999, and "a unique symbol of Denver's commitment to its American Indian residents." (In 1999, an estimated 30,000 American Indians lived in the metropolitan area.) Richard Tall Bull, a Cheyenne, initiated the proposal for the grounds as a way to help young people remain in touch with their heritage.

"Where we now live was the home of various Indian nations. Where our homes are, our neighborhoods are, was Indian land," said James Mejia when he was with the city Department of Human Rights and Community Relations in the 1990s. "The least we could do is provide a sanctuary for the Indian community."

The agreement committed the council to improve the property and mountain parks staff to maintain roads. However, as informal structures deteriorated, the city sought a grant and hired Youth Corps workers in the 1990s to help fence the site and make safety improvements.

Each year since 1979, the White Buffalo Council has held a public powwow here featuring American Indian dances and crafts. This High Plains environment still provides a fitting place for cultural and spiritual renewal, with the park's bison herd providing

additional historical context. Tall Bull members have worked to preserve the area's natural quality. In March 2000, council leaders sent a letter to the Douglas County Board of Commissioners in support of a development-free cultural overlay zone that protected 7,000 additional acres north and west of Daniels Park as an Open Space Conservation Area.

The elder Richard Tall Bull passed away in 2002, a respected leader who conscientiously followed tribal religious customs and encouraged respect for ancestral traditions. The Tall Bull Memorial Council still manages the site he worked to establish, and his grandsons continue to participate in activities there, as do representatives of dozens of tribes. Subsequent Denver mayors have extended the agreement, ensuring American Indians a place to celebrate their traditional cultures.

Bill McNichols

RETURN OF THE CCC

Late in the 1970s, with the 50th anniversary of the Civilian Conservation Corps (CCC) approaching in 1983, men who had served in that program began to recall their youthful accomplishments. CCC alumni chapters formed across the country and Denver alumni soon came together as Mile High Chapter 7. Recognizing Red Rocks Amphitheatre as a major CCC accomplishment, they discovered Mount Morrison Camp SP-13 surviving almost intact from its days housing the men of Companies 1848 and 1860. They approached Mayor McNichols, who gave permission to the group to use the camp for meetings and events.

After the departure of the CCC in 1942, Denver had rented out parts of the Morrison camp for use by various groups. Girl Scouts and Boy Scouts held programs there through the 1940s and 1950s.

"The CCC Worker"

What better spot than Red Rocks Amphitheatre, one of their grandest efforts, to honor the workers of the Civilian Conservation Corps (CCC) with a commemorative statue? This life-size sculpture, known as "The CCC Worker," joins more than 50 others in places across the United States. For two years, the local CCC alumni chapter worked to get a statue placed at Red Rocks. Its dream came true thanks in part to a grant from Denver's "Preserve the Rocks" fund. The statue was dedicated on Labor Day, September 6, 2004; many alumni attended to honor the men who built Red Rocks Amphitheatre between 1936 and 1941. The men who gave part of their youth to improving themselves and our parks and forests hoped the statue will remind future generations of their work.

Don Bess, who served in Meredith, Colo., dressed in his original CCC work clothes for the statue dedication in September 2004. Denver Mountain Parks files

Perspective and Recognition

Federico Peña

Office of Federico Peña

In the late 1980s, 25 years after Pat Gallavan's funding requests went unanswered, Denver planners and mountain parks staff realized the numerous historic structures in the parks were at risk. Mayor Federico Peña appointed Carolyn and Don Etter as managers of the Parks & Recreation Department in 1987; the couple shared the position for several years. Although they immediately had to implement a 10-percent across-the-board cutback, one of their most important tasks, Carolyn Etter recalls, involved "helping the mayor and city council understand" the importance of the Denver Mountain Parks and the resources they contain. They also worked to allocate funds in the Parks & Recreation budget specifically for the Denver Mountain Parks, a previously lacking detail that had made it too easy to shift funds into the city parks system.

LONG-TERM VISION INCLUDES HISTORIC PRESERVATION

The Etters also focused on historic preservation. Passage of a gaming amendment by Colorado voters in 1990 established the State Historical Fund, a pool of funds designated for restoration and rehabilitation. With more than 50 historic structures, many falling into disrepair, Denver Mountain Parks were well positioned to benefit from the new support.

By November 1988, the first nomination of mountain parks properties to the National Register of Historic Places (NRHP), researched by Ann Moss, was ready to submit to the National Park Service. This Multiple Property Submission was approved two years later, with Red Rocks Park and the Mount Morrison CCC camp as the first Mountain Park District designated on May 18, 1990. That November saw designation of the five older parks of the inner circle drive in central Jeffco—Lookout Mountain, Colorow Point, Genesee, Bergen, and Dedisse—along with the Lariat Trail and Bear Creek Canyon scenic mountain drives. The Corwina/O'Fallon/ Pence Park District was listed in December, completing the NRHP record for the core of what is now the Lariat Loop National Scenic Byway.

With NRHP designation, the Parks & Recreation Department obtained a $2,500 grant from the State Historical Fund in 1993 to assist in documenting the properties. A second Multiple Property Submission, prepared by Maureen van Norden, led to seven more parks (Echo Lake, Summit Lake, Fillius, Little, Daniels, Starbuck, and Katherine Craig) being listed in February and June 1995. Together, these NRHP listings recognized the significance of all but a handful of the developed parks.

The first State Historical Fund grants directed to building repairs contributed $10,000 to a restoration plan and roof restoration at the Morrison CCC camp in 1996. In 1997, $48,750 supported roof repairs at the Red Rocks Trading Post (Indian Concession House). National Register status enabled application for more significant State Historical Fund grants of almost $300,000 to date.

The Recreation Hall at Mount Morrison CCC Camp SP-13 was in poor condition in 1983 before Chapter 7 alumni worked to re-side and restore it. NACCCA Chapter 7 archives

Rehabilitation of the Morrison camp became a focal point for Chapter 7 in the 1980s. The alumni rallied around the work needed to make two buildings, the Recreation Hall and Mess Hall, fit to occupy. They found or solicited materials and tools, painted and patched, and in some cases, rebuilt. In the Recreation Hall, which they knew as "Old Wreck," they rebuilt the stage and upgraded the fireplace. A few men, including Bill Short and Dick Stroup, came almost daily to work on the projects. With help from mountain parks staff, they re-sided the buildings, painted them white, and propped up foundations.

By the early 2000s, the alumni experienced trouble mustering enough members for effective meetings. Albert Coven was elected Chapter 7 president and, with no replacement in sight, remained in office as the chapter slowly dissipated. A national CCC Legacy Conference in October 2009, the first to be held in Colorado, attracted 65 attendees to the Morrison camp and brought the remaining Chapter 7 alumni together to celebrate the CCC one last time.

Throughout their tenure at the camp, Chapter 7 collected artifacts, stories, and memorabilia from members in hopes of creating a museum in the old Recreation Hall—one legacy that remains alive. Denver Mountain Parks, with help from a new Mile High Chapter 7 resurrected from the original, still hosts their collection and conducts tours by appointment at the Morrison camp.

The camp buildings and cultural landscape were documented as part of the pending National Historic Landmark nomination of Red Rocks Park and its evidence of CCC works. Mount Morrison Camp SP-13 is today, as far as can be determined, the most intact such camp surviving in Colorado and is among a handful nationwide. Its future looks bright: The buildings have been freshly painted, and AmeriCorps National Civilian Community Corps (NCCC) teams are helping staff renovate one of the barracks for use by temporary work crews.

STOIS 1990-2015

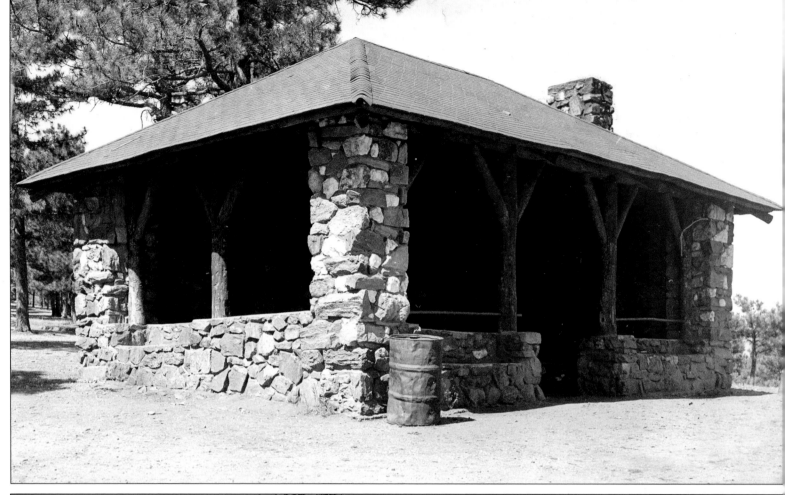

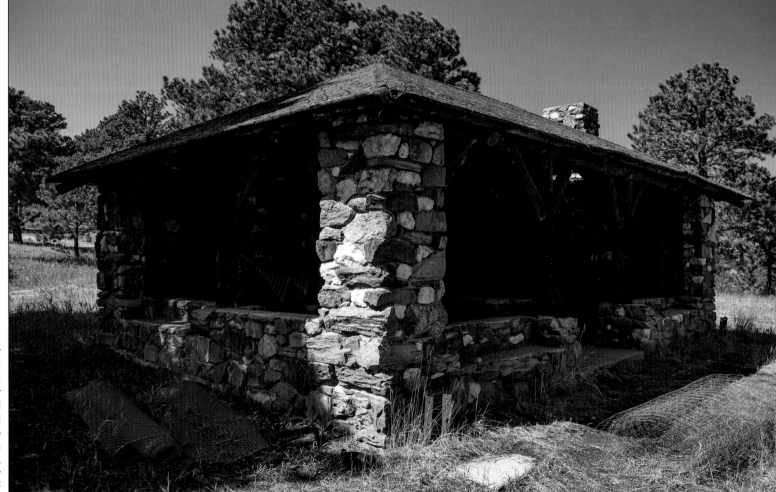

This early shelter (top) near Chief Hosa Lodge was designed by J.J.B. Benedict. Bypassed by I-70 in 1965, it is no longer in use but is much in need of restoration. A planned trail nearby might stimulate its restoration and return it to productive use.

Denver Public Library, Western History Collection, X-20422

A $50,000 Historic Structure Assessment grant received in 2000 laid the foundation for future work by enabling consultants to carefully document the condition and needs of buildings across the entire Denver Mountain Parks system. That grant created the groundwork for later successful requests: $86,000 was awarded to help restore the Daniels Park barn in 2006, and a $100,000 grant in 2010 was devoted to log restoration at Echo Lake Lodge.

BETTER PLANNING MEANS BETTER FUNDING

During their tenure as managers, the Etters also pioneered a more comprehensive planning view of the Denver Mountain Park system. A May 1988 *Denver Post* editorial suggested that their first task should be to work with other agencies to link Denver's mountain parks with those of other entities, creating better regional connections. Don Etter chaired a multiagency effort called the Metro Mountain Recreation and Open Space Project. Public landowners and park and recreational agencies, including the U.S. Forest Service, Bureau of Land Management, Colorado Division of Wildlife, Denver Water, and representatives of Jefferson and Clear Creek counties, jointly issued an initial report in February 1989. This effort, Carolyn Etter says, laid the foundation for what became, in 2008, the Denver Mountain Parks Master Plan.

With the Historic Structure Assessment outlining the needs, the system attracted Capital Improvement Project funds through the next 15 years. Some became matching funds for other grants, which needed a city contribution to complement the grant award. Funded projects have since addressed safety, structural, and historic renovation needs throughout the system. "It all started," notes former superintendent A.J. Tripp-Addison, "with the National Register designations."

This image shows restoration work in progress at the Daniels Park barn in 2006. When complete, this project became a prized example of the State Historical Fund–supported work in the Denver Mountain Parks.
Denver Mountain Parks files

During the 20 years before moving to Denver Mountain Parks as superintendent in 2010, park planner Dick Gannon helped carry out most of the capital projects in Denver's mountain parks. The productive partnership with Parks & Recreation planners has facilitated major structural improvements to Pahaska Tepee and Chief Hosa Lodge, including accessibility; a new roof and electrical and heating systems at Patrick House; and new fire sprinkler systems at Echo Lake Lodge and Pahaska Tepee. City capital funding, via Winter Park payments, has prevented deterioration, enhanced safety, and kept historic buildings serving visitors at a high level.

Early AmeriCorps NCCC teams assisted mountain parks crews with roof restoration at the Mount Morrison Civilian Conservation Corps camp.
Denver Mountain Parks files

AmeriCorps to the Rescue

In 1994, dwindling budgets ended the county jail work crews in the mountain parks. Fortunately, losing this manpower coincided with a new national program, AmeriCorps. Signed into law by President Bill Clinton in 1993 to consolidate opportunities for national service, the program introduced the National Civilian Community Corps, or NCCC. This residential program for youth, modeled after the Civilian Conservation Corps, became an immediate boon to Denver Mountain Parks. Parks staff worked with their first NCCC team in 1993; one or more teams have assisted mountain parks projects most years since, with tens of thousands of contributed hours helping to offset staff constraints under decreasing budgets.

That first year, AmeriCorps team members worked side-by-side with parks staff to construct a corral system for the bison and elk at Genesee Park. Over time, they helped replace roofs on historic buildings in the Morrison CCC camp, conducted wildland fire mitigation at several parks, rerouted a section of the Beaver Brook Trail, and built accessible trail and fishing amenities at Echo Lake. Throughout these and many other projects, team members performed in an "energetic, capable, and adaptable" manner, wrote Superintendent Tripp-Addison in a letter to AmeriCorps. Forestry and fire mitigation, roof replacement, historic structure rehabilitation, and trail construction and maintenance continue as major tasks for AmeriCorps NCCC teams in the Denver Mountain Parks.

Trail restoration work at Echo Lake Park involved volunteers and staff on a beautiful fall day in September 2008. S.L. White, Denver Mountain Parks files

EXPERIENTIAL EDUCATION AT GENESEE

In 1994, Superintendent Lee Gylling coordinated with the Recreation Division to establish a Denver Outdoor Recreation program; a picnic area at the west end of Genesee Park was closed to the public and made available for more formal programming. The city's Outdoor Recreation staff established the Genesee Experiential Outdoor Center, which offers programs for school, corporate, community, and nonprofit groups. These programs include the Genesee Challenge Course, hiking, backcountry rock climbing, camping, and snowshoeing—activities focused on teambuilding, creative problem-solving, and personal growth. Groups leave Genesee with a better sense of "what they are capable of doing as individuals and how to respond to the environment in which they live," according to the center.

The Genesee program has proven immensely successful, with revenues in 2011 almost 40% higher than in 2009. In 2011, staff worked with 130 organizations and served more than 5,000 participants. A high percentage of the participants are Denver youth, and for a majority of them Genesee is their first experience in a mountain environment.

Additionally, Outdoor Recreation staff conducts programs at other Denver Mountain Parks including Winter Park and Echo

Participants at the Genesee Experiential Outdoor Center test their sense of balance—and trust—in the "Friends and Family Fall." Courtesy Denver Parks & Recreation, Outdoor Recreation

Lake. Other organizations have historically utilized Denver Mountain Parks. The Balarat Outdoor Education Center, which brings busloads of students to Genesee Park each year, has operated in concert with Denver Public Schools since 1969. For decades, Boy Scout, and later Girl Scout, programs used Katherine Craig Park, near Genesee.

Opportunities for further developing programs at Genesee Park are significant, and hark back to 1917, when the first interpretive nature trail in Colorado was established along part of the Beaver Brook Trail. A Park Improvement Plan will address these and other prospects for future education efforts at Genesee Park.

CHANGES COME TO RED ROCKS PARK

Until the establishment of Denver Theatres & Arenas, staff from Denver Mountain Parks oversaw events in Red Rocks Amphitheatre. The new agency created a partnership in Red Rocks Park: Theatres & Arenas (now Arts & Venues Denver) oversees the amphitheatre and its popular concerts, and Denver Mountain Parks manages the park's natural resources and other park visitors.

When the city bought about 170 acres of land adjacent to Red Rocks Park in 2000, it became Denver's first major acquisition outside city limits since 1940. Fabby Hillyard, Director of Theatres & Arenas in the early 2000s, explains that Jefferson County was preparing to rezone the entire strip east of Red Rocks, which was—and still is—undeveloped ranchland and open property. Several

residential properties had already been developed at the park's doorstep. Fearing that additional development could create potential future impacts on amphitheatre operation, Denver sought means to acquire the property. One of the owners was Bear Creek Development Corporation, and Denver met with lawyer Leo Bradley in negotiations. Coincidentally, Bradley had his eye on a Denver-owned parcel on South Table Mountain, and the exchange for the developer's 98 acres was completed. A purchase was also arranged for the historic Derby-Nelson ranch property at the park's Entrance 1, as well as for a 10-acre parcel already on the market.

Minor parcels had been purchased or exchanged over the years to fill in a park boundary or address other issues, but this substantial investment represented something new since the 1955 city government reorganization. In separating the Parks & Recreation Department from Public Works, the city had amended the City Charter, formally dedicating all existing park properties as "parkland" and protecting them from sale without a vote of the people. It also specified that future acquisitions would not be considered parklands unless designated by city council action.

To date, scattered small parcels totaling less than 20 acres have been acquired for several parks, but only one 10-acre parcel outside the city has been specially designated as "parkland" since 1955. Mayor Wellington Webb, who prided himself on his contributions to Denver's park system, recognized

Office of Wellington Webb

Wellington Webb

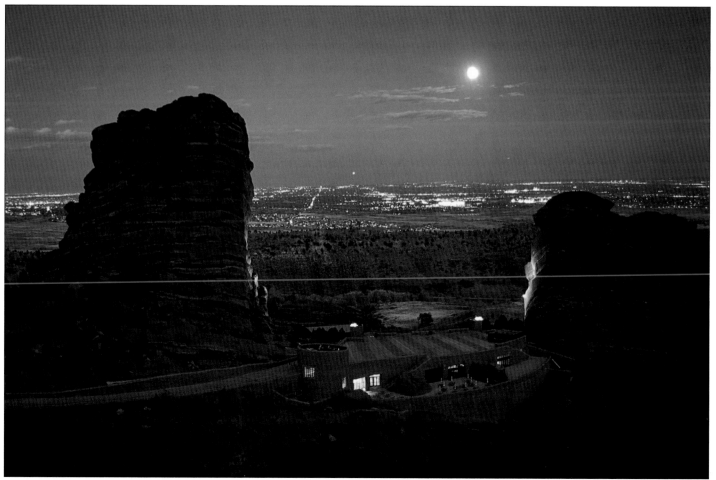

Since its completion in 2003, the Red Rocks Visitor Center, visible mainly in this view from behind, has become the centerpiece of the amphitheatre. The center houses a restaurant and exhibits on park and concert history. Matthew Lancaster, Remarkable Earth Photography

that dedicating parks near public-use facilities could be restrictive, so the future of this sizable parcel at Red Rocks remains uncertain. The public often perceives such lands as parks, and their use or disposition can become quite controversial.

Building a New Visitor Center

Hillyard's tenure at Theatres & Arenas also encompassed the planning and development of the new visitor center at Red Rocks. Initial proposals for amphitheatre changes had startled most reviewers, notably the Denver Landmark Commission, which had designated the amphitheatre a city landmark in 1973. By the time Hillyard took over, people were reacting to news of ads projected onto the rocks, removal of the planter boxes to expand seating, and other dramatic proposals. Denver residents formed a group, Friends of Red Rocks, to respond to what they saw as threats to the amphitheatre's character.

Hillyard's team slowed the process down, took time to hear objections, and smoothed ruffled feathers by ensuring that the quality of improvements would remain in keeping with the site, and would equal the standard of the amphitheatre's original CCC construction. Denver Landmark Commission signed off on a "simplified plan" in January 2000. Groundbreaking, scheduled for September 11, 2001,

> *"We have to act as stewards … we have a responsibility to preserve this remarkable place."*
>
> —**Fabby Hillyard,** Director of Theatres & Arenas,
> *The Denver Post,* January 2000

was delayed by the tragic events of that day; construction commenced later that year.

Structural problems were soon discovered under the upper rows, but these were dealt with carefully, as were other details, monitored by a preservation consultant at each step. Most of the $26 million spent on improvements, Hillyard says, "is underground and isn't even visible." The final results, unveiled in a grand opening on May 15, 2003, reported Thomas J. Noel in *Sacred Stones,* are generally acclaimed as a significant enhancement to the natural attractions of historic Red Rocks Park & Amphitheatre.

Concerts Benefit Parks

In the mid-2000s, representatives of Theatres & Arenas, Denver Mountain Parks, Parks & Recreation, and the National Park Service met to launch the process of evaluating the park and amphitheatre for status as a National Historic Landmark. At publication time, following extensive documentation and review, this nomination is nearing completion and hopes remain high that Red Rocks will soon join Civic Center to become Denver's second National Historic Landmark.

During the visitor center's construction, the surrounding park changed little. However, in 2009, as a result of the 2008 Master Plan, a fee-sharing agreement was reached between Theatres & Arenas and Parks & Recreation to provide, for the first time, direct financial return to Denver Mountain Parks from operations at the amphitheatre. In the first two years, total receipts exceeded $350,000, creating an earmarked fund to support improvements in Red Rocks

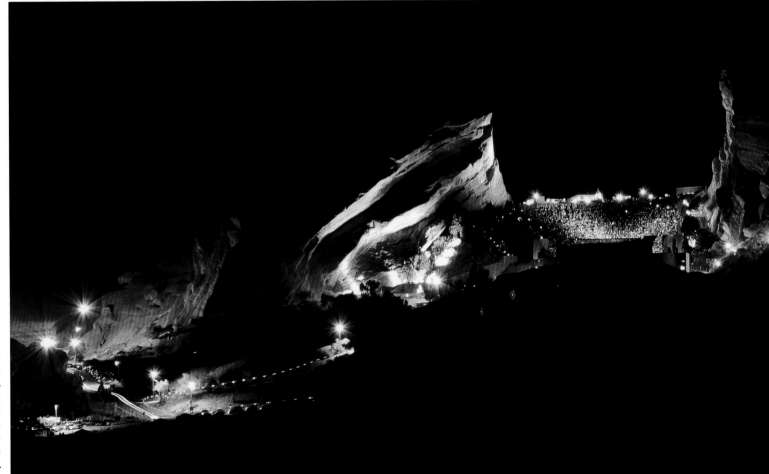

In addition to Easter Sunrise services and the Film on the Rocks series, Red Rocks Amphitheatre hosts as many as 80 concerts each year. More than 600,000 people attended events at the popular venue in 2012.
Dave Elin

and other mountain parks. To date, this special fund has repaired park trails, closed social trails, and created new access where needed. In addition, the fund supports staff, including increased ranger presence in Red Rocks and systemwide. In coming years, the ranger program is expected to expand further, as will interpretive opportunities at Red Rocks and other parks.

PLANNING FOCUS IN THE NEW MILLENNIUM

Goals identified in a Denver Mountain Parks Strategic Plan, developed in 2000, focused on ensuring quality customer service and protecting and enhancing the "quality of natural, cultural, historic, scenic and recreational resources of the parks for future generations." The plan also recommended continuing to establish partnerships and fostering appreciation for the parks' natural and cultural features.

"The most pressing concerns for the district in the near term will focus on public safety, capital improvements for our historic structures, picnic site improvements, trail development and mapping, control of noxious weeds that threaten natural areas, and maintaining our forests. It is imperative that the district be funded adequately to support the needs of a district that has national and worldwide recognition."

—Denver Mountain Parks
Strategic Plan, 2000

Historically, the Mountain Parks Police provided the primary visitor contact and enforcement services. The mountain parks ranger program, started in 2002 with a single ranger, has been growing since 2010. Rangers now oversee trail construction and other volunteer projects year-round. Here, lead ranger Rob Krueger uses a GPS unit to inventory trail damage on the Chavez Trail in Genesee Park. Andrew Perri, Denver Mountain Parks files

Parks provide homes for diverse wildlife, including this coyote pup at Genesee Park, who is just waking up from his nap. Richard Brune

Work began in 2001 on a cooperative project among Denver Parks & Recreation, Jefferson County Open Space, and the Lariat Loop Heritage Alliance. A successful grant proposal for Smart Growth funding from the state Department of Local Affairs produced a joint Recreation Management Plan between Denver and Jeffco in the foothills area and simultaneously developed an interpretive plan for the Lariat Loop, designated a Colorado Scenic & Historic Byway in 2002.

With public input, the joint effort aimed to strengthen cooperative natural resource management, cope with impacts of public use, and create a recreation plan that would protect the parks' historic nature while meeting contemporary user needs. The interpretive plan would assist the Lariat Loop partners in providing visitors with an authentic regional experience. Since 2002, this plan has helped guide the installation of more than 20 interpretive signs around the 40-mile Lariat Loop, now a National Scenic Byway.

The Denver Mountain Parks Foundation

The advent of a dedicated foundation has helped and highlighted the accomplishments of the Denver Mountain Parks. W. Bart Berger founded the organization in 2004 to increase awareness of Denver's mountain parks, to aid in developing and implementing the master plans, and to support the realization of the Olmsted Plan. Upon the foundation's creation, Mayor John Hickenlooper stated that it "will greatly aid our city's continuing effort to care for and celebrate these great recreational resources." Jefferson County Open Space Director Ralph Schell added in 2005, "Considering all the cultural and recreational significance of Denver's Mountain Park System, it's a wonder this hasn't been done previously."

The foundation aims to help fulfill the mission of Denver Parks & Recreation to preserve, protect, and enhance these recreational resources through a public/private partnership that can engage city representatives and interested citizens. Professional city staff prioritizes and manages projects; the foundation assists in finding outside funds, engaging support, and enhancing the public and political visibility of this historic park system. Among its projects, the Denver Mountain Parks Foundation has provided matching funds for building-restoration grants, negotiated agreements, and underwritten production of this book. The foundation also played a leadership role in bringing stakeholders and interested parties together to create the 2008 Denver Mountain Parks Master Plan.

Managing a park system in other counties challenges everyone to find the best solutions to issues that can easily become contentious. An outside advocate such as the Denver Mountain Parks Foundation has the ability to bring parties to the table, in ways that paid staff cannot, to resolve issues that occur in the ongoing maintenance of such a dynamic park system. At these times, the value of such friends as the foundation has proven critical for the Denver Mountain Parks.

The Denver Parks & Recreation Department was pursuing its own strategic plan, known as the "Game Plan." Although focused largely on the needs of urban parks, it also addressed issues related to Denver's mountain parks. Under the leadership of Susan Baird, the Game Plan identified four core values shared by both systems: sustainable environments, equity in facilities and services, engagement of the community, and sound economics. Adopted in April 2003 as a supplement to the city's 2000 Comprehensive Plan, the Game Plan called for protecting historic structures and for "revitalizing" the mountain parks. Surveys conducted in support of the plan showed that 92 percent of Denver residents believed the mountain parks "contributed to the quality" of Denver's parks and recreation; 66 percent considered that contribution "major."

MONEY FOR MOUNT EVANS

In 1997, the U.S. Forest Service instituted a fee for vehicles accessing Mount Evans under the terms of a recreation fee demonstration program enacted by Congress. Clear Creek District Ranger Corey Wong noted in the *Clear Creek Courant* that the fees would help the Forest Service protect the area's natural resources. Where in 1992 four to six rangers had patrolled the Mount Evans road, funding cuts had left only that number in the entire 300-square-mile district.

An agreement between Denver and the Forest Service provided, as of 2005, that 18 percent of the fees would go into a fund

Wildland Restoration Volunteers built the new accessible trail from the Summit Lake parking lot to the Chicago Lakes Overlook in 2010 and 2011. A Land & Water Conservation Fund State Trails Grant supported the project. Denver Mountain Parks files

for the Denver Mountain Parks. Denver received about $45,000 per year and was relieved of most of the daily burden of managing the park from a distance. Using its accumulated fees as matching funds, Denver received a $200,000 State Trails Grant in 2009, which gave visitors a user-friendly trail to the Chicago Lakes Overlook, new interpretive signs, and state-of-the-art restrooms, completed in 2011.

However, in 2001, the Western Slope No-Fee Coalition formed in Colorado to battle public land fees. The struggle continued into lawsuits, ending in 2012 with the fee program eliminated. New sources of financial support will have to be found to ensure reasonable maintenance and future improvements in the heavily visited Summit Lake Park; gate fees specifically for this park are under consideration to help offset the high costs of maintaining facilities at such high altitudes.

CREATING A NEW MASTER PLAN

In 2006, the Denver Mountain Parks Foundation, led by W. Bart Berger, sought ways to aid the neglected park system. In a meeting with Councilwoman Peggy Lehman, Berger reports, she suggested

Office of John Hickenlooper

John Hickenlooper

a master plan, an idea that came out of the earlier Game Plan, which had addressed the Denver Mountain Parks only in passing. Berger also met with Gordon Rippey, who served on the board of Great Outdoors Colorado (GOCO), to discuss the role his foundation could play. Learning that planning grants were available through GOCO, Berger followed up with Susan Baird of Parks Planning, who worked with staff to submit a grant request to support development of the mountain parks' first systemwide comprehensive plan since the Olmsted days. Mayor John Hickenlooper appointed a 50-member advisory committee of agency representatives, city employees, and public citizens to help guide the Denver Mountain Parks Master Plan.

With Mundus Bishop Design as the primary consultants, Baird coordinated development of the plan, which has become an important reference document. Key among recommendations of the plan was the need for a "funding quilt" of strategies that would help overcome the perennial challenges of "economic instability and shrinking city budgets." The 2008 Master Plan suggested a three-pronged approach: to reaffirm the city's commitment and give the mountain parks a commensurate share of city resources; to build capacity and partnerships, tapping unused potential, including that of the foundation; and to take better advantage of existing revenue producers within the system, including Winter Park and Red Rocks Amphitheatre.

As a major population base, Denver must "fund its fair share of the regional partnership," according to the 2008 Master Plan, through reinvestment in the quality of the system and its historic facilities.

AN ENDURING LEGACY

Today, new partnerships and ideas are beginning to assist the Denver Mountain Parks system in making the most of its properties and opportunities. With more than 14,000 acres to manage, mountain parks staff, now fewer than 10 full-time employees, leverage their energies to keep this system alive.

Created from a grand vision at the dawn of the automobile age, the system weathered a major depression, two world wars, and several recessions, yet limited resources and distant management still pose a challenge. The 2008 Master Plan reaffirmed the significance of the Denver Mountain Parks and their value to the city. Denver cannot relinquish its responsibility, but with foresight and leadership, the city can rediscover and celebrate a historic park system that should serve as a major source of civic pride and acclaim now and in the future.

More Than One Hundred Flag Day Celebrations

And counting …

When the Peace Pipe Chapter of the National Society Daughters of the American Revolution celebrated its first Flag Day on Genesee Mountain on June 14, 1911, it must have taken considerable effort to reach the site. Neither the Denver Mountain Parks system nor Genesee Park officially existed; roads and transportation were challenging. They might not have realized what a tradition they were launching, nor what a long partnership with Denver Mountain Parks it would become.

Grace E. Tarbell, as regent, led that first ceremony; one hundred years later, her grandson Donald Cluxton was there to commemorate that very first Flag Day celebration. The Mile High Fife & Drum Corps led a processional of the Sons of the American Revolution color guard. General George Washington, portrayed by Dave Wallace, stirred the crowd with reminders of the original patriots and the symbolism of the flag.

Each year the Peace Pipe Chapter presents new flags to the Denver Mountain Parks superintendent. The amount of pomp and circumstance varies, but the annual Flag Day ceremony at Genesee is always a meaningful reminder of our heritage. Check www.denvermountainparks.org for times and details.

Sons of the American Revolution color guard raises Old Glory, June 14, 2011, on the hundredth anniversary of the first Flag Day celebration at Genesee Mountain. S.L. White, Denver Mountain Parks files

80

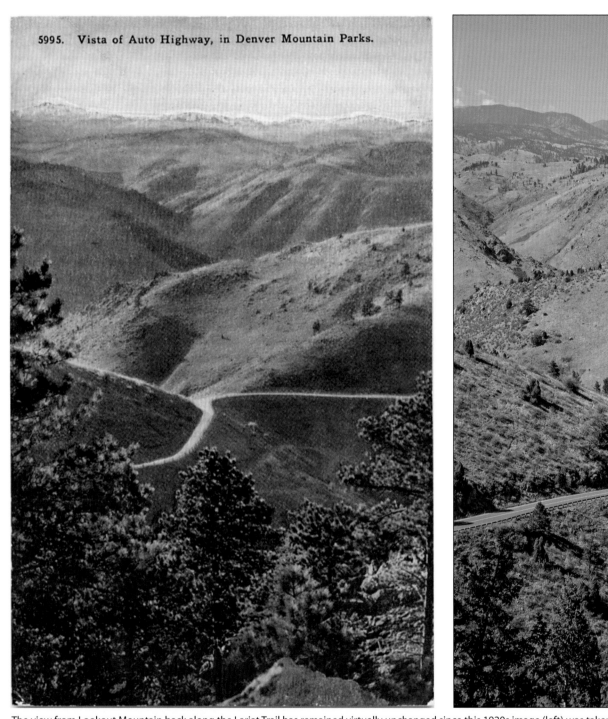

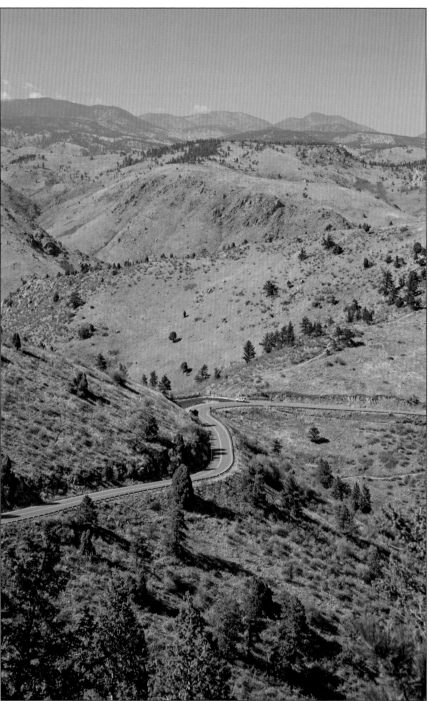

5995. Vista of Auto Highway, in Denver Mountain Parks.

The view from Lookout Mountain back along the Lariat Trail has remained virtually unchanged since this 1920s image (left) was taken. A parking area at Windy Saddle, at the curve, provides access to the Beaver Brook Trail and connects to Golden via the Chimney Gulch Trail without intruding on this historic scene. H.H.T. Co.

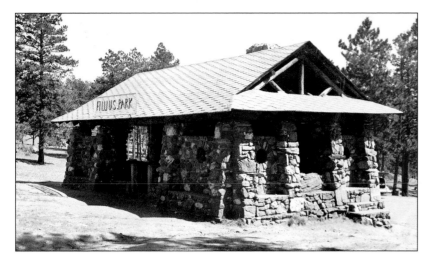

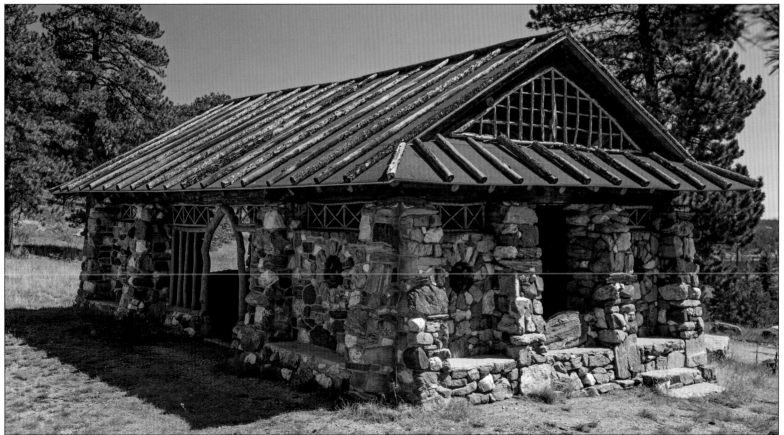

TOP: **Fillius Shelter in the 1930s.** Denver Public Library, Western History Collection, X-20462

MIDDLE: The neglected building was restored in 2003–2004 to J.J.B. Benedict's original design by mountain parks staff, including roof replacement, arched log entryway, wattle decoration, and tuck-pointing and stone replacement as needed. All work was done in-house at a fraction of the cost of outside contracting and was supported by city funds using no outside grants. John Griffith, Denver Mountain Parks files

BOTTOM: The structure as it currently stands.

82

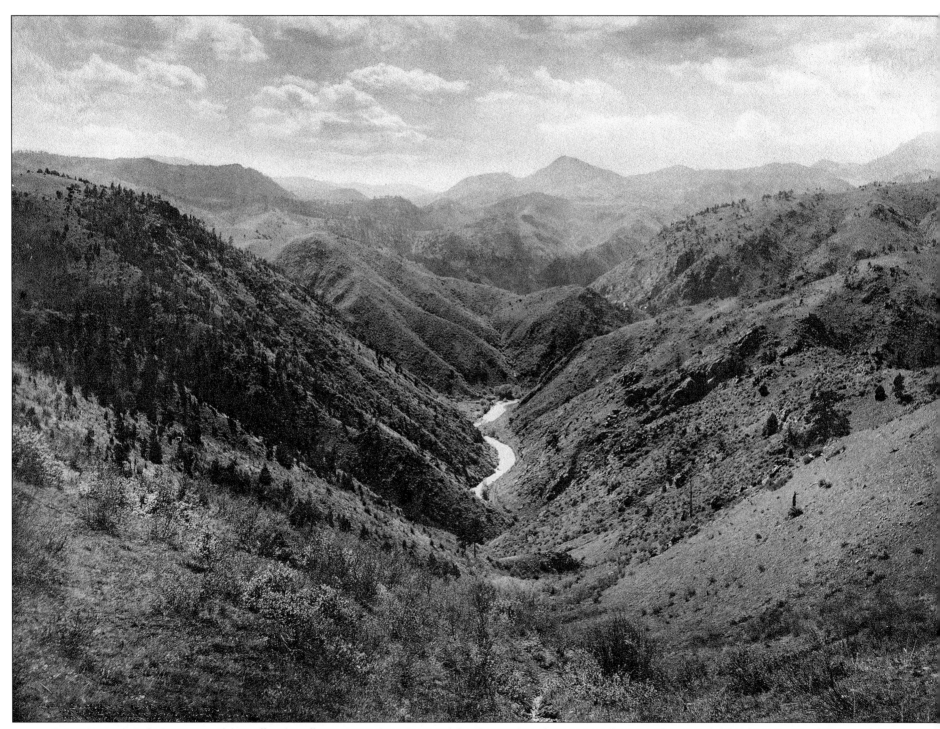

Denver Mountain Parks, in concert with later efforts by Jefferson County Open Space and the Clear Creek Land Conservancy, have together protected this dramatic vista of Clear Creek Canyon. Note the development of a healthy forest and the increase in the number of trees since the above image was made in the 1920s. Travelers on the historic Lariat Trail, now and in the future, will continue to benefit from the foresight of early park visionaries. Kendrick-Bellamy Co.

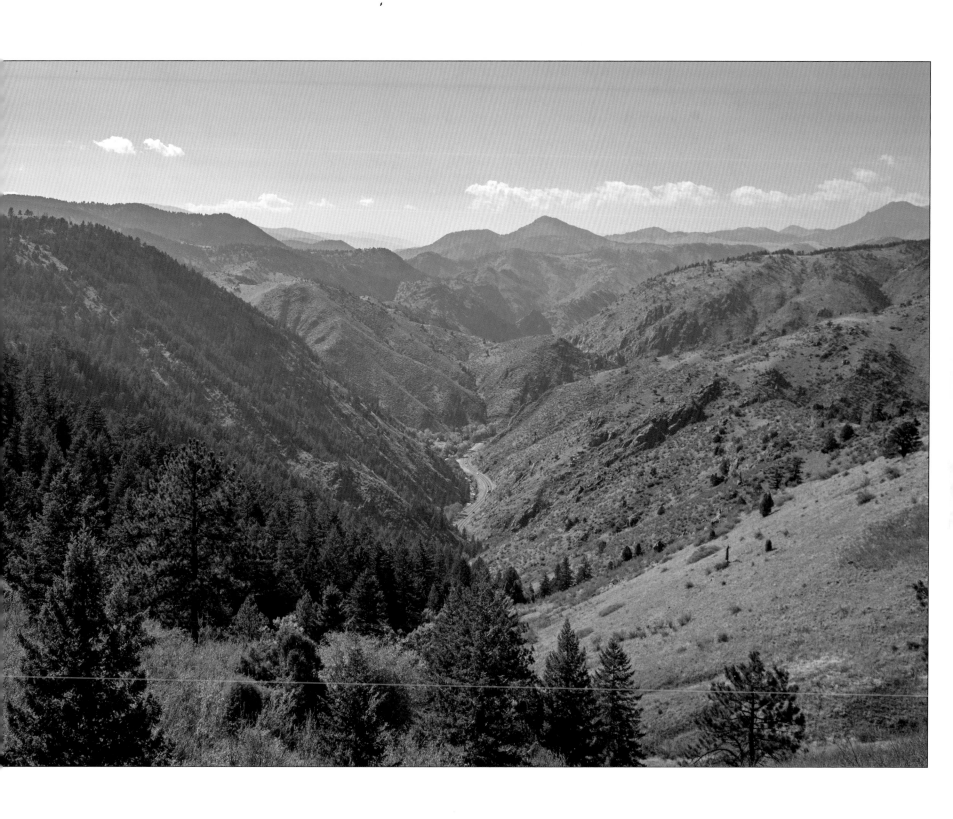

Discovering the Mountain Parks

The tendency nowadays to wander in wilderness is delightful to see. Thousands of tired, nerve-shaken, over-civilized people are beginning to find out that going to the mountains is going home; that wilderness is a necessity; and that mountain parks and reservations are useful not only as fountains of timber and irrigating rivers, but as fountains of life.

—**John Muir,** *Atlantic Monthly,* 1898 (excerpted in *Denver Municipal Facts,* 1913)

The Denver Mountain Parks offer a remarkable range of activities and places to enjoy. Whether you want to hike, picnic, ski, golf, or explore some of Colorado's most famous historic sites, chances are you'll find what you're looking for in a Denver Mountain Park. And if you just need to get away, you can find plenty of wide-open spaces and breathing room.

The 22 developed mountain parks and 24 conservation areas span Jefferson, Clear Creek, Douglas, and Grand counties and are connected by watersheds, forests, trails, scenic drives, and other open space. From the smaller parks, which offer picnic facilities and hiking trails, to Red Rocks and Lookout Mountain, which are well known and attract millions of visitors each year, the system offers a wide diversity of landscapes, facilities, and amenities.

Erika D. Walker

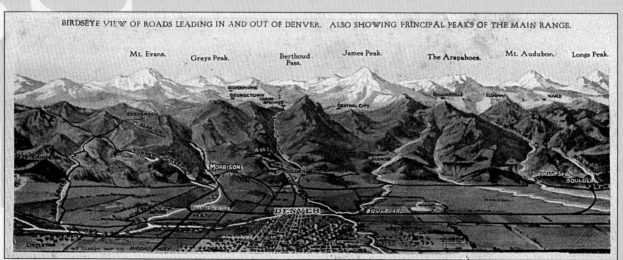

Gateways to the mountain parks are shown in this historic illustration. H.H. Tammen Co.

Evergreen Lake, Dedisse Park

Planning Your Visit

Whether you have an entire day or just a few hours, the mountain parks offer many options for adventure. To help you plan your trip, this guide is organized along convenient travel routes that reflect the development of the historic circle drives: the North Gateway, Bear Creek Gateway, South Gateway, and Mount Evans, followed by Winter Park and Daniels Park. Please refer to the map on the inside front cover for the 16 featured locations.

The symbols listed below accompany the featured parks and convey at-a-glance information about amenities, activities, and special features.

This guide distinguishes between developed parks and undeveloped conservation areas based on whether or not facilities exist at the site. With few exceptions, a "park" can be expected to have facilities such as parking, trails, and other visitor amenities, while "conservation areas" do not. The conservation areas, which protect wildlife habitat and open vistas but often are surrounded by private property with no access, appear at the end of Part III.

The Denver Mountain Parks are listed on the National Register of Historic Places. All parks are considered natural areas and all wildlife and plants are protected and preserved. Hikers are encouraged to wear appropriate shoes, carry water, be aware of wildlife and changing weather conditions, and follow "Leave No Trace" principles of treating wild areas with care (visit www.lnt.org).

Although every effort has been made to ensure the accuracy of park information, the mountain parks are a living system and are constantly evolving and changing. For the latest information and a complete list of park regulations, please contact individual facilities, the Denver Mountain Parks office at 720-865-0900, or visit www.denvermountainparks.org. For picnic facility reservations, call the Denver Parks & Recreation permit office at 720-913-0700.

Icon key: 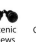 Scenic Views 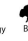 Geology 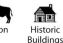 Bison Historic Buildings Shelter Restrooms Food/Gifts Picnic Tables Grills Hiking Biking Fishing Skiing Golf Volley-ball Softball Horse-shoes

North Gateway Parks

The parks' founders dreamed of giving city dwellers access to spectacular mountain scenery, but when they initially proposed the mountain parks, mountain travel was difficult. Automobiles were rare, and roads were few and rugged. From the start, the parks' founders realized they would need new and improved roads. The historic Lariat Trail was the first road linking Denver to her mountain parks. Built in 1913 and flanked by monumental stone gateways, the Lariat Trail begins in Golden and provides a stately beginning to the historic drive to Lookout Mountain Park and beyond.

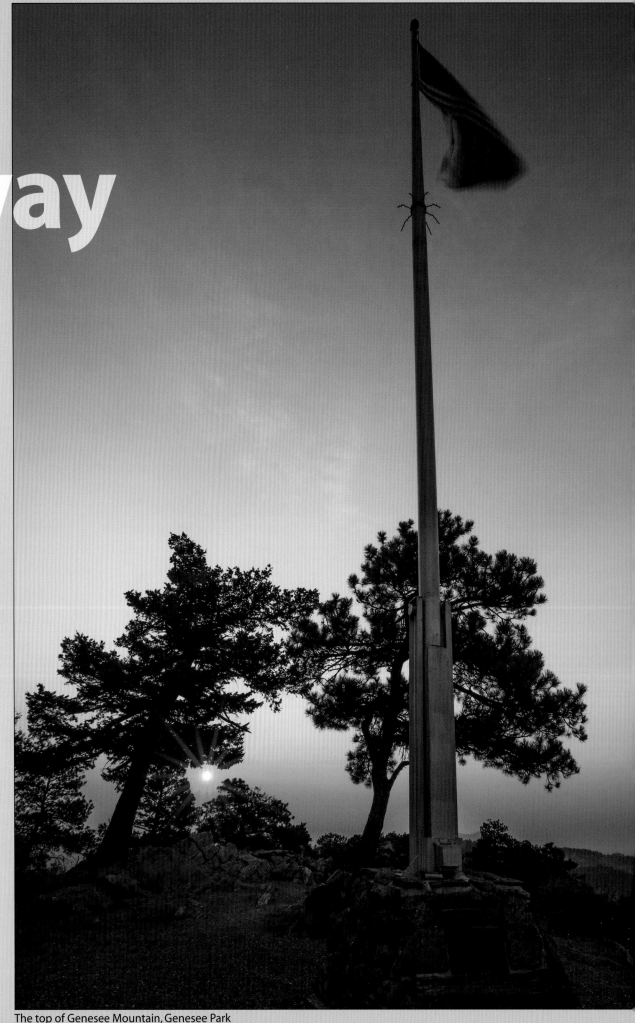

The top of Genesee Mountain, Genesee Park

I Lookout Mountain Park, Buffalo Bill Museum and Grave, and Colorow Point Park

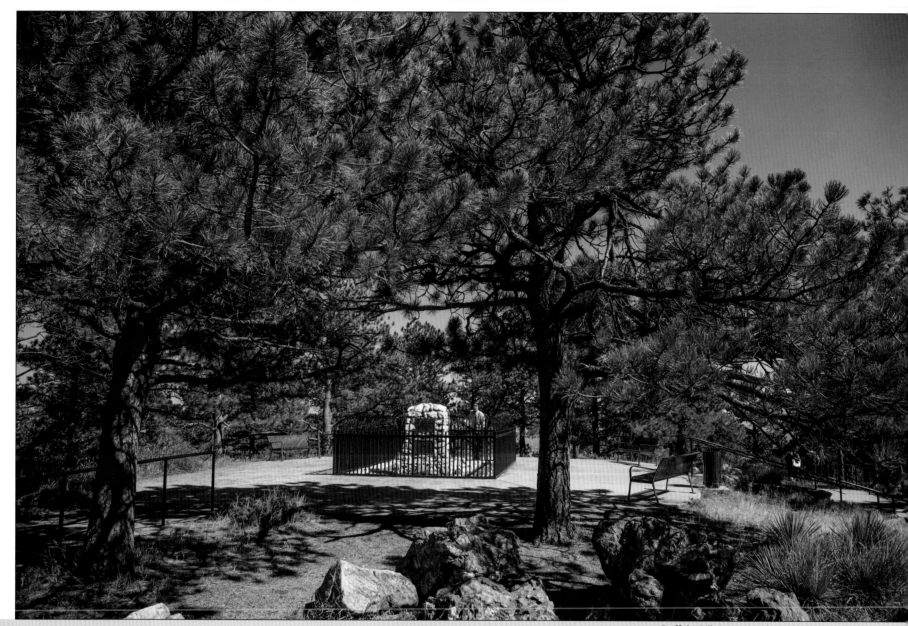

Buffalo Bill Grave, Lookout Mountain Park

LOOKOUT MOUNTAIN and **BUFFALO BILL MUSEUM and GRAVE**

66 acres, Jefferson County

Acquired 1913

Highlights
- Spectacular views from the Continental Divide to downtown Denver
- Buffalo Bill Museum and Grave
- Pahaska Tepee and Gift Shop
- Historic Lariat Trail scenic mountain drive
- Historic picnic shelter
- Colorow Point Park

Hiking A 1-mile trail connects the Buffalo Bill Museum to the Lookout Mountain Nature Center.

The historic 8.65-mile Beaver Brook Trail links Lookout Mountain and Genesee Park. To access the east trailhead, drive 3.6 miles up Lookout Mountain Road from Golden. Watch for a sign on your right marking Windy Saddle Park. From the east, hikers travel westward across rockslides, above forested ravines, and out to a ridgetop meadow overlooking Clear Creek Canyon before descending to Beaver Brook. The Chimney Gulch Trail descends eastward to Golden from Windy Saddle. Beaver Brook Trail is rugged and challenging.

Biking Cyclists enjoy the historic Lariat Trail from Golden to the summit of Lookout Mountain. (Drivers, remember to watch for cyclists and provide ample clearance when passing.)

Location 19 miles from downtown Denver. Take I-70 west to Exit 256, turn right at the top of the ramp, and then take an immediate left. Follow this road to Lookout Mountain Road. Turn right and travel approximately 4 miles. The museum is on the left. Alternatively, take 6th Avenue west to Golden and turn west onto 19th Street, which becomes the historic Lariat Trail. Follow it to Lookout Mountain Park.

Contact Buffalo Bill Museum (call for admission and group rates), 303-526-0744, www.buffalobill.org; general information, 303-526-0747; Pahaska Tepee Gift Shop, 303-526-9367

Summer Hours May 1–October 31. Museum: Daily 9 a.m.–5 p.m. Gift Shop/Café: Daily 8:30 a.m.–sunset

Winter Hours November 1–April 30. Museum: Tuesday–Sunday, 9 a.m.–4 p.m.; closed Christmas Day. Gift Shop/Café: Daily 9 a.m.–sunset

Sunset along the Beaver Brook Trail, which links Lookout Mountain and Genesee Park

Famous for its panoramic views stretching from the Continental Divide to downtown Denver, Lookout Mountain Park is one of the top visitor attractions in metro Denver and Colorado. It is perhaps best known as the final resting place of legendary frontiersman William F. Cody, who was buried here on June 3, 1917. Cody, who earned the nickname "Buffalo Bill" for his hunting skill, had worked as a fur trapper, gold miner, Pony Express rider, and scout before developing his Wild West Show, which entertained millions in the United States and abroad.

In 1921, Johnny Baker, Cody's friend and adopted son, opened the Buffalo Bill Museum in the Pahaska Tepee. (The Lakota called Cody "Pahaska," meaning "long hair.") The museum, now in a separate building, contains extensive exhibits and collections of artifacts, including Cody's show outfits, favorite rifles, and saddles. In addition, the museum hosts special events throughout the year, such as Buffalo Bill's birthday celebration, the Mountain Music Festival, and a western roundup. Events are subject to change, so call ahead for the most up-to-date information.

Today the Pahaska Tepee, a rustic building of native log and stone near Cody's gravesite, contains a large gift shop and a restaurant serving buffalo burgers and other tasty offerings. Across the parking lot, the mountain parks' first picnic shelter—designed by architects W.E. and A.A. Fischer and built out of native stone in 1913—overlooks the Continental Divide and is surrounded by meadows and forests of ponderosa pine.

The historic Lariat Trail that begins in Golden and climbs 1,500 feet to the summit of Lookout Mountain was the first, and one of the most difficult, roads constructed to a mountain park. Frederick Law Olmsted Jr., Saco Rienk DeBoer, and Frederick C. Steinhauer contributed to the road's design and engineering. "Cement Bill" Williams began building the road and was later hired by Denver as the project foreman. Constructed from 1910 to 1913 on a nearly vertical mountainside, the road represents a remarkable engineering feat. Most of the road was blasted out of solid rock. This popular scenic drive does not exceed a 6 percent grade, and features hairpin turns, switchbacks, and broad views of plains, mountains, and canyons. After Cement Bill's death in 1963, a monument was erected honoring his contribution. It is now located in the parking area near the museum.

Colorow Point Park At 0.53 acre, Colorow Point—the smallest park in the mountain parks system—was acquired in 1914. Designed by Frederick Law Olmsted Jr. and named for the Ute Chief Colorow, who used this area as his tribe's lookout point in the early 19th century, the park sits across from the entrance to Boettcher Mansion and Lookout Mountain Nature Center on Colorow Road. Though small, the park offers expansive views.

> *When the history of our western frontier is at last written, the name of Buffalo Bill will stand out perhaps as no other. He was symbolical [sic] of the heroic west. He inspired the pioneer, guided the soldier, and helped the builders of the railroad. And his life was more thrilling than any wild, adventurous and moving romance.*
>
> **—Zane Grey,** from his foreword to *Last of the Great Scouts* by Helen Cody Wetmore

2 Genesee and Katherine Craig Parks

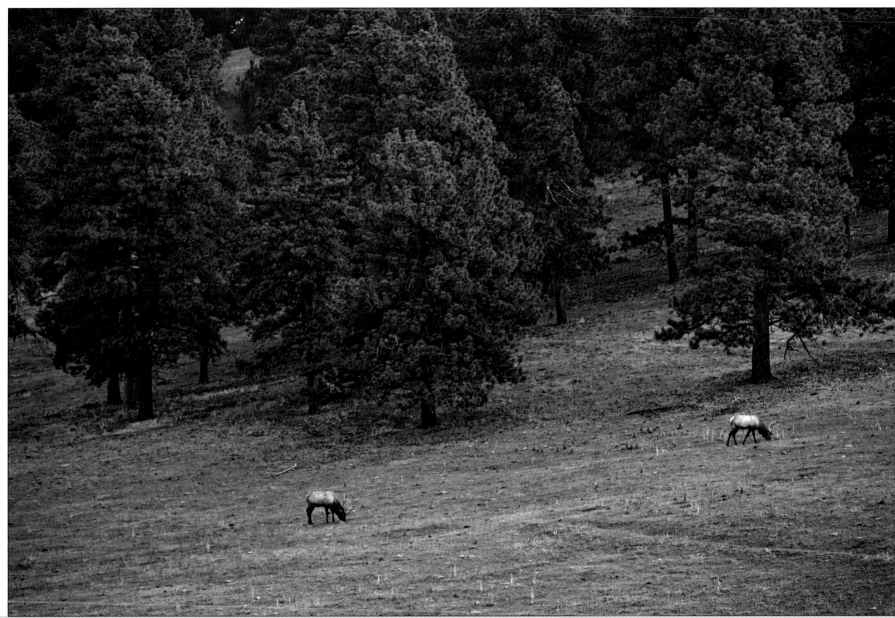

Elk, Genesee Park

GENESEE

2,413 acres, Jefferson County

Acquired 1913

Highlights

- Scenic gateway view of the Front Range
- Bison overlook along I-70
- Chief Hosa Lodge and historic Civilian Conservation Corps shelter (available for events)
- Summer public camping at Chief Hosa Campground (fee charged)
- Historic 8.65-mile Beaver Brook Trail
- Braille Nature Trail for the visually impaired
- Youth programs, ropes course, Genesee Experiential Outdoor Center

Hiking To reach the Beaver Brook Trail's west trailhead, follow I-70 west to Exit 253. Turn right on Genesee Drive and take an immediate right onto Stapleton Drive. Follow it for approximately 1 mile to trailhead parking. (The east trailhead is at Windy Saddle Park; see p. 87.) From the west trailhead, the trail descends along Bear Gulch through thick forest to Beaver Brook, and then climbs steeply out of the canyon to Garnet Point. Continuing east, the trail drops to gentler terrain; the last section is mostly level or slightly downhill. This is a rugged backcountry hike, remarkable for being so close to the city.

The 2-mile Chavez Trail and the Braille Nature Trail, just under a mile long, also start at the Beaver Brook Trail's west trailhead. The Braille Nature Trail offers waist-high guidelines and interpretive signs in Braille. At the bottom of the loop, hikers can pick up the Beaver Brook Trail.

Location Genesee Park is 20 miles west of Denver on I-70. Take Exit 253 (Chief Hosa) for Chief Hosa Lodge, campground, and Beaver Brook trailhead. Take Exit 254 (Genesee Park) for bison viewing and park.

Contact For picnic facility reservations, call the Denver Parks & Recreation permit office, 720-913-0700. For information about youth programs at Genesee Experiential Outdoor Center, call Denver Parks & Recreation's Outdoor Recreation department, 720-865-0680.

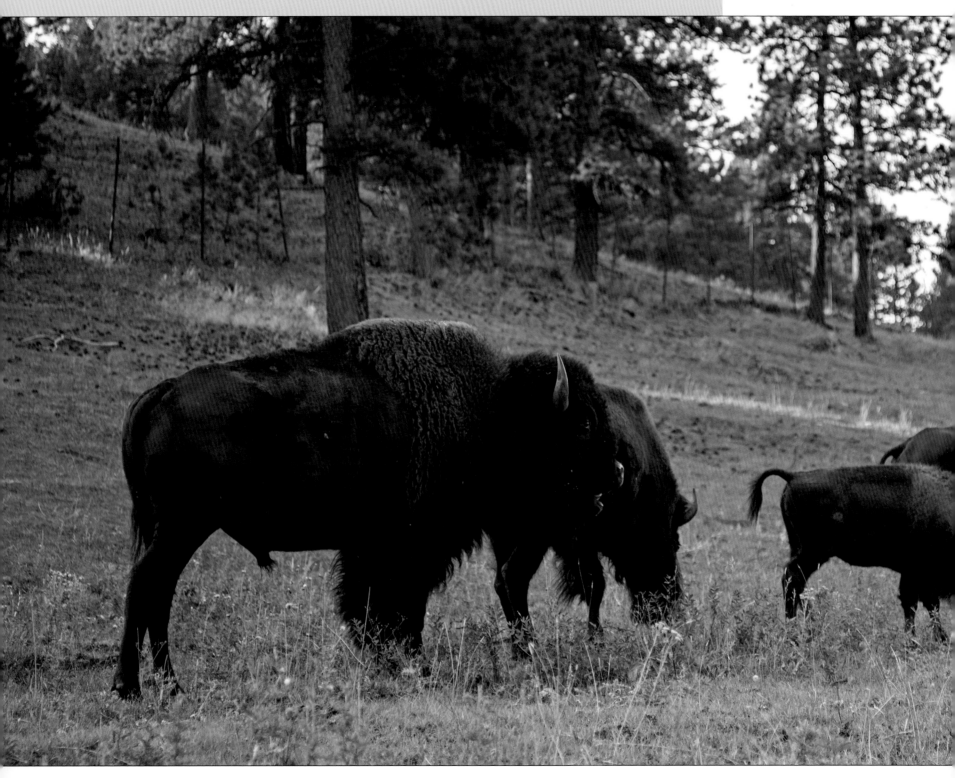

In 1911, the foresight and quick action of a group of Denver businessmen saved several hundred acres of Genesee Mountain's old-growth ponderosa forest slated for logging. They safeguarded this land in a trust in preparation for Genesee to become Denver's first mountain park. With additional land purchases over the years, Genesee, now at 2,413 acres, is Denver's largest mountain park.

Genesee, reportedly an American Indian term for "shining valley," has an expansive character of rolling hillsides, mountain valleys, thick pine forests, and open grassy glades. Stands of old-growth ponderosa remain and provide important habitat for wildlife.

I-70 cuts the park into two parts. To the south of the interstate, Genesee Mountain offers a 360-degree view from its 8,284-foot summit. Bald Mountain, at 7,988 feet, rises prominently on the north side of the park, which reaches all the way to Clear Creek Canyon, at 6,280 feet.

Genesee is probably best known for its bison herd, often visible from I-70. In 1914, Denver contributed to pioneering efforts to re-establish the nearly extinct bison. Today, herds at both Genesee and Daniels parks number about 50 each and provide a living link to western history.

The bison are just part of Genesee's colorful history. Chief Hosa Lodge once provided respite for weary travelers and is now available for private events. "Chief Hosa" was a sobriquet for Little Raven (1810–1889), a progressive Southern Arapaho chief. Designed by Jules Jacques Benois Benedict, one of Colorado's most prominent architects, the lodge was built of native stone and logs in 1918. The historic Beaver Brook Trail, completed by Colorado Mountain Club volunteers in 1918 and connecting to Lookout Mountain, offers hikers a rugged 8.65-mile opportunity to experience backcountry wilderness where the only likely sound is the scolding of a squirrel—or simply silence. Visually impaired hikers can experience Genesee along the Braille Nature Trail, which offers interpretive signage in Braille.

The circa 1860 Patrick House, the oldest structure in the Denver Mountain Parks, served as a toll station, collecting fees from those heading to the gold fields. Visitors who want to experience living history can join the Daughters of the American Revolution as they commemorate Flag Day in a service they've been performing atop Genesee Mountain every June 14 since 1911 (see p. 79).

The many other options for enjoying Genesee include picnicking at the large Civilian Conservation Corps shelter and other picnic areas near the summit of Genesee Mountain, and RV or tent camping at Chief Hosa Campground.

A new master plan for Genesee Park will explore options for park improvements, consider new uses for the Katherine Craig parcel, and possibly change the park's name to Genesee Mountain Park.

Katherine Craig Park This 56-acre park, 0.5 mile east of Genesee Park, was donated in 1935 and became the site of the Genesee Civilian Conservation Corps Camp SP-14. Several buildings from this era remain, and have been used since the 1940s by the Boy Scouts, and later by the Mile High Council of Girl Scouts. The site is currently used by Youth Corps and other groups and has no public access.

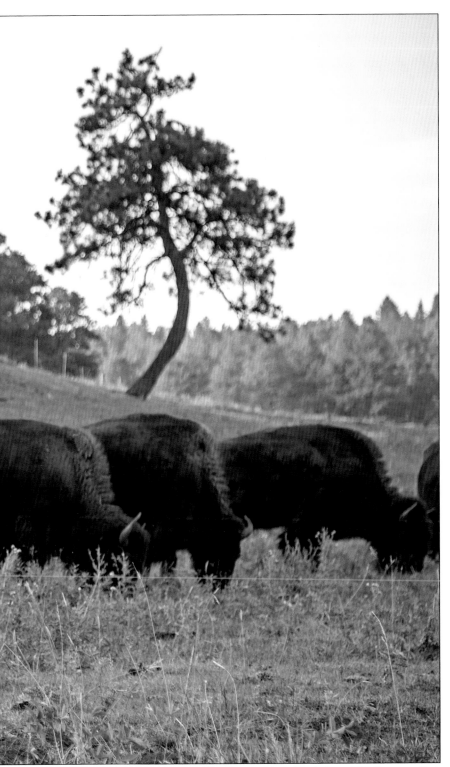

The famous bison herd along I-70, Genesee Park

3 Fillius Park

The well-house at Fillius Park is now a picnic shelter.

108 acres, Jefferson County

Acquired 1914

Hiking Short walking trails are available within the park.

Location Approximately 23 miles west of Denver. Take I-70 west to Exit 252. Merge onto CO 74 South/Evergreen Parkway; travel for 2.5 miles and turn right onto Bergen Parkway. Fillius Park shelter is on your right as you enter the park.

Adjacent to CO 74, on the way to Squaw Pass and Evergreen, Fillius Park was one of the early resting spots along the scenic drives in Denver's foothills. Acquired in 1914, the park was named for Jacob Fillius, a member of the Denver Park Board.

Prominently placed is the distinctive 1918 stone shelter designed by J.J.B. Benedict. The openings on its north façade orient toward the Continental Divide. The shelter's refined detailing makes it one of the most important structures in the mountain parks system.

In 1937, the Civilian Conservation Corps built two looping park roads for picnicking. Portions followed the original Bergen Park Road and the Beaver Creek Wagon Trail.

Bergen Parkway divides the park, with the stone well-house, shelter, and picnic area to the southeast, set among ponderosa pines. The steeper west portion has a meadow and dense ponderosa and Douglas-fir woods. It is currently accessible only on foot.

4 Bergen Park

T.C. Bergen monument at Bergen Park

25 acres, Jefferson County

Acquired 1915

Hiking The regional Jefferson County Pioneer Trail runs along the western edge of the park. Buchanan Park, owned by the Evergreen Park and Recreation District, abuts Bergen Park to the south. An internal trail connects Buchanan and Bergen parks.

Location Approximately 23 miles west of Denver. Take I-70 west to Exit 252. Merge onto CO 74 South/Evergreen Parkway; travel 2.5 miles to Bergen Parkway. Turn left. Bergen Park is on your right in approximately 0.3 mile.

Built on land donated by Oscar N. Johnson in 1915, Bergen Park is one of the better-known and most-used of the Denver Mountain Parks. On warm days, families and groups of friends enjoying picnics often fill the park. At 25 acres, it is one of the smaller mountain parks, but its open grasslands and mature ponderosa pine forest offer an exquisite wooded setting.

A striking stone shelter built in 1917 rules the center of the park. Built of white quartz and timber, the shelter was designed by J.J.B. Benedict; a well-house of the same materials lies just south of the shelter.

Bergen Parkway divides the park into two sections. A small monument commemorating early settler Thomas C. Bergen sits in the east section and a historic stone restroom, no longer in use, remains to the south of the monument.

Bear Creek Gateway Parks

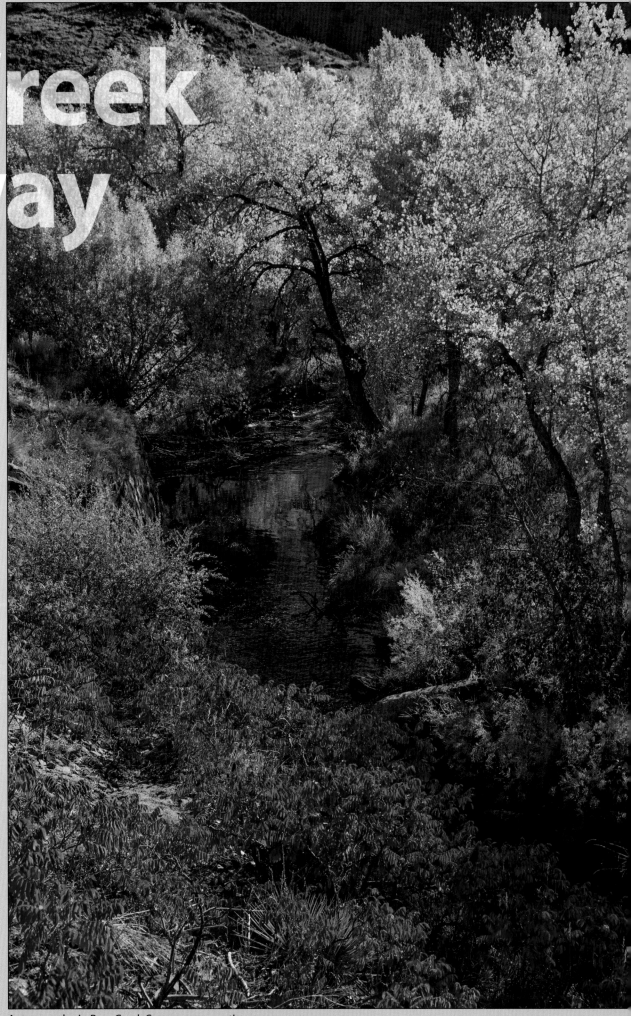

In the early 1900s, Denver began building scenic drives through the foothills to access the mountain peaks and popular flowing streams just west of the city. With the growing popularity of the automobile, groups could venture out for the day, and Denver moved to acquire parkland along Bear, Deer, Turkey, and Cub creeks. In these parks, motorists could enjoy a picnic and fill their radiators at well-houses before continuing into the mountains.

The curving scenic drive of CO 74 connects Morrison to Evergreen, providing access to Red Rocks Park and to some of the earliest and busiest mountain parks: Little, Corwina, O'Fallon, and Pence. Cub Creek and Bell parks are just south of Evergreen on the Bear Creek tributaries of Cub Creek and Little Cub Creek.

Autumn color in Bear Creek Canyon conservation area

Red Rocks Park

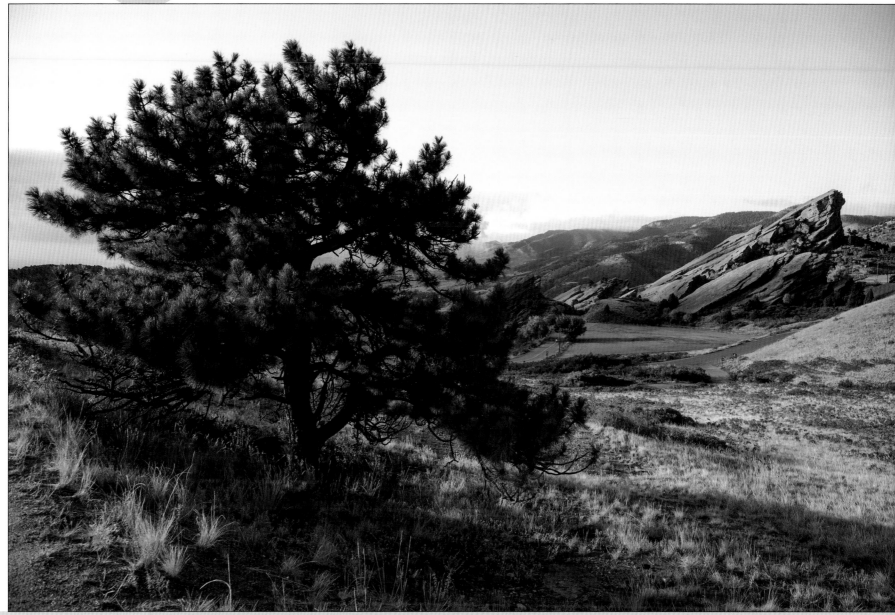

Looking south along the foothills at Red Rocks Park

868 acres, Jefferson County

Acquired 1928

Highlights

- 200-mile panoramic view of Denver and the plains
- Towering 300-foot sandstone formations
- World-renowned amphitheatre completed in 1941
- Historic 1931 Trading Post housing a Colorado Welcome Center
- Visitor center with restaurant, gift shop, and park interpretation
- Historic scenic roads, a favorite route for cyclists

Hiking The 1.4-mile Trading Post Trail begins and ends at the Trading Post and travels through spectacular rock formations, valleys, and a meadow. Some of the terrain is rough and the majority of the trail is less than 30 inches wide.

The Red Rocks Trail starts at the park's lower north lot as a hiker-only trail and connects to the multi-use Red Rocks and Dakota Ridge trails in Jefferson County's Matthews/Winters Park, creating a dramatic 6-mile loop.

Off-trail use and rock climbing are prohibited at Red Rocks. All trails close one hour after sunset.

Biking Scenic roads and Red Rocks Trail (see Hiking).

Location 15 miles west of downtown Denver. Take I-70 west to Exit 259, turn left at the bottom of the Morrison exit ramp, and continue south 1.5 miles to the Red Rocks Park entrance. Coming from south Denver, take C-470 to the Morrison exit, turn west, and follow the signs to the park entrances.

Contact Visitor center, 303-697-4939; amphitheatre office, 720-865-2494; www.redrocksonline.com

Park and Amphitheatre Hours 5 a.m.–11 p.m.

Visitor Center Hours May–September, 8 a.m.–7 p.m.; October–April, 9 a.m.–4 p.m.; closed Thanksgiving and Christmas. On concert days, the visitor center generally closes after lunch for sound checks and other technical work. To check closure times on concert days, call the amphitheatre office. On non-concert days, call the visitor center. Admission is free.

Ship Rock, as viewed from across the plaza atop the amphitheatre

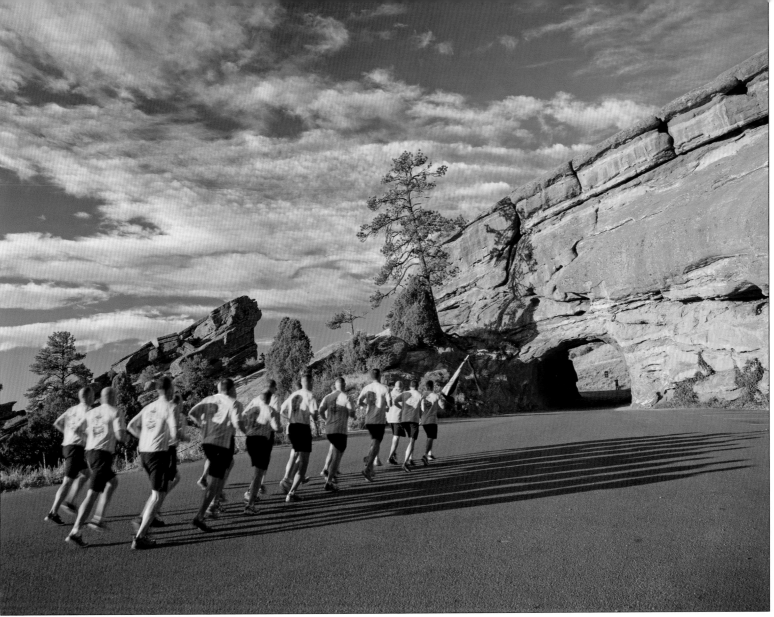

Tunnel on Creation Rock Drive

When Denver businessman J.B. Walker first described his dream of a magnificent system of mountain parks, surely he imagined Red Rocks as the crown jewel. Named for the towering red sandstone formations that rise dramatically in the foothills and form one of the most perfect natural amphitheatres in the world, Red Rocks, the most famous of the mountain parks, is a singular and magical place.

Visiting Red Rocks is like taking a trip back in time. Three hundred million years ago, the land that makes up present-day Colorado was not landlocked. As the area's ancient seas rose and fell, they left sandy beaches that became sedimentary deposits. About 65 million years ago, an immense surge pushed these ancient beds of rock upward, lifting and tilting them on edge. Water and wind sculpted them into the modern red rocks. The area was home to giant dinosaurs including *Apatosaurus*, *Stegosaurus*, and *Triceratops*, and, much later, to American Indians, miners, and settlers.

In 1905, J.B. Walker purchased Red Rocks, once known as the Garden of the Angels, and renamed it Garden of the Titans. Determined to showcase the park's wonders, he built a funicular railway to the top of Mount Morrison, improved carriage roads and trails through the rock outcrops, and installed ladders to help visitors scale the rocks. The rocks are now strictly off-limits, but visitors can still explore miles of hiking and biking trails. In 1928, Denver bought this "Park of the Red Rocks" and immediately began building scenic roads and contemplating a huge

amphitheatre. The scenic roads capitalized on the park's natural features, providing spectacular views.

The park's best-known feature, Red Rocks Amphitheatre, lies in the naturally formed bowl between Creation Rock and Ship Rock. Composed of an upward-sweeping arc of wood-edged seats and built of simple indigenous materials, the amphitheatre was designed by Burnham Hoyt, one of Colorado's most celebrated architects. Hoyt took great care to integrate the amphitheatre into its natural setting, building it to preserve the site as much as possible. Beginning in 1936 and progressing for five years, the work of hundreds of men from the Mount Morrison and Genesee camps of the Civilian Conservation Corps created this masterpiece; the workers toiled for only a dollar a day.

More than one million people visit Red Rocks Park each year to enjoy the amphitheatre's world-renowned acoustics and breathtaking setting. Each year, dozens of concerts and shows offer a wide variety of entertainment and attract a broad mix of people. In addition to concerts, the amphitheatre receives heavy use from geology classes, runners zigzagging up the steps and rows of seats, photographers, international tourists, and special events.

The visitor center, completed in 2003, offers a gift shop, restaurant, meeting rooms, and exhibits highlighting the park's development and musical and natural history. The popular Trading Post, just south of the amphitheatre, serves as one of the official Colorado Welcome Centers.

FIRST OVERLEAF:
Sunrise on Red
Rocks Park from
Dinosaur Ridge

SECOND OVERLEAF:
Shelter at Geologic
Overlook along View
Road, Red Rocks Park

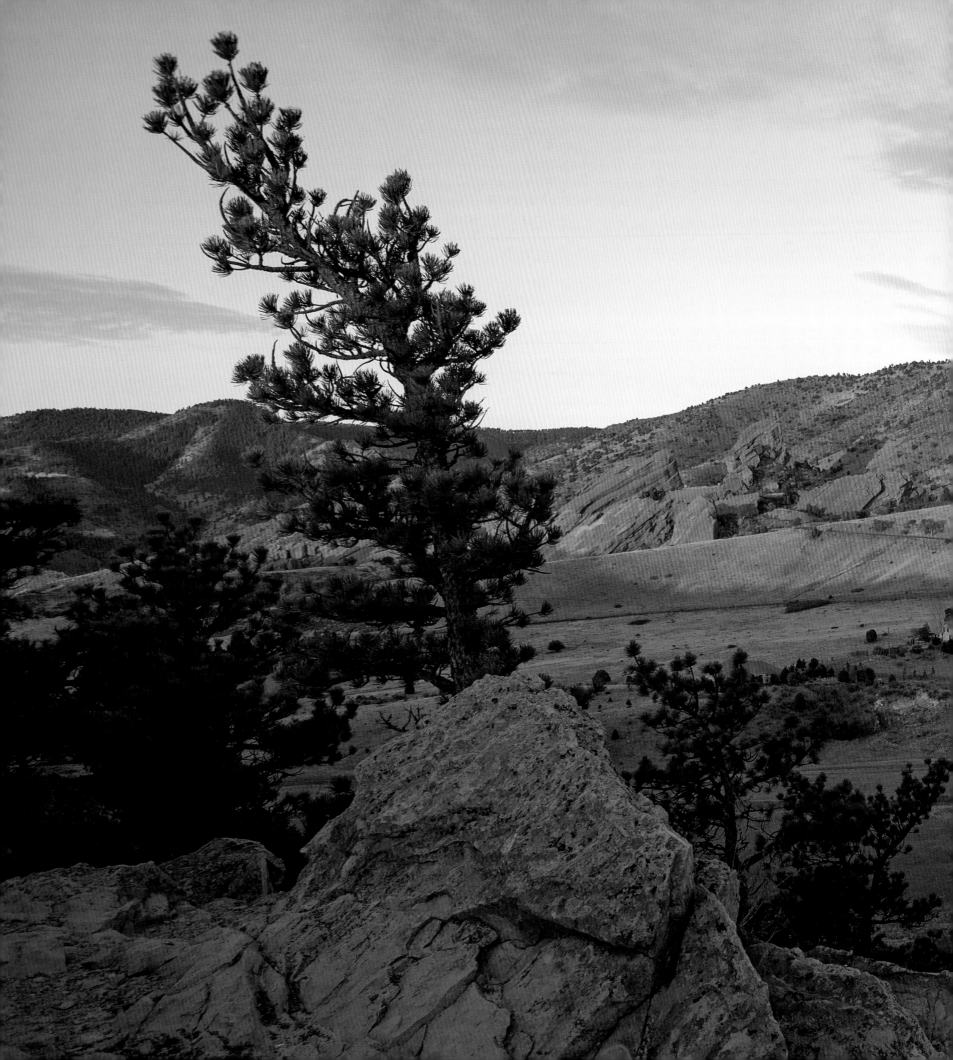

6 Morrison Park

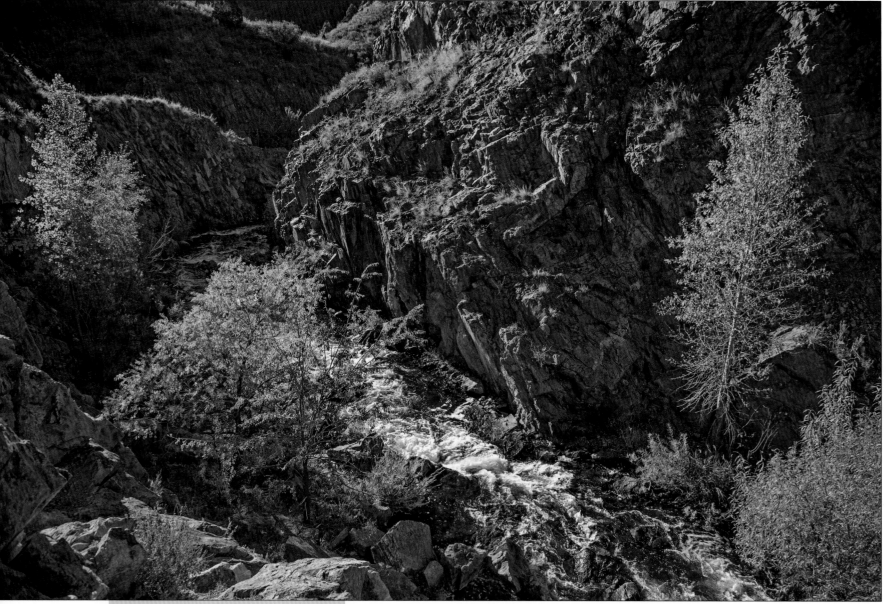

Autumn in Bear Creek Canyon conservation area

2 acres, Jefferson County

Acquired 1928

Hiking Just east of Morrison Park, a parking area and trailhead for Bear Creek Trail provides access eastward toward the urban portions of this regional trail.

Location South of Bear Creek in a southern extension of Red Rocks Park, which also includes the adjacent Mount Morrison Civilian Conservation Corps (CCC) Camp SP-13.

Morrison Park is technically a section of Red Rocks Park. The CCC camp is open to the public only by appointment. Morrison Park is a picnic area available on a first-come, first-served basis or by reservation for larger groups. Surrounded by cottonwoods and other trees, the open picnic area extends eastward into the adjacent Morrison Town Park, where the Bear Creek Trail begins. The historic stone wall next to the creek was built in 1935 to provide protection from floods.

Bear Creek Canyon A nearby conservation area is Bear Creek Canyon, which the City and County of Denver acquired in 1928. Bear Creek Canyon is a 400-foot-wide strip, 4 miles long, stretching from Morrison toward Idledale along Bear Creek and CO 74. It consists of 130 acres of undeveloped open space in the foothills and provides fishing access.

Winter in Bear Creek Canyon conservation area
OVERLEAF: Autumn in Bear Creek Canyon conservation area

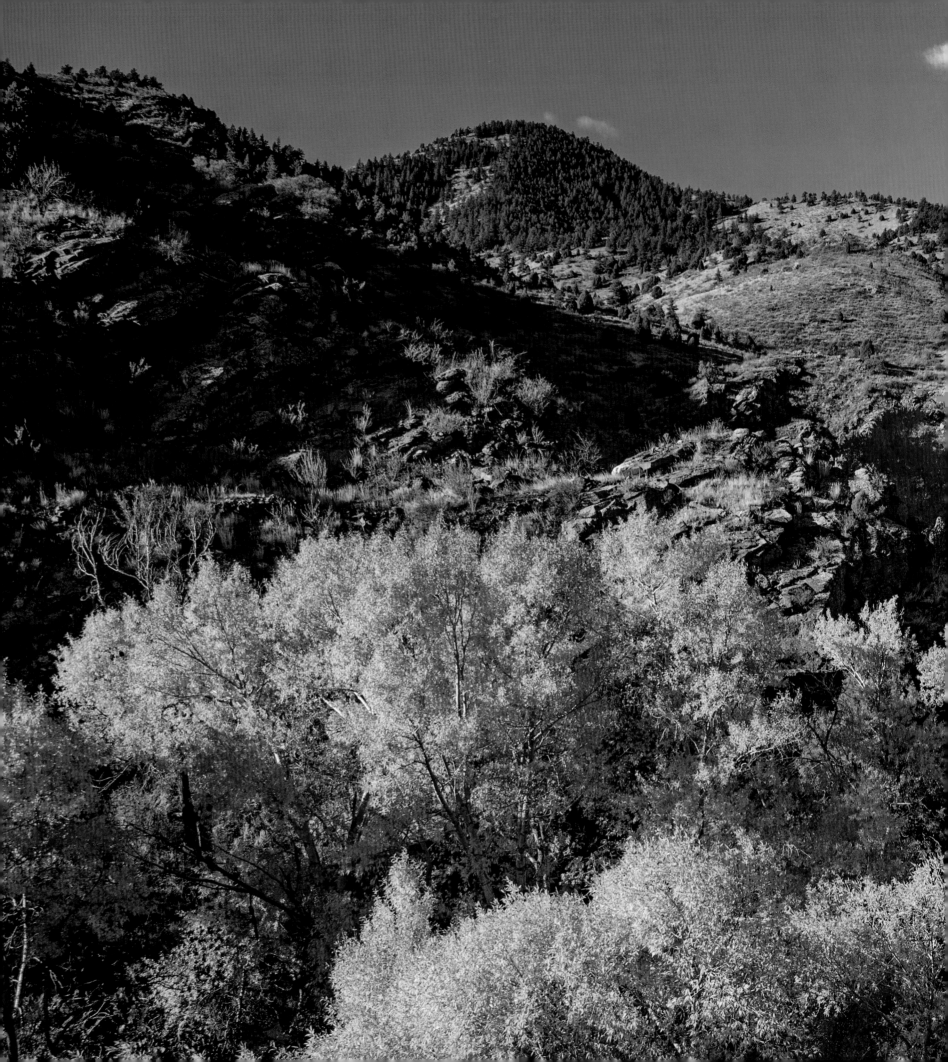

7 Corwina, O'Fallon, and Pence Parks

CORWINA
298 acres, Jefferson County
Acquired 1916

O'FALLON
860 acres, Jefferson County
Acquired 1938

PENCE
320 acres, Jefferson County
Acquired 1914

Hiking Corwina Park boasts the 1.4-mile Panorama Point Trail. In O'Fallon Park, hikers find the Picnic Loop Trail (1 mile), Meadow View Loop Trail (1.8 mile), and West Ridge Loop Trail (1.9 mile). The hiker-only trails in O'Fallon and Corwina parks connect with the multi-use Bear Creek Trail. Denver and Jefferson County Open Space completed the Bear Creek Trail from Pence through O'Fallon and Corwina to Lair o' the Bear Park in 2002.

Location Approximately 24 miles west of Denver on CO 74 in Bear Creek Canyon.

View through the Corwina Park shelter

Corwina, O'Fallon, and Pence parks share boundaries and embody the quintessential characteristics of the Denver Mountain Parks system: backcountry forests, challenging trails, flowing water in natural creeks, and shaded picnic sites. They have distinct names and histories, though they are managed as a single unit. Except for Pence, the parks center directly on Bear Creek, and their picnic sites make for a popular destination on weekends.

Acquired in 1916, Corwina Park is a wonderfully wooded picnic park with an intimate scale. The park straddles Bear Creek and CO 74, with a small developed picnic area on the north side of CO 74.

Corwina and O'Fallon parks each have beautiful stone structures. On the southern hillside of the creek, a rustic stone rubble shelter, designed by J.J.B. Benedict and built in 1918, characterizes Corwina Park; an iconic stone fireplace (missing its roof), strategically sited to be seen from Bear Creek Canyon Road, commemorates Martin J. O'Fallon.

O'Fallon's 1938 donation of 860 acres is one of the last major additions to the Denver Mountain Parks system. This donation connected Corwina Park on the creek with Pence Park to the south. Together, the three parks comprise 1,478 acres of contiguous parcels. Most of the park acreage is open space that protects and sustains natural resources, including wetlands, watersheds, open meadows, and evergreen and riparian forests.

Located astride Dix Saddle on Myers Gulch Road, the land for Pence Park, originally known as Dixie Park, was acquired in 1914. In 1937, the Civilian Conservation Corps built a picnic site, a hiking trail, and Denver's first sled run here; two years later, the corps built a hiking trail to Independence Mountain.

Bear Creek autumn reflection, O'Fallon Park

Little and Starbuck Parks

LITTLE
400 acres, Jefferson County
Acquired 1917

Hiking The trailhead at Little Park's parking lot accommodates hikers heading west on the popular Bear Creek Trail, which extends westward through Jefferson County's Lair o' the Bear Park, as well as Corwina, O'Fallon, and Pence parks.

Biking The trailhead at Little Park's parking lot also accommodates mountain bikers heading west on Bear Creek Trail.

Location Little Park is 21 miles southwest of Denver and immediately west of Idledale on CO 74 in Bear Creek Canyon. The access from CO 74 is at the northern tip of the park, most of which lies south of Bear Creek.

Little Park, named after the land donor, C.W. Little, was among Denver's first 10 mountain parks. It sits at the west edge of the town of Idledale, formerly known as Starbuck. To the south of Little Park lies Mount Falcon Park and to its west is Lair o' the Bear Park, both owned and managed by Jefferson County Open Space.

With its low meadows immediately adjacent to Bear Creek, and its unique octagonal-roofed well-house built in 1919, Little Park continues to offer a secluded, serene spot for a day of leisure by the creek. There is fishing access along Bear Creek. South of Bear Creek, Little Park is characterized by steep canyons and ridges covered with ponderosa pine and Douglas-fir forests, open shrublands, and prominent rock outcrops.

Starbuck Park is an 11-acre parcel donated by John C. Starbuck on February 19, 1916. Just east of Idledale, it contains a small well-house but no other facilities. Most of the park is on a steep slope north of CO 74.

9 Bell and Cub Creek Parks

W. Bart Berger with DMP forester Andy Perri and lead ranger Rob Krueger on top of Bell Park

BELL
480 acres, Jefferson County
Acquired 1915

CUB CREEK
549 acres, Jefferson County
Acquired 1922

Location Approximately 30 miles west of Denver. Take I-70 west to Exit 252. Merge onto CO 74 South/Evergreen Parkway. Travel about 8 miles to downtown Evergreen. At the light, take a sharp right onto CO 73 South. For Bell Park, turn left on Little Cub Creek Road. For Cub Creek Park, continue on CO 73 South to Brook Forest Road. Turn right on Brook Forest Road.

Upstream in the Bear Creek drainage, two mountain parks sit quietly side by side, protecting rolling ponderosa forests, mixed forested ridges, riparian habitat, and tributaries of Bear Creek. Bell Park, the eastern of the two, consists of 480 acres that frame the Little Cub Creek drainage. To its west is Cub Creek Park, a parcel of 549 acres of rolling forests that includes two prominent drainages, Cub Creek and Little Cub Creek. Although officially two distinct parks, they are managed as one open space. Together, these mountain parks define the southern gateway into the town of Evergreen.

Two major roads—CO 73 and Brook Forest Road—cross Cub Creek Park, and several graded dirt roads cross the park to access private land. Limited picnic facilities are provided in Cub Creek along Brook Forest Road. This picnic area is called Dillon Park. Bell Park climbs steeply to wonderful views of the area and has no parking or recreation facilities.

10 Dedisse Park

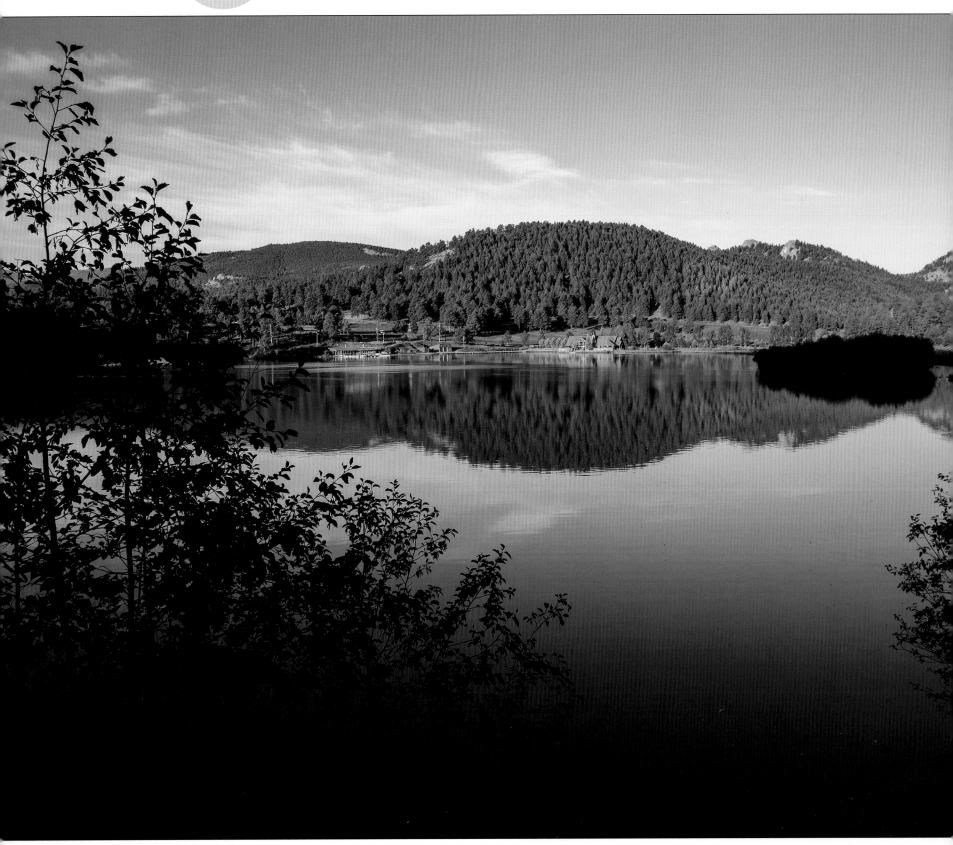

Evergreen Lake reflection, Dedisse Park

420 acres, Jefferson County

Acquired 1919

Highlights
- "Mirror of the Mountain Parks" with lake view west to horizon
- 65-acre Evergreen Lake, featuring boating, skating, and year-round fishing
- Evergreen Dam, completed in 1928
- Evergreen Golf Course, Colorado's first mountain golf course
- Evergreen Nature Center, opened in 2008
- Historic group picnic shelter; other picnic areas

Hiking The multi-use Dedisse Trail extends across the north and west parts of the park, connecting the Pioneer Trail, managed by Jefferson County Open Space, with the trail system in Alderfer/Three Sisters Park. There is also a trail around Evergreen Lake.

Biking Biking is available on the multi-use Dedisse Trail.

Location 27 miles west of Denver. Take I-70 west to Exit 252. Merge onto CO 74 South/Evergreen Parkway and continue about 8 miles. Then, at the lake, turn right onto Upper Bear Creek Road.

Contact For picnic facility reservations, call the Denver Parks & Recreation permit office, 720-913-0700. For information about Evergreen Lake in Dedisse Park, call 720-880-1300.

Upstream on Bear Creek, looking across Dedisse Park and the Evergreen Golf Course

At Dedisse Park, using a little imagination, visitors can contemplate a way of life very different from that of most people today—life on a mountain ranch. Julius and Mary Ann Dedisse homesteaded here in the late 1860s and the land remained in the family until Denver purchased it in 1919. The house, barn, and outbuildings are long gone, but the expansive meadows and pine forests, and the peace and solitude, remain.

Dedisse's ranching history is only part of what draws visitors. Dedisse is also the home of Colorado's first mountain golf course, which Denver acquired in 1925. The land, on the west side of the valley, was donated by Harry Sidles, the owner of nearby Troutdale-in-the-Pines, a hotel and resort that attracted a wealthy clientele. Sidles donated the land with the condition that it always remain a golf course. The octagonal log clubhouse, designed by F. W. Ameter and built in 1925, features a central fireplace and rustic architecture.

With boating in the summer, ice skating in the winter, and fishing year-round, Evergreen Lake—a perfect mirror of mountain parkland—forms the centerpiece of Dedisse Park. The Evergreen Park and Recreation District built the Lake House and manages it as an event center. Depending on the season, paddleboats, canoes, and ice skates are rented in the historic warming house. The Evergreen Naturalists Audubon Society provides programs and displays at the Evergreen Nature Center in the warming house in summer.

Upper Bear Creek Road bisects Dedisse Park's 420 acres of forested ridges and open meadows. During the 1930s, the Civilian Conservation Corps developed the area north of the road into a park. One picnic site and a stone and timber shelter, available by reservation, are currently open for use.

OVERLEAF: Canada geese on Evergreen Lake with the Lake House in the background, Dedisse Park

South Gateway Parks

As the mountain parks system expanded, Denver acquired land along North Turkey Creek (US 285) and built Turkey Creek Park as the gateway to western scenery. Land for Newton Park was acquired in 1939 and 1962. Deer Creek Park lacks public facilities and is a conservation area that protects a narrow riparian corridor west of the Hogback near Jefferson County Open Space's Deer Creek Canyon Park, as well as other conservation land in the area.

Newton Park shelter and picnic area

434 acres, Jefferson County

Acquired 1939

Highlights

- Special events park available only by reservation
- Three large group shelters and picnic facilities
- Montane forests of ponderosa pine and Douglas fir
- Excellent wildflowers

Location 32 miles from downtown Denver on Foxton Road, just south of US 285.

Contact For facility reservations, call the Denver Parks & Recreation permit office, 720-913-0700.

Newton Park, one of the last to join the mountain park system, has controlled access and is available only by reservation. James Quigg Newton Sr., the father of James Quigg Newton Jr.—Denver mayor from 1945 to 1951—donated the park through two transactions, one in 1939 and the other in 1962. It originally served as the family ranch.

Newton Park has three distinct valleys featuring large shelters, potable water, electricity, restrooms, and recreation areas for private group retreats, with spectacular views to the south. Rolling hills separate the valleys, and the northernmost hill rises to a craggy, unnamed peak that is visible from US 285. Each valley hosts a named picnic site, beginning with Juvenile at the north, Commissioner to the east in the center, and Stromberg farthest southeast. The 1960s–1970s design of the shelters gives Newton Park a modern character unlike that of the other Denver Mountain Parks.

The sites are popular for family and company gatherings and for special events, especially on warm weekends in the spring, summer, and fall. Large grills, informal ball fields, volleyball courts, horseshoe pits, and fire pits offer all the basic amenities for these gatherings.

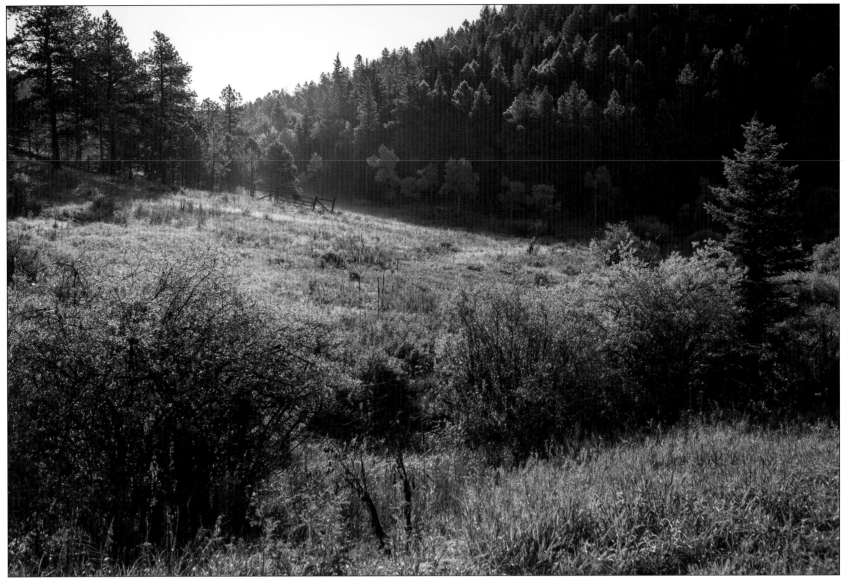

Newton Park

Turkey Creek Park

61 acres, Jefferson County

Acquired 1927

Location Approximately 24 miles west of Denver. Take I-70 west to Exit 260 and merge onto C-470 East toward Colorado Springs. Travel about 6 miles to US 285 South toward Fairplay. Travel approximately 6 miles and exit on North Turkey Creek Road. Turn left, then left again at the stop sign. The park will be on your left.

Turkey Creek Park, a quiet roadside park with a wonderful, highly accessible riparian setting, is probably the least known of all the developed Denver Mountain Parks. Strategically sited where North Turkey Creek meets South Turkey Creek, the park straddles North Turkey Creek Road.

An informal picnic area with parking, picnic tables, and a restroom sits adjacent to the riparian corridors under the canopy of mature cottonwood trees.

Mount Evans Parks

Only an hour from Denver, 14,264-foot Mount Evans is the city's closest Fourteener, or peak with an elevation higher than 14,000 feet. Named for John Evans, the second governor of Colorado Territory, and home to alpine wildflowers, mountain goats, marmots, birds, and Rocky Mountain bighorn sheep, the area affords spectacular views of distant mountain peaks, serene alpine lakes, and glacial valleys.

CO 5/Mount Evans Road is considered the highest paved road in North America. Depending on weather conditions, the road closes in September and usually reopens in late May. However, even when the road is closed to motorized vehicles, it is still possible to hike, bike, snowshoe, or cross-country ski along the road, depending on the season.

Visitors to Mount Evans should remember that the altitude is high and weather conditions can be extreme.

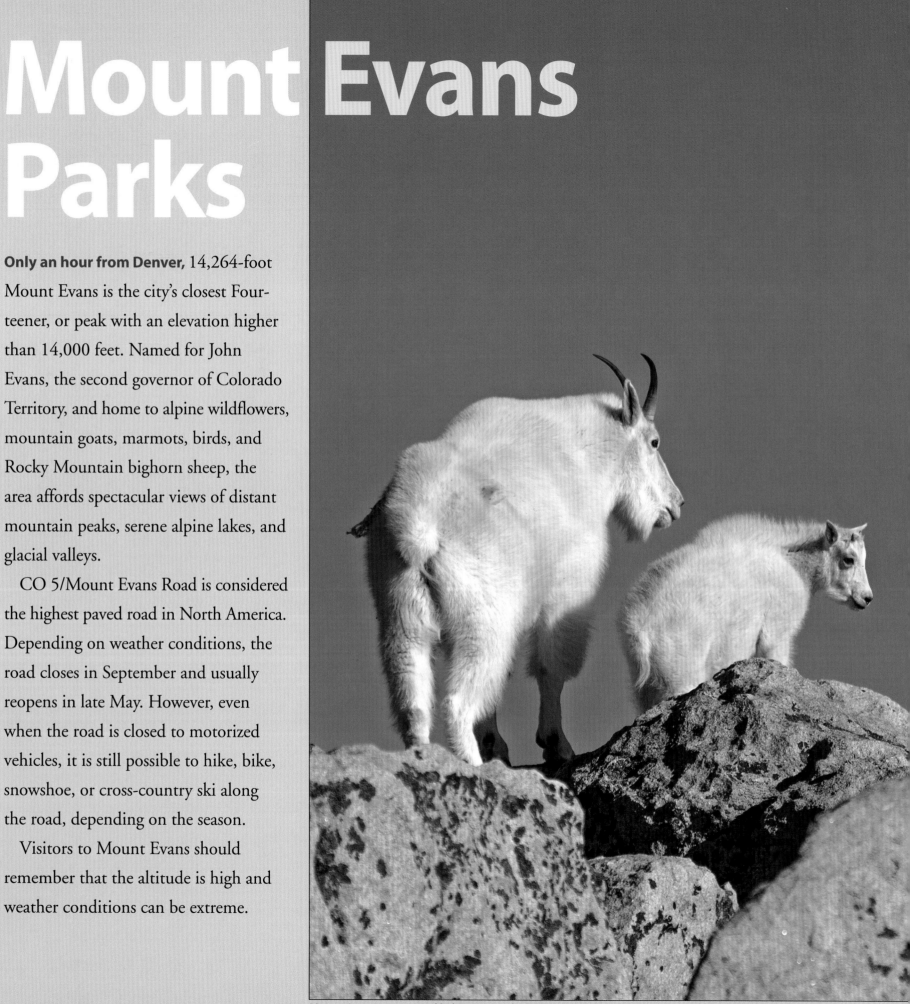

Mountain goat nanny and kid, Summit Lake Park

Summit Lake Park

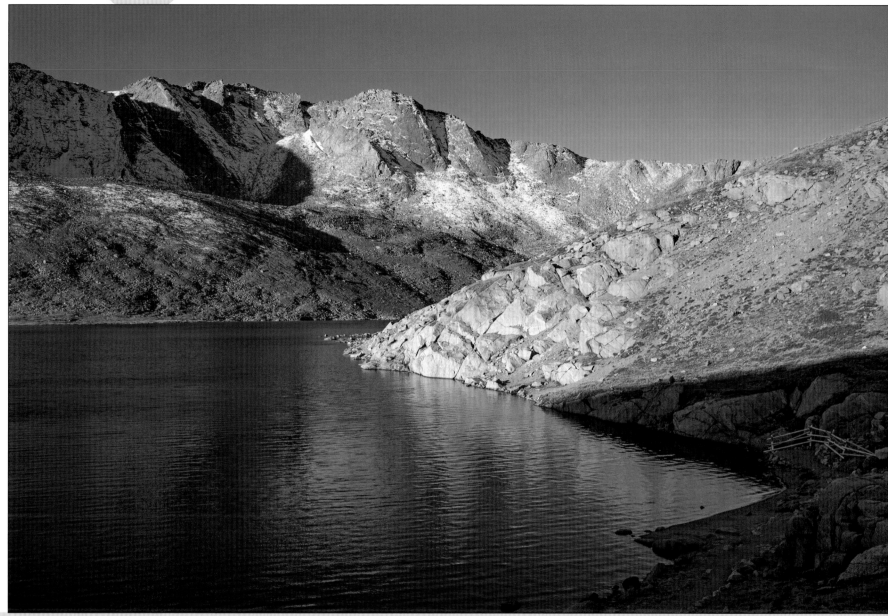

Summit Lake with Mountain Evans behind

162 acres, Clear Creek County

Acquired 1924

Highlights

· At 13,000 feet, the highest city park in the United States and the only Denver Mountain Park in the alpine zone

· Alpine lake and tundra wildflowers

· Best place to see mountain goats

· Headwaters of Bear Creek

· Nearby Dos Chappell Nature Center at Goliath Peak

Hiking Several trails begin at the Summit Lake parking area, including a 0.25-mile walk to the Chicago Lakes Overlook. The rugged wilderness of Mount Evans and the Chicago Lakes basin makes it a popular backcountry hiking destination. A hiking trail that follows the Chicago Lakes basin, located primarily in Arapaho National Forest, connects Summit Lake to Echo Lake. Off-trail use is prohibited at Summit Lake Park.

Location 62 miles west of Denver. Take I-70 to Idaho Springs, Exit 240 (CO 103Chicago Creek Road). Travel 14 miles to Echo Lake, then take CO 5/Mount Evans Road to Summit Lake (about 15 miles). On the return trip from Echo Lake, an alternative is to take CO 103/Squaw Pass Road to Bergen Park, creating a loop drive.

Contact For additional information about Mount Evans, visit the Clear Creek Ranger District Headquarters (Exit 240 at Idaho Springs), 303-567-2901.

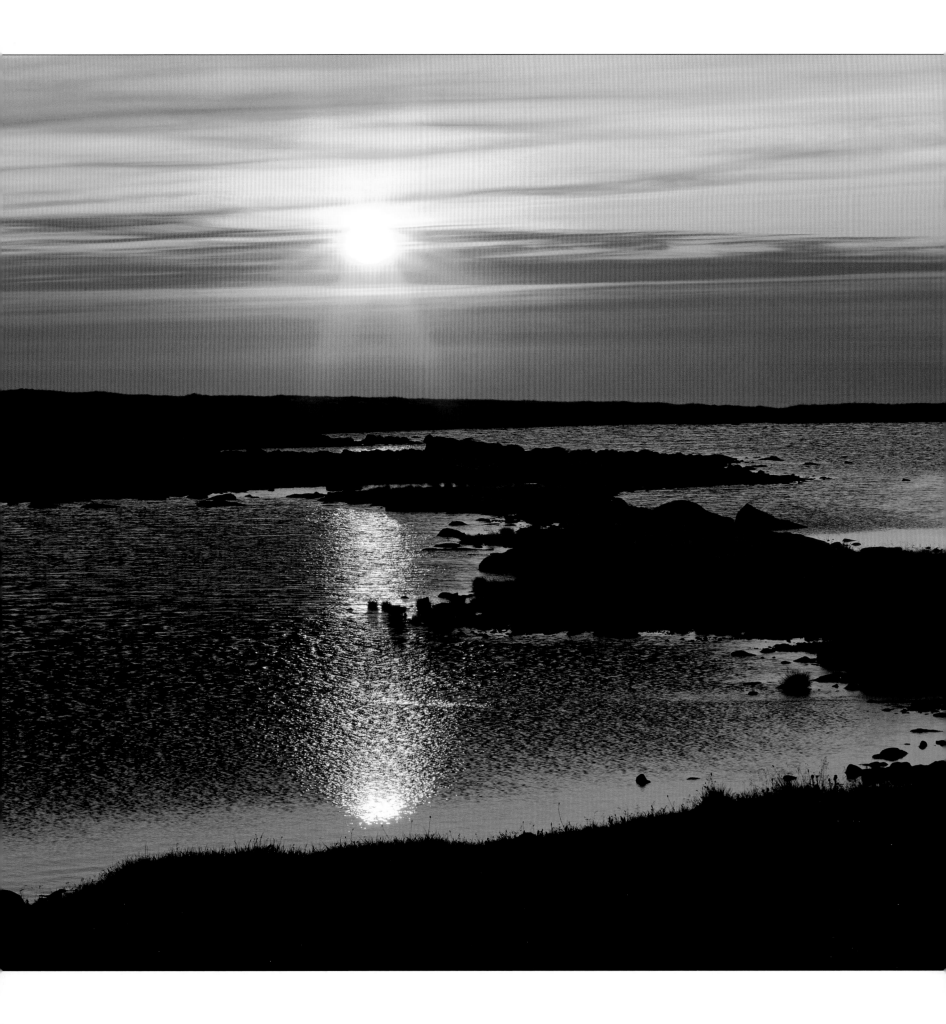

Situated above timberline at 13,000 feet, Summit Lake Park—the highest of the mountain parks—is one of the most scenic and special. In fact, *Westword* named it the "Best Denver Mountain Park" in 2013, citing its appeal to "youngsters and elders," photographers, and wildflower enthusiasts alike. (The paper also deemed the entire mountain park system the "Best Outdoorsy Gift from the Past.") Summit Lake nestles at the bottom of a high alpine cirque about 0.5 mile north of and 1,300 feet below the summit of Mount Evans, and is the only Denver Mountain Park in the alpine zone.

Summit Lake and its alpine wetlands rank as the park's most striking features. A small stone structure, built in 1926, sits in a gradually sloping alpine meadow on the lake's eastern edge, offering a welcome refuge from what can be wild, windy weather. Other than the stone shelter house, little protection from harsh weather exists at Summit Lake. Storms can arise quickly in the afternoon; please take cover in your car or the shelter if lightning threatens. It can snow at any time of year.

The extreme conditions and short growing season at this altitude make life a challenge for the many slow-growing tundra wildflowers that must complete their entire life cycles in just a few weeks. "Spring" arrives in early July and fall follows quickly by mid-August. This rare alpine vegetation—some plants only grow here and in the Arctic Circle—is fragile. To protect this valuable resource, visitors must stay on the trails and never pick wildflowers.

Common and noticeable wildlife species at the park include the yellow-bellied marmot, pika, and mountain goat, as well as bighorn sheep, weasel, and several species of vole. Common bird species include white-tailed ptarmigan, water pipit, and rosy finch.

Summit Lake Park is accessible only from late spring until early autumn along the Mount Evans Road that begins at Echo Lake Lodge. Arapaho National Forest lands entirely surround the park. Except for the Mount Evans Road corridor, these lands are designated as Mount Evans Wilderness.

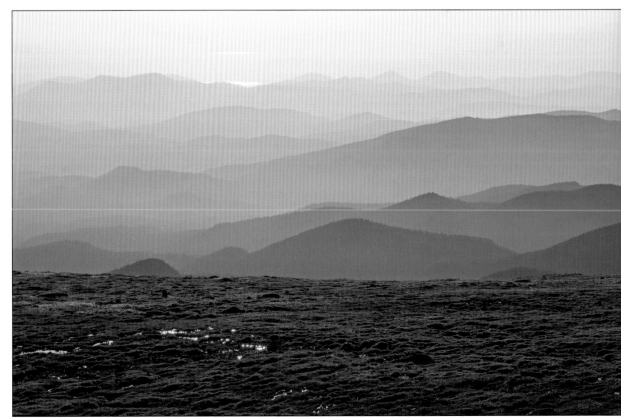

Summit Lake ponds and wetlands

Smoky sunrise from Summit Lake Park looking east to Marston and Cherry Creek lakes

14 Echo Lake Park

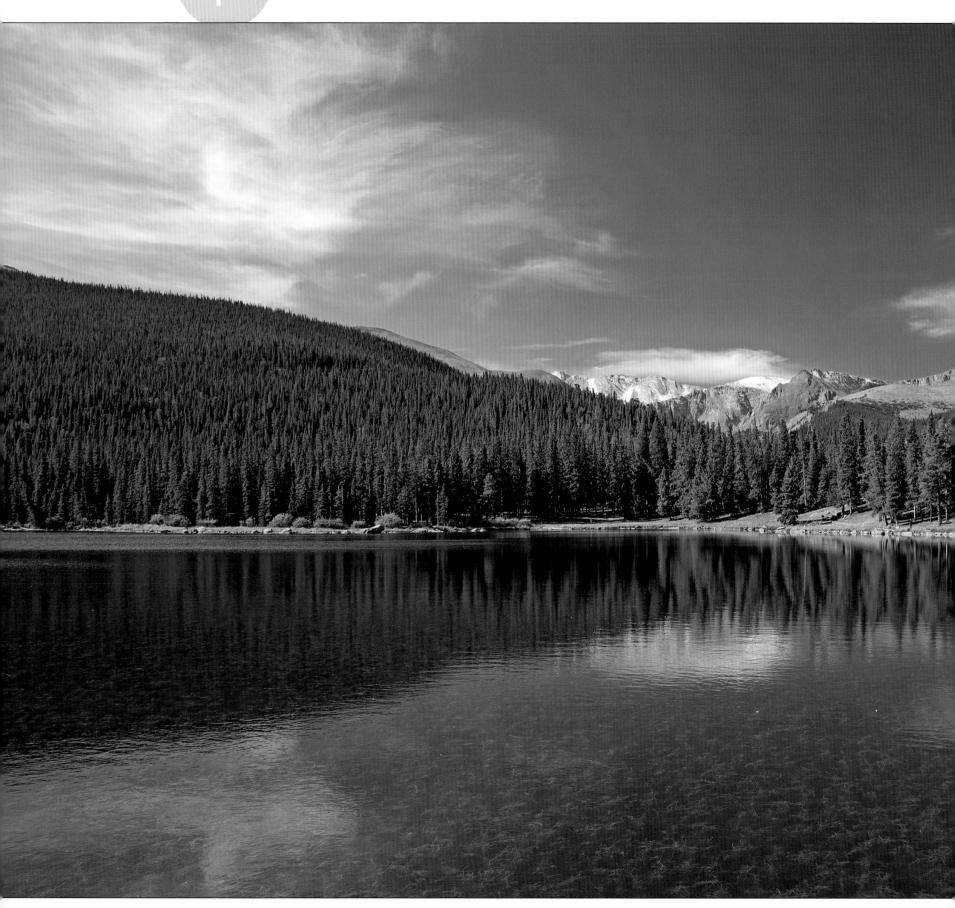

616 acres, Clear Creek County, acquired 1921

Echo Lake Park, reflection of Mount Evans

Highlights

- Majestic views of the lake, lodge, and Mount Evans
- At 10,600 feet, the only mountain park within the subalpine zone
- Echo Lake Lodge, open seasonally May–September
- Natural 24-acre lake formed by glacial lateral moraine
- Forests of subalpine fir, limber pine, bristlecone pine
- Portions of the wetland may be a 10,000-year-old fen

Hiking

A short (approximately 0.6 mile), accessible hiking trail loops around Echo Lake and connects to the lodge and its parking lot. Trails from the parking lot and back side of the lake lead to backcountry access into the Chicago Lakes area, with a route up Mount Evans. The lake trail is easy, but consider the high altitude and quickly changing weather conditions when planning your hike.

Biking Cyclists enjoy Mount Evans Road and come from all over the world to compete in the annual Mount Evans Hill Climb, a 27.4-mile bicycle race with a total of 6,915 vertical feet of climbing.

Location 47 miles west of Denver. Take I-70 to Idaho Springs, Exit 240 (CO 103/Chicago Creek Road). Travel 14 miles to Echo Lake. Alternatively, from Echo Lake, CO 103/Squaw Pass Road returns to Bergen Park, creating a loop drive.

Contact Echo Lake Lodge (open seasonally May–September), 303-567-2138. For the most current road information, visit www.coloradodot.info.

If you get up early, before the wind, it's possible to enjoy and photograph the spectacular view of mountain peaks reflected in the still waters of Echo Lake. And if you're lucky, you might glimpse Rocky Mountain bighorn sheep or hear a marmot whistling from the rocks.

This gem of a lake at 10,600 feet in the valley at the base of Goliath Peak offers excellent fishing. Surrounded by a thick spruce-fir forest, the lake was created in the Late Pleistocene period when glacial moraine deposits blocked the outlet of the depression in which the lake now lies. The wetland at the east end of the shallow lake may be 10,000 years old. It is considered an important habitat and a sensitive area.

The Municipal Lodge at Echo Lake, a log building completed in 1927, perches majestically on the lake's eastern shore overlooking a striking subalpine setting. Echo Lake Lodge was designed for visiting overnight guests, complete with sleeping rooms, a fireplace lounge, and dining room. Today, the lodge serves as a seasonal gift shop and restaurant where visitors can meet their needs for food, water, hiking supplies, and souvenirs.

The 1924 Echo Lake Shelter, a granite rubble stone structure, faces the lake and lodge. To the north of the shelter is the Echo Lake Concession Stand, of similar construction and also built in 1924.

15 Winter Park Resort

89 acres, Grand County

Acquired 1939

Highlights

- Year-round activities including skiing, snowboarding, tubing, ski biking, mountain biking, mini-golf, and alpine slides
- Ski area with more than 3,000 acres of skiable terrain, 25 lifts, 143 designated trails, and five terrain parks
- National Sports Center for the Disabled
- Slopeside village including lodging, restaurants, and shops

Biking Two lifts serve 28 miles of downhill/free ride trails. The Trestle Bike Park is the fastest-growing bike park in the United States.

Location 67 miles west of downtown Denver. Take I-70 west to Exit 232, then take US 40 west toward Empire/Granby approximately 25 miles to Winter Park Resort.

Contact Guest Services, 970-726-1564, www.winterparkresort.com

Fortunately for the Denver Mountain Parks, George Cranmer, who first envisioned a resort at Winter Park, dreamed big. The driving force behind Red Rocks Amphitheatre, Cranmer, who became Denver Improvements and Parks Manager in 1935, also imagined a mountain park that would become a winter sports center comparable to European resorts. He negotiated with the U.S. Forest Service for the use of 6,400 acres at the West Portal of the Moffat Tunnel, raised funds, and gathered volunteers to clear the slopes and build the first tow. Denver acquired 89 acres for the ski resort base and, in January 1940, 10,000 people attended the grand opening.

Winter Park Resort, set at the base of the Continental Divide in the Fraser Valley, consists of four adjacent areas—Winter Park, Mary Jane (including Parsenn Bowl), Vasquez Cirque, and Vasquez Ridge. The ski area, Colorado's oldest continually operated resort, offers 25 lifts, 143 designated trails, and more than 3,000 skiable acres—all only an hour-and-a-half from Denver.

Denver no longer manages the ski resort but partners with Intrawest Corporation, which leases and operates it, providing the city with more than $2 million annually. Recent developments at the base include new hotels, restaurants, shopping, and summer attractions such as mountain biking, alpine slides, mini-golf, and scenic chairlift rides. Winter Park Resort is also home to the U.S. National Sports Center for the Disabled, one of the largest therapeutic recreation agencies in the world, which provides winter and summer activities for more than 3,000 people each year.

Winter Park Resort

Daniels Park

16 Daniels Park

Daniels Park historic ranch barn

1,001 acres, Douglas County

Acquired 1920

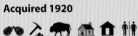
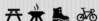

Highlights
- Hundred-mile panoramic view
- Bison preserve
- Stone shelter designed by architect J.J.B. Benedict
- Daniels Park Road, a historic Territorial Road
- Historic Florence Martin Ranch buildings, a designated Denver Landmark Historic District (closed to public)
- Tall Bull Memorial Grounds, an American Indian site (open to public for special events only)
- Kit Carson Memorial

Hiking Short paths link picnic sites near the shelter house on Daniels Park Road.

Biking Biking is permitted along Daniels Park Road.

Location 21 miles south of Denver and about 5 miles from Sedalia. Access the park via I-25 south to Castle Pines Parkway (Exit 188), then go west 2 miles to Daniels Park Road and turn right. Or, take Santa Fe Drive (US 85) to Sedalia, then go 2.5 miles east to Daniels Park Road, turn left, and continue 2.5 miles to the park.

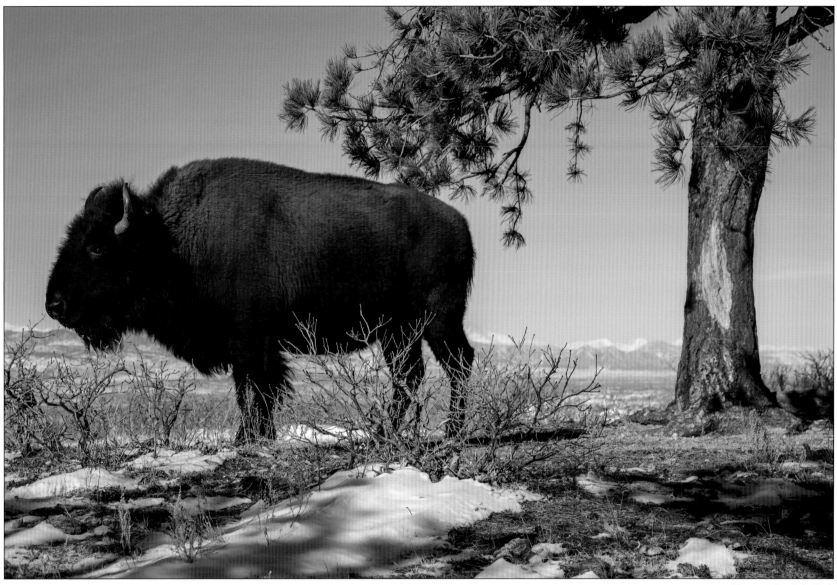

Bison at Daniels Park

OVERLEAF: Autumn Gambel oak and the view southwest to Devils Head and the Front Range

With its hundred-mile view extending from Pikes Peak to the Snowy Range in Wyoming and including downtown Denver and Denver International Airport, Daniels Park Road offers one of the most expansive vistas in Colorado. It's easy to understand why this reportedly served as a popular lookout for outlaws spotting stages to rob.

Daniels Park Road traverses the top of the park's high sandstone mesa along an elevation of approximately 6,500 feet and follows the original path of one of Colorado's first Territorial Roads, an 1850s wagon and stage road. Canyons, low mesas, and hills spread out below the mesa's rim. Today's visitors can enjoy this spectacular view from any of several picnic areas. Near the southern entrance, a stone shelter designed by J.J.B. Benedict and built in 1922 provides additional picnicking opportunities.

One of the largest of the Denver Mountain Parks, Daniels Park represents the system's only High Plains environment and is its sole park in Douglas County. Charles MacAllister Willcox and Florence Martin donated the first approximately 40 acres of Daniels Park in 1920. Martin donated the remaining acreage to Denver in 1937. The park is named for Major William Cook Daniels, a partner in the Daniels & Fisher department stores and a close friend of the Martin family.

Most of Daniels Park is an 800-acre bison preserve, where visitors can observe the animals in a natural habitat. Daniels Park also contains many historic sites, including the Florence Martin Ranch headquarters, designated as a Denver Landmark Historic District. The ranch currently accommodates park maintenance and is closed to the public. The Tall Bull Memorial Grounds in the park's north section are reserved for American Indians who use the site for ceremonies and activities. In the park's south section, the Kit Carson Memorial marks the site of Carson's last campfire in 1868.

We come to the park every Sunday to enjoy the views and check up on the animals. Everything there gives us a sense of peace and enjoyment we have not found anywhere else.

—Michael and Michaela Anne Palermo, residents of Daniels Park area, September 2012

Daniels Park represents an important landscape within a larger regional open-space system of 11,000 acres that protects the rimrock landscape stretching from Sedalia to C-470 in Highlands Ranch. The other open-space parcels are private and public lands that include the Sanctuary Golf Course, immediately adjacent to Daniels Park on the south; The Backcountry, a private open space to the west, managed by Highlands Ranch; and Cherokee Ranch, a 3,000-acre historic ranch protected by a conservation easement, south of the park's undeveloped land.

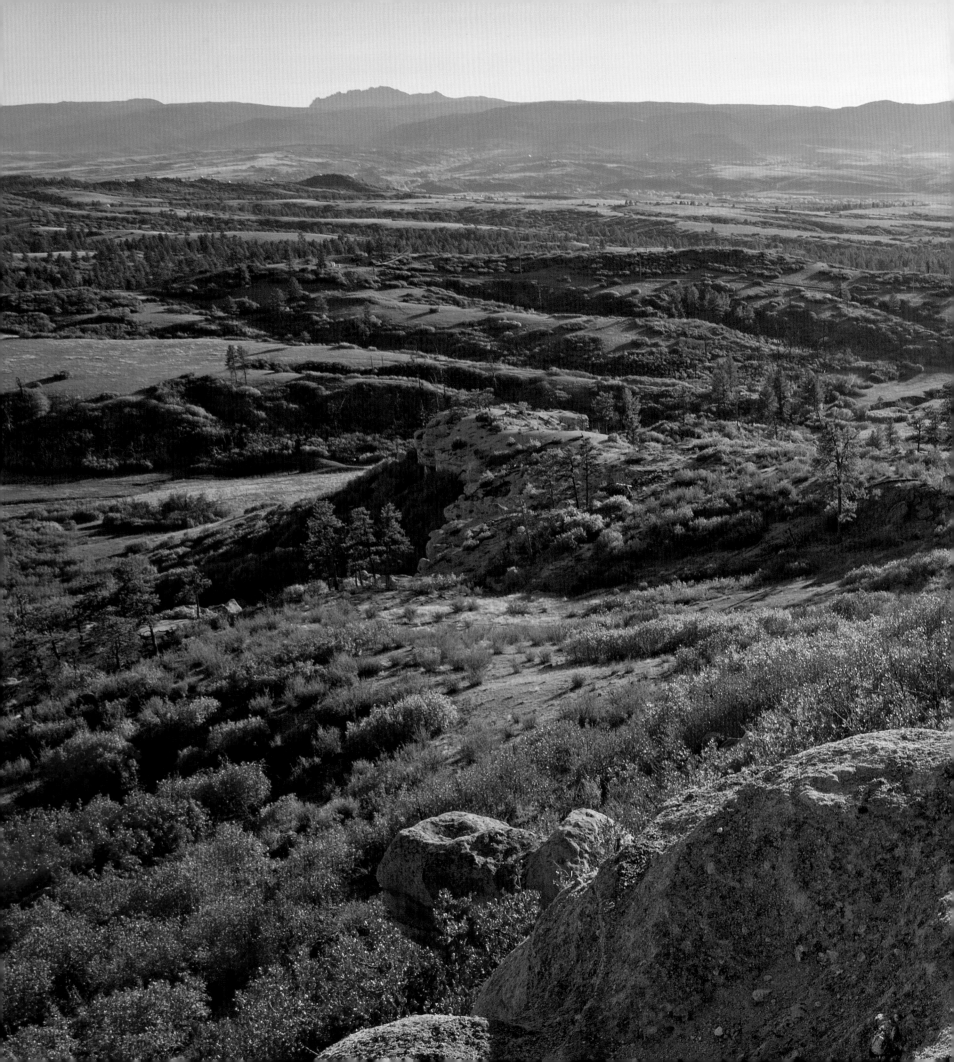

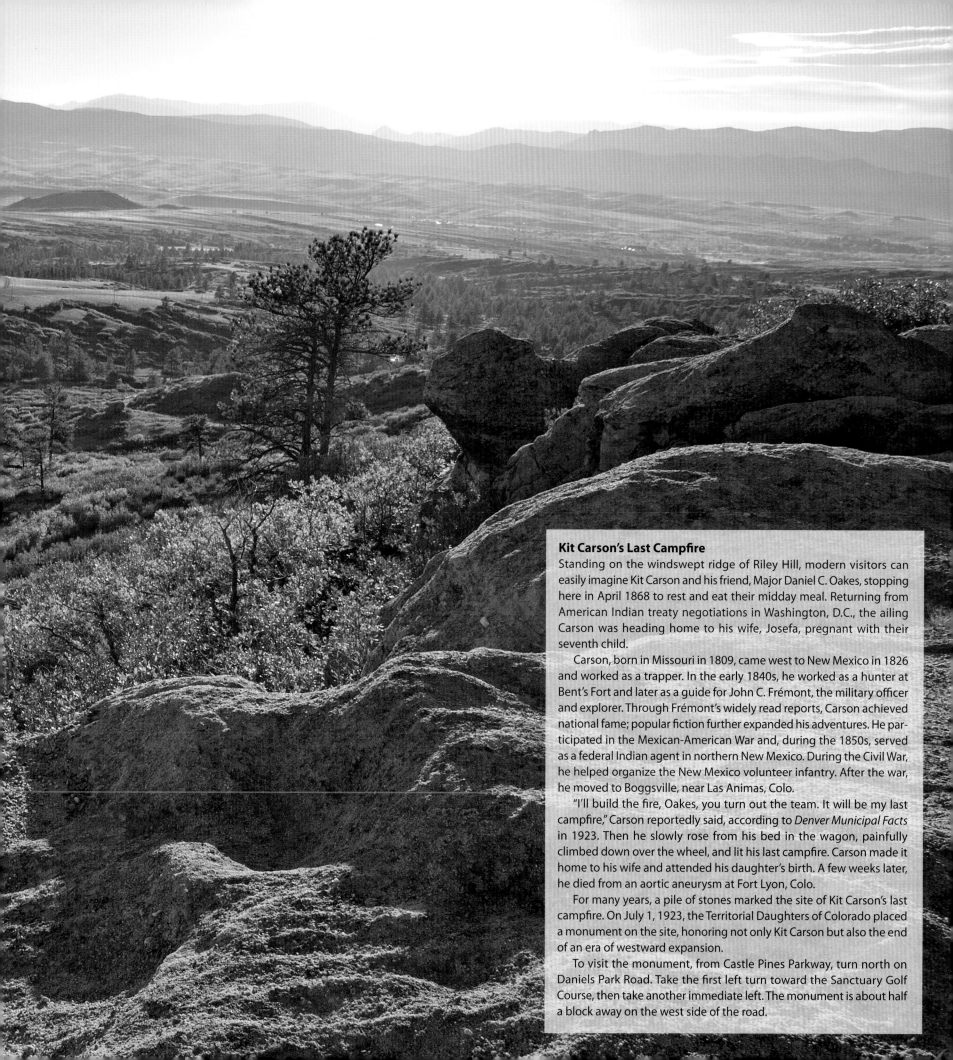

Kit Carson's Last Campfire

Standing on the windswept ridge of Riley Hill, modern visitors can easily imagine Kit Carson and his friend, Major Daniel C. Oakes, stopping here in April 1868 to rest and eat their midday meal. Returning from American Indian treaty negotiations in Washington, D.C., the ailing Carson was heading home to his wife, Josefa, pregnant with their seventh child.

Carson, born in Missouri in 1809, came west to New Mexico in 1826 and worked as a trapper. In the early 1840s, he worked as a hunter at Bent's Fort and later as a guide for John C. Frémont, the military officer and explorer. Through Frémont's widely read reports, Carson achieved national fame; popular fiction further expanded his adventures. He participated in the Mexican-American War and, during the 1850s, served as a federal Indian agent in northern New Mexico. During the Civil War, he helped organize the New Mexico volunteer infantry. After the war, he moved to Boggsville, near Las Animas, Colo.

"I'll build the fire, Oakes, you turn out the team. It will be my last campfire," Carson reportedly said, according to *Denver Municipal Facts* in 1923. Then he slowly rose from his bed in the wagon, painfully climbed down over the wheel, and lit his last campfire. Carson made it home to his wife and attended his daughter's birth. A few weeks later, he died from an aortic aneurysm at Fort Lyon, Colo.

For many years, a pile of stones marked the site of Kit Carson's last campfire. On July 1, 1923, the Territorial Daughters of Colorado placed a monument on the site, honoring not only Kit Carson but also the end of an era of westward expansion.

To visit the monument, from Castle Pines Parkway, turn north on Daniels Park Road. Take the first left turn toward the Sanctuary Golf Course, then take another immediate left. The monument is about half a block away on the west side of the road.

Conservation Areas

Bear Creek Canyon

Bergen Peak

Berrian Mountain

Birch Hill

Deer Creek

Double Header Mountain

Elephant Butte

Fenders

Flying J

Forsberg

Hicks Mountain

Hobbs Peak

Legault Mountain

Mount Falcon

Mount Judge

Mount Lindo

North Turkey Creek

Parmalee Gulch

Pence Mountain

Snyder Mountain

Stanley Park

Strain Gulch

West Jefferson School

Yegge Peak

Mule deer, Mount Judge conservation area

Imagine enjoying the everyday pleasures of the Denver Mountain Parks—the satisfaction of casting a line into a smooth mountain lake, the discovery of a rare wildflower in a sun-dappled forest clearing, or, on a winter morning, the sight of a bison, its breath white against the cobalt sky. Certainly, the park founders envisioned these experiences, only a small part of what Denver's 22 developed mountain parks have provided for the past one hundred years. But the mountain parks' founders also imagined—and amazingly recognized the importance of protecting—wild conservation areas, never to be used or developed.

When Frederick Law Olmsted Jr. designed and mapped the mountain parks, he didn't simply seek landscapes where people could camp, hike, picnic, and fish. To preserve their scenic quality, he also included mountain ridges, rocky outcrops, and peaks such as Snyder Mountain, Hicks Mountain, and Mount Judge. In fact, most peaks and ridges visible along the main routes west from Denver—including US 285, CO 73 and CO 74 through Evergreen, and I-70—that are *not* dotted with houses are Denver Mountain Parks.

Olmsted mapped steep slopes of evergreen forests that now offer critical habitat for elk, mule deer, black bears, mountain lions, wild turkeys, and mountain goats. He mapped narrow riparian corridors and important watersheds such as Bear, Clear, and Turkey creeks and their smaller tributaries, all of which eventually reach the South Platte River. Some of these conservation parcels may be small or seem disconnected from larger parcels, but they were carefully selected and acquired to safeguard specific natural areas.

To assure these conservation areas' permanent protection, many deed restrictions prohibiting the sale of the land were included in the parklands' transfer from government and private property to city ownership; these agreements continue to be enforced in the present day.

These wild conservation areas will become increasingly important as the metropolitan region's population continues to grow and open space disappears. By providing clean air, protecting watersheds, and maintaining healthy forests and wildlife populations, they will help ensure sustainable communities. The 22 developed mountain parks are important, but the 24 conservation areas are as important, if not more so—for it is these wild places, even viewed from afar, that speak to us of the freedom and spirit of the West.

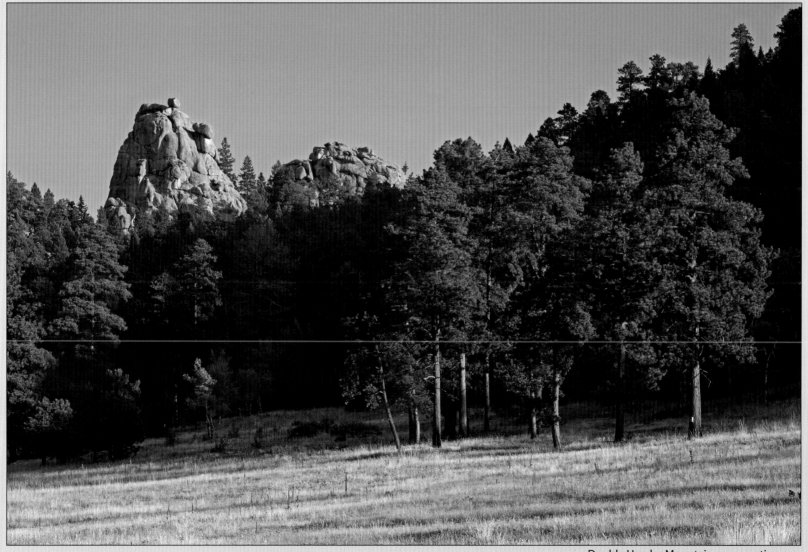

Double Header Mountain conservation area

OVERLEAF: Jefferson County Open Space's Elk Meadow with Bergen Peak conservation area in the background

Jefferson County Open Space's Elk Meadow in winter with Bergen Peak conservation area in the background

Sunrise in Snyder Mountain conservation area
OVERLEAF: Bull elk at Meyer Ranch with Berrian Mountain conservation area in the background

The Future of the Mountain Parks

One hundred years ago, the builders of Denver's mountain parks had a magnificent dream and they worked tirelessly to see that vision through. Their dedication led to the protection of more than 14,000 acres of scenic wild country in and around Denver's foothills. The expansive meadows of the mountain parks remain the place "where the buffalo roam," something essential to the heart of any westerner or would-be westerner. Rocky hillsides and thick pine forests frame spectacular views of distant snowcapped peaks. Nearby canyons beckon, offering the promise of cool mountain streams and refuge from the city.

Denver's dream of mountain parks has been realized—but their story is far from over. As we celebrate their centennial, it is vital to plan for their next one hundred years.

What will the Denver Mountain Parks need to survive— and thrive—in the coming century?

To address this complex question, Denver Mayor John Hickenlooper commissioned a master plan in 2006 to evaluate the management, funding, and future of the mountain parks. An advisory group of civic leaders, stakeholders, and park users began an 18-month research and planning process, supported by funding from a Great Outdoors Colorado Planning Grant, the Denver Mountain Parks Foundation, city capital fund, and Denver Parks & Recreation.

The Denver Mountain Parks Master Plan, published in 2008 and available in its entirety at www.denvermountainparks.org, resoundingly affirmed the parks' value. Surveys showed that more than 2 million people visit the mountain parks annually, including 68 percent of Denver residents. Surveys also showed that 78 percent of Denver residents considered the Denver Mountain Parks important to their quality of life, even more so than some of the other segments of the park and recreation system. These findings echoed the results of the 2003 Denver Parks & Recreation Master Plan, known as the "Game Plan."

The many benefits the parks provide include enhancing our quality of life, protecting natural resources, and boosting civic pride. Research also confirmed their longstanding economic value, particularly in terms of tourism, business-location decisions, and direct revenues to Denver. For example, Winter Park contributes more than $2 million a year to the city.

The comprehensive 2008 plan detailed recommendations for the mountain park system as a whole, as well as for individual parks. Some key recommendations included renewed commitment to the parks, increased funding, marketing, and leadership.

RENEWED COMMITMENT

An important goal of the master plan was to review all options for ownership and management of the mountain parks. The research confirmed that charter and deed restrictions would make selling the parks extremely difficult, if not impossible. Additionally, research found that Denver voters would be unlikely to approve a sale of the mountain parks and consider such a sale shortsighted. The master plan concluded that Denver should retain ownership and management of the mountain parks, and renew its commitment to them: "Denver was the visionary leader in acquiring public open space and maintains that responsibility to its citizens, as well as to the region, today."

Erika D. Walker

INCREASED FUNDING

One of the most pressing needs for the mountain parks is additional funding. When Denver citizens embraced the idea of mountain parks in 1912, they established a property tax to pay for them. For years, these funds were used to acquire land, build facilities and roads, and maintain the system. However, starting in 1955, Denver no longer imposed the tax. With their source of dedicated funding gone, the mountain parks have had to compete with the many other maintenance districts in the parks department for limited dollars.

According to the 2008 Master Plan, Denver's mountain parks funding is one-third of what other counties and cities spend per acre on their open space and mountain parks. In addition, Denver Mountain Parks receive only 1 percent of the Parks & Recreation operating budget and 3 percent of its capital budget—even though they comprise more than 70 percent of the Denver Parks System total acreage.

The master plan calls for Denver to increase investment in the mountain parks in order to bring them up to a quality comparable with other open-space parks in the region. Despite outstanding staff efforts, park facilities have been minimally maintained and improvements deferred. Insufficient funds have prevented implementation of many of the needed improvements detailed in the master plan. Most urgent is the need to restore, repair, and protect deteriorating park facilities and underlying natural resources. The plan proposes cost-effective basic improvements such as ADA access, new maps, additional rangers, and new hiking trails.

To address the funding shortfall, the master plan recommends short- and long-term funding and partnership strategies including: dedicating a larger share of Denver capital and operating funds to the mountain parks; building capacity and partnerships with neighboring cities, counties, and other organizations such as the Denver Mountain Parks Foundation; and pursuing new opportunities that take advantage of existing revenue producers within the mountain parks system, including Winter Park and Red Rocks Amphitheatre.

IMPROVED MARKETING AND COMMUNICATION

An informed and engaged public is vital for the future of the mountain parks. Yet, even though many mountain parks suffer from overuse, research for the 2008 Master Plan revealed that 60 percent of people using the mountain parks didn't realize they were in a Denver park. Because of the number and variety of mountain parks, some users might be familiar with one or two favorites but remain unaware of the scope of the entire system. Before users can advocate for the mountain parks, they must be aware of them.

Compounding this problem, the mountain parks have no direct representation in city government through Denver City Council because they lie outside city limits. Without public advocacy, the mountain parks can be left behind when competing for scarce resources. Improved marketing and communication is vital to educate users about the mountain parks. The recently developed mountain parks logo and professional brochure are important first steps in addressing this problem.

Sunset over Daniels Park

VISIONARY LEADERSHIP

As they begin their second century, Denver's mountain parks will need more dreamers like J.B. Walker, Warwick Downing, Kingsley Pence, and Frederick Law Olmsted Jr. The parks' future success depends on continuing their legacy of visionary leadership, coupled with citizen involvement and advocacy.

Ongoing problems, such as overuse resulting in litter and trampled vegetation, neighbors encroaching on conservation areas by building private trails, and control of noxious weeds and pine beetles, will require new and creative solutions. Important questions of adequate funding, best management, and land use will persist. What is the best way to address pressures for active recreation and increasing public use without sacrificing the quality of park experiences or the natural environment? How can the mountain parks best honor their history and legacy, unique among other regional open spaces?

In 1913, J.B. Walker wrote: "Denver has not yet begun to comprehend what she possesses in the Park of the Red Rocks." It's still true of Red Rocks—and of all the mountain parks. We will continue to discover their best use and full potential. With wise stewardship, the mountain parks will remain our treasure—to enjoy, cherish, and protect forever.

Advocate for Mountain Parks

The Denver Mountain Parks need your help. Get involved today to ensure their legacy continues for another one hundred years.

- **Enjoy the mountain parks:** You may have a favorite mountain park and not even realize it. Find out when you're using and enjoying a Denver Mountain Park or another public open space. Many popular parks—such as Red Rocks, Evergreen Lake (in Dedisse Park), Lookout Mountain Park (Buffalo Bill's Grave), Summit Lake, and Winter Park—are part of the Denver Mountain Park system.

- **Contact City Hall:** The mountain parks have thrived when City Hall has made their welfare a priority. Especially if you live in Denver, contact the mayor and your city council representative. Tell them why the mountain parks matter to you and how important they are for future generations.

- **Donate your time:** Become a volunteer. Check www.denvermountainparks.org to learn about opportunities.

- **Provide financial support:** Please visit the Denver Mountain Parks Foundation at www.mountainparksfoundation.org to contribute.

- **Spread the word:** Tell your friends that you believe in the mountain parks and why we should all care about them. Show your support of Denver Mountain Parks and Parks & Recreation and share your park experiences through social media.

Afterword

Why is Denver in the mountain parks business, anyway?

—**Richard L. Deane,** former chairman, Denver Planning Board, June 2004

In 2004, I only knew Chief Hosa as an exit sign on I-70. As a fourth-generation native, I am embarrassed to admit I knew next to nothing about Denver's mountain park system, its size, scope, history, or its importance. When I toured them, I could see signs of deterioration and abuse, and wondered if anything was being done or if anything could be done. Therefore, I sought out people with ties to the Denver Mountain Parks. Among those I queried was Dick Deane, chairman of the city's planning board in the 1980s and a much smarter guy than I am.

I knew him to be knowledgeable and honest. I told him it looked like this historic system of properties could really use some advocacy. I asked him about forming a foundation to do that. He stopped me cold: "Bart, why is Denver in the mountain parks business, anyway?"

He asked if the City of Denver might have better things to do than to direct time, energy, and financial resources to places outside its boundaries when we have real issues to contend with at 5,280 feet. I fumbled for a simple answer. But the answer is not simple, and it depends on when you ask it. Things change, and the reason we do things changes with the times. Change is, after all, the essential element of history. Without change, Professor Noel's history classes would be substantially shorter.

At long last, here is my response, Mr. Deane.

At the turn of the 20th century, Denver's economy was foremost on the minds of civic leaders, and promoting this new town and attracting business was as important as making life here livable. Only slightly more than 40 years in existence, Denver stood at a continuing, precarious crossroads of economic failure and success. Two particular things—having the Union Pacific pass Colorado by and the 1893 repeal of the Sherman Silver Purchase Act—could well have proven fatal to this fledgling community. Nevertheless, the spirit of civic leaders of the time was irrepressible.

Concurrently, in response to American urbanization and the Industrial Revolution, a back-to-nature movement brought a new appreciation and desire for health, the outdoors, fresh air, and nature. This ethic, manifest in the City Beautiful Movement, the work of Frederick Law Olmsted and son Frederick Law Olmsted Jr., and showcased in the 1893 Colombian Exposition in Chicago, became the stuff of inspiration for Denver's forefathers. But what did Denver offer?

Denver is a pretty city, I grant you, but people who come here from the Atlantic seaboard and from the prairies of the Middle West do not come to look at handsome buildings and well-kept streets.

—**John Brisben Walker,** *The Denver Post,* 1910

The concept of a system of mountain parks right at Denver's doorstep intrigued the city's early leaders. The land was close and cheap and the air was cool. The economic benefit to Denver was compelling; such a system would entice tourists into the area. A plan along with financing through a modest mill levy to build roads and create parks could easily win at the polls. For businesspeople, a mountain parks system meant money.

But if people could not easily get there, why would voters vote to spend money on a mountain parks system? Neither citizens nor visitors to Denver could easily access the lands to the west. Roads were few and not well suited for recreational travel. In general, a trip to higher elevations was not just a quick matter for the ordinary family, as it is today. Moreover, remote Jefferson County offered few facilities, an important consideration for mother, father, and the children, and for the horses that had to take them there. Here was the dilemma—and the competition:

They come here to see the marvelous mountain scenery they have heard and read so much about. And when they get here they find so many difficulties in the way of reaching this scenery that they quickly become discouraged and rush off to Colorado Springs or somewhere else, where the people have improved the splendid gifts nature has placed within their reach. —**John Brisben Walker,** *The Denver Post,* 1910

Enter the Model T. The advent of affordable transportation into everyday life pulled the voting levers for the Denver Mountain Parks. With the automobile, new roads and improvements to existing ones opened everything up. Providing shelters, pump-houses for water, and places to drink in heretofore-unseen views—all in a day trip from town—made for an exciting experience. With dedicated funding, the volunteer Mountain Parks Advisory Commission worked with city administrations to direct the building and operation of the system.

Immediately popular, the system inspired immense civic pride. As time progressed, this funding and visionary leadership on the part of Mayor Benjamin Stapleton and Improvements Manager George Cranmer made it possible to add features we should not take for granted: Red Rocks Amphitheatre and Winter Park.

In those days, the answer to your question, Mr. Deane, would have been: Because they increased business and revenues for the city.

After World War II, things changed in Denver. When new administrations decided that the mountain parks should fall under the aegis of the city's Parks & Recreation Department, and derive funding therefrom, the mountain parks became a division of the larger Parks Department: Unequal among Equals.

Additionally, after wartime rationing of gasoline and rubber, people yearned for the open road. Cars became bigger, faster, more powerful, and more comfortable. With the Interstate Highway System, the range of day trips from Denver increased dramatically. People blithely passed by the heretofore-popular mountain parks in

W. Bart Berger among lichen-covered rocks, Red Rocks Park

favor of the Continental Divide and newly developed places such as Vail or Aspen. Frankly, as demographics changed, so too the city's commitment to the mountain parks. Affluent advocates were gone; less vocal park users were not. Shameful.

Thus began a spiral of decline for the Denver Mountain Parks.

The most severe cut in the Mountain Parks budget came in 1982, when it was slashed from $700,000 to $350,000. … The budget dropped slightly from then to 1986. In that year, even the small contribution of inmates from the Denver County jail picking up litter in the mountain parks was withdrawn for lack of money.

—Barbara and Gene Sternberg,
Evergreen, Our Mountain Community

In 1988, a cooperative project called the Metro Mountain Recreation and Open Space Project launched. Its cogent analysis that "the area is not presently living up to its potential for providing outdoor recreation opportunities" recognized that "without a significant effort the area will not meet the needs and demands of the metropolitan community." Despite its recommendations, including the establishment of a "Metro Mountain Recreation and Open Space Council," little came of it for lack of adequate funding levels to enable the necessary coordinated management and resource planning. Considering urban park costs, Denver Mountain Parks had been relegated to the back of the line. Denver Parks & Recreation's Game Plan showed that the mountain parks comprised 71.8% of Denver's park acreage, yet were supported with 1.4% of the department's budget. Of the 1,400 Denver Parks & Recreation staff, eight worked in mountain parks.

The effect of such marginalization was dramatic, sad, and pervasive. Despite yeoman efforts on the part of the staff, facilities began to deteriorate, despoiled by the thoughtless and the malicious.

The system's degradation formed the subject of the 2001 District-Wide Historical and Cultural Facilities Assessment by Andrews and Anderson. Just to repair and restore the historically and architecturally significant facilities, estimated costs topped $3,125,000.

Many times, well-meaning but underinformed city council members would ask if we should sell off the lands for development. Fortunately, deed restrictions and the City Charter prevented such shortsighted action. Moreover, Councilman Dennis Gallagher considered any idea of selling an outrage.

Denverites were able to hang onto the mountain parks during the Great Depression, and selling them now would be a betrayal. It would be like selling Sloan's Lake to Edgewater and Washington Park to Glendale.

—Dennis Gallagher, "Mountain Perks" by Stuart Steers, *Westword*, August 2002

To be fair, they were not the tourist draw they had been. Perhaps their purpose (and the answer to Mr. Deane's question) had changed.

Meanwhile, the Olmsted dream of more than 41,000 acres of parkland only lay dormant. Denver had acquired around a quarter of that. When Jefferson County citizens realized that unchecked sprawl endangered their cherished lifestyle, voters approved a 0.5-percent sales tax and the creation of Jefferson County Open Space (JCOS). Simply put, acquiring and preserving these lands would protect property values as well as quality of life.

Similarly, Clear Creek and Douglas counties initiated open-space programs, with dedicated funding. Front Range counties of Boulder and Larimer instituted sales taxes and mill levies as dedicated funding sources. Denver's mountain parks became the unfunded exception, and the city's $54 per acre investment compared poorly with the neighbors' $100 to $200 per acre annual commitments.

To its credit, Denver has slowly come to see its system of mountain parks in a larger context and has reached out to Jeffco about working together. In 2002, with a grant from the state Department of Local Affairs, Jefferson County and Denver commissioned landscape architects Mundus Bishop Design to draft the Recreation Management Plan to evaluate usage and impacts on their park/open-space systems and to develop "a strategic plan that describes methods for the two agencies to work together to preserve resources and to enhance recreational experiences."

Also important, Denver Mountain Parks provide a means for ongoing intergovernmental dialogue with all our neighbors, serving as a unique and valuable tool for the kinds of cooperation and collaboration demanded in an ever-more-populous region. These parks and open spaces now function as a regional resource with common challenges and opportunities. As part of "Counties in Partnership," Denver eventually forged cooperative relations not only with Jefferson County, but also with Douglas County in the revamping of Daniels Park Road and a Daniels Park Master Plan. With Jefferson County and JCOS as partners, a new Genesee Mountain Park Master Plan integrating trails and bike paths is nearing completion as of this publication. Approached collaboratively, fire mitigation, forest and noxious weed management programs, habitat preservation, and even

ranger patrols have become management considerations that the Mountain Parks Advisory Commission might not have contemplated.

It's easy to see how these lands interrelate when one views the panorama west from Evergreen Lake—thousands of acres of protected landscape—or witnesses the synergy of Bergen Peak (Denver Mountain Parks) and Elk Meadow (JCOS) between Evergreen and Bergen Park and up Squaw Pass Road.

In recent years, Denver has begun to look again at how mountain parks serve its own citizens beyond the city. Parks and natural open areas fill a need for outdoor education and recreation. Increasingly, we are coming to understand the value of introducing children to all these places and how they can help in combatting childhood obesity, ADHD, hypertension, and diabetes. Recreational and educational programming for youth organizations create new opportunities for many to get outdoors, to experience unstructured nature.

The parks have developed expanded purposes. Planned are new trail systems and interpretive signage in Genesee and new uses for many underutilized facilities. Also contemplated are expanded intramural cultural relationships with the Denver Zoo and Denver Botanic Gardens, in much the same way that Denver Parks & Recreation works with Denver Public Schools (DPS) at the Balarat Outdoor Education Center.

A lot has changed—and is changing—in the mountain parks. Efforts on behalf of concerned citizens resulted in the 2004 creation of the Denver Mountain Parks Foundation (DMPF), and through its efforts, the city obtained a Great Outdoors Colorado grant to conduct and compile the Denver Mountain Parks Master Plan, completed in 2008 after a lengthy stakeholder-involved process. Out of that effort came a mountain parks logo, designed by artist Michael Schwab, which created a distinct public identity for the 95-year-old system for the first time; so too came updated maps and brochures introducing the system and its features. In 2012–2013, DMPF initiated and provided most of the funding for this book, the first comprehensive overview in the system's one hundred years.

Denver Mountain Parks might have started life as an economic driver for the city, but we see today that they do that and much more. The metropolitan area's expansion to well over 2 million people, and the division of that area into a multitude of independent political entities driven by varying social and economic pressures, brought changes that Olmsted could not have foreseen. However, these changes merely underline the significance of his work and add more subtle and important purposes that the mountain parks can serve.

The future of these People's Parks lies in the vision captured within the details of the 2008 Master Plan, as current management reflects.

We must remain committed to the vision of a Mountain Park system that meets the needs of our Denver citizenry; but at the same time we must acknowledge that our mountain parks are now part of a larger fabric of protected lands and open space.

—Bob Finch, Denver Director of Natural Resources

The mission of the Denver Mountain Parks Foundation is to restore the historical integrity, relevance, quality and appreciation for Denver's Mountain Parks system; to advocate for it and ensure its future as a recreational, educational and open space resource for the City of Denver: its citizens, neighbors and visitors. … This is an opportune time to apply Denver's tradition of leadership by continuing the legacy we have been given.

—W. Bart Berger,
Denver Mountain Parks Foundation, 2004

Sunrise in Elephant Butte conservation area

But, do our civic leaders now—or will they continue to—honor the vision? Will we make sure of it? Will future bond issues pass the impecunious mountain parks by, as they all have in the past? Will a dedicated funding source ever again exist? The answers will largely depend on the leadership we demand of our mayors and city councils and the commitment we inspire.

… [O]utside of the one day of mountain recreation that DPS's 4,400 fifth-graders receive each year, more than 90 percent of Denver kids still never get to the mountains during their entire youth. … We have hundreds of thousands of kids who live at the doorstep of what is arguably the most extraordinary mountain recreation resource in the world; and yet most of our kids never get there. … [I]sn't this embarrassing for a city that is literally defined by its mountains?

—Roberto Moreno, Founder of Alpino Mountain Sports Foundation,
Denver, August 2007

The names, places, events, and people connected to the mountain parks constitute a distinguished legacy for Denver. For a century, these places have been well loved, if not loved well, by Denver taxpayers, locals and neophytes; by mayors and city councils; by citizens and visitors to the Mile High City.

We have a brilliant opportunity to continue this new awareness of the natural gifts our predecessors preserved for us. We will no longer warehouse them, but fulfill our additional responsibility to utilize them, not only for the financial benefits we might receive, but also for the lessons they teach us about stewardship—about our relationships to the land and to each other.

This is what I have learned from the Denver Mountain Parks, and my journey to answer your important question, Mr. Deane. Denver doesn't stand still. We are constantly taking an exciting past and creating an exciting future. That's what we do in Denver. We "Imagine a Great City," as Mayor Federico Peña trumpeted in the 1980s, and then—we build it. This legacy is one part of that. That's why Denver is in the mountain parks business.

Most important, I learned that these places do not thrive without citizen involvement. Without that, elected officials will prioritize urban concerns. Too long have the Denver Mountain Parks been in sight and out of mind. We can no longer be spectators. If our book has brought you some pleasure, if it has brought you some new awareness—if it inspires you—get involved.

—W. Bart Berger, Denver Mountain Parks Foundation, Denver, Colo.
www.mountainparksfoundation.org

To my family.
We walk the mountain trails together.
—wra

To the Denver Mountain Parks superintendents and their staffs,
who have worked over the years to maintain and protect
the mountain parks on behalf of all who enjoy them.
—slw

To my son Stephen and those of his generation,
that they may love and protect the mountain parks.
—edw

Acknowledgments Denver Mountain Parks Foundation owes a debt of gratitude to our founding Board of Directors—a number of individuals whose commitment to Denver, to history, and to the outdoors has been instrumental in bringing this effort to fruition—and most especially the late Chips Barry, Doug Hall, and Fabby Hillyard. Thanks also to Wick Downing for his grandfather's portrait and to Derik Wangaard (Sanborn Publishing Co.) for the use of the Sanborn postcards. *Sine qua non* are Councilwoman Peggy Lehmann, Tina Bishop, Susan Baird, and Gordon Rippey. Special thanks to John Fielder, editor Jenna Browning, and designer Rebecca Finkel for your commitment, talent, and professionalism. You've made the book sing.

The authors wish to express our warmest thanks to all of those who made the research and writing of this book possible. Thank you to current and former Denver Mountain Parks personnel, whose dedication to the parks is truly unsurpassed, including former superintendent A.J. Tripp-Addison, planner Susan Baird, superintendent Dick Gannon, and buffalo wrangler Marty Homola. We are particularly indebted to A.J., Susan, and Carolyn and Don Etter for their thoughtful manuscript reviews. Steve Friesen has generously shared Buffalo Bill Museum collections and his historical insights. The research librarians in the Western History Department of the Denver Public Library were tremendously helpful as we worked in the collections there; special thanks to Coi Gehrig for her expeditious help with the historic photographs. We are indebted also to Wick Downing, the National Association of Olmsted Parks, and History Colorado for selected photographs. Special thanks go to Bart Berger, who championed this project and continues to champion the mountain parks. We would also like to thank our families and friends for their support and good cheer during this journey to the past: Wendy is grateful to Jonathan, Ethan, and Madeline; Erika extends her appreciation to Don, Stephen, Terri, and Beth; and Sally thanks Hadi.

www.denvermountainparks.org

ISBN: 978-0-9860004-6-1

TEXT: © 2013 Denver Mountain Parks Foundation. All rights reserved.

PHOTOGRAPHY: © 2013 John Fielder/Denver Mountain Parks Foundation. Other photos copyright to source indicated. All rights reserved.

EDITOR: Jenna Samelson Browning
DESIGNER: Rebecca Finkel, F + P Graphic Design
PROOFREADER: Caroline Schomp

PUBLISHED BY:
John Fielder Publishing, P.O. Box 26890, Silverthorne, CO 80497-6890, www.johnfielder.com

Printed in China by C & C Offset Printing Co., Ltd.

No portion of this book, either text or photography, may be reproduced in any form, including electronically, without the express written permission of the publisher.

CURRENT PRINTING (last digit) 10 9 8 7 6 5 4 3 2 1

Library of Congress Control Number: 2013903089

ABOUT THE AUTHORS

Wendy Rex-Atzet, Ph.D., is a cultural historian who studies wilderness, parks, preservation, and outdoor recreation in the American West. She earned her doctorate from the University of Colorado, Boulder, where she completed her dissertation on the rise of the Denver Mountain Parks.

Sally L. White, MS, is a writer and historical researcher who works for Denver Mountain Parks. Her career in natural history diverged into cultural history in 1996. She is a member of the Jefferson County Historical Commission and is a longtime open-space advocate.

Erika D. Walker, MS, is a native Coloradan with a passion for preserving open space. She works as a writer and educator, and serves on the board of Bluff Lake Nature Center. She is the great-granddaughter of early Denver Mountain Parks advocate John Brisben Walker.

W. Bart Berger, founder and chair of the Denver Mountain Parks Foundation, is a fourth-generation Denverite and Coloradan. An avid historian and open-space advocate, he has served on the Denver Landmark Preservation Commission, and 15 years on the board of History Colorado (formerly the Colorado Historical Society), for which he has served five terms as chairman.

ABOUT THE PHOTOGRAPHER

John Fielder has worked tirelessly to promote the protection of Colorado's ranches, open spaces, and wildlands during his 30-year career as a nature photographer. His photography has influenced people and legislation, earning him recognitions including the Sierra Club's Ansel Adams Award in 1993 and, in 2011, the Aldo Leopold Foundation's first Achievement Award given to an individual. More than 40 books have been published showcasing his Colorado photography. He lives in Summit County, Colo., and operates a fine-art gallery, John Fielder's Colorado, in Denver's Art District on Santa Fe. He teaches photography workshops to adults and children. For information about Fielder and his work, visit www.johnfielder.com.

Bibliography

Published Sources

Bradley, Seth. "The Origin of the Denver Mountain Parks System." *Colorado Magazine 9* (January 1932): 26–29.

Burnett, J.A. "Denver Mountain Parks to be Extended." *Colorado Highways Bulletin,* September 1918.

Cosper, Vanita G. "Faded Lady: The Story of Troutdale-In-The-Pines." *Historically Jeffco 6,* no. 2 (1993): 4–13.

———. "Tourism in Evergreen: Where Have All The Tourists Gone?" *Historically Jeffco 8,* no. 1 (1995): 10–17.

Dittman, Catherine. "John Brisben Walker: The Man and the Myth." *Evergreen Magazine* (Fall/Winter 1978): 21–27.

Downing, Warwick M. "How Denver Acquired Her Celebrated Mountain Parks." *Denver Municipal Facts* (March–April 1931): 12–14, 23, 28.

Etter, Carolyn, and Don Etter. *The Denver Zoo: A Centennial History.* Denver: The Denver Zoological Foundation, 1995.

Friesen, Steve. *Buffalo Bill: Scout, Showman, Visionary.* Golden: Fulcrum Publishing, Inc., 2010.

Gleyre, L.A., and C.N. Alleger. *History of the Civilian Conservation Corps in Colorado, Summer 1936.* Denver: Press of the Western Newspaper Union, 1936.

Goodstein, Phil. *Robert Speer's Denver, 1904–1920: The Mile High City in the Progressive Era.* Denver: New Social Publications, 2004.

Kelly, George V. *The Old Gray Mayors of Denver.* Boulder: Pruett Publishing, 1974.

Leonard, Stephen J., and Thomas J. Noel. *Denver: Mining Camp to Metropolis.* Boulder: University Press of Colorado, 1990.

McMillin, John. "Mountains of Memories, Mountains of Dreams: A History of Skiing in Jefferson County." *Historically Jeffco 10,* no. 18 (1997): 6–14.

Melrose, Frances. "Time Shatters Tycoon's Dream of a Colorado White House." *Rocky Mountain News,* July 10, 1983.

Noel, Thomas J., and Barbara S. Norgren. *Denver: The City Beautiful.* Historic Denver, Inc., 1987.

Noel, Thomas J. *Sacred Stones: Colorado's Red Rocks Park and Amphitheatre.* Edited by Eric Dyce. Denver: Denver Division of Theatres and Arenas, 2004.

Remley, David. *Kit Carson: The Life of an American Border Man.* Norman: University of Oklahoma Press, 2011.

Rex-Atzet, Wendy. "Denver's Mountain Playground: The Denver Mountain Parks, the City Beautiful, and the Rise of Modern Wilderness Recreation in Colorado, 1910–1940." Ph.D. diss., University of Colorado, 2011.

Schneirov, Matthew. *The Dream of a New Social Order: Popular Magazines in America, 1893–1914.* New York: Columbia University Press, 1994.

Simmons, Marc. *Kit Carson and His Three Wives.* Albuquerque: University of New Mexico Press, 2003.

Sternberg, Barbara, and Gene Sternberg. *Evergreen: Our Mountain Community.* Evergreen Kiwanis Foundation, 2004.

Stone, Wilbur Fisk. *History of Colorado, vol. 1.* Chicago: S.J. Clarke, 1919.

Warren, Louis S. *Buffalo Bill's America: William Cody and the Wild West Show.* New York: Knopf, 2005.

West, William Allen. "S.R. DeBoer: An Appreciation," in S.R. DeBoer Pamphlet. Denver Public Library, 1983.

Wetmore, Helen Cody, and Zane Grey. *Last of the Great Scouts: Buffalo Bill.* New York: Grosset and Dunlap, 1918.

White, Sally L. "John Brisben Walker, The Man and Mt. Morrison." *Historically Jeffco 18,* no. 26 (2005): 4–8.

Winter Park: Colorado's Favorite for Fifty Years, 1940–1990. Winter Park Recreational Association, 1989.

Weber, William A. "The Alpine Flora of Summit Lake, Mount Evans, Colorado." *Aquilegia: Newsletter of the Colorado Native Plant Society 15,* no. 4 (1991): 4–10.

———. "Guide for Field Trip to Summit Lake, Colo." VII Congress of the International Association for Quaternary Research, 1965.

Government Documents

An Act Granting Public Lands to the City and County of Denver. Statutes at Large of the United States of America, v. 38, ch. 286, pp. 706–8. Washington, D.C.: GPO, 1915.

Annual City Employees Year Book. City Employees Union of Denver, Colorado, 1939.

City and County of Denver v. Mary Ann Dedisse, et al. Case no. 2157. May 27, 1919. District Court of Jefferson County, Colorado.

Denver Board of Park Commissioners. *Annual Report for the Year 1913.* Denver: Williamson-Haffner Co., 1913.

Denver Mountain Parks Charter Amendment. Denver City Ordinances. Ordinance No. 56, Series 1912, pp. 17–18.

Denver Mountain Parks. Historic Documents, Clippings, and Departmental Records. Denver Mountain Parks Headquarters, Morrison.

Denver Municipal Facts, 1909–1912; *City of Denver,* 1912–1914; *Municipal Facts,* 1918–1931. The city's house news organ was published in weekly, monthly, and bimonthly editions under three different names from 1909–1931.

Denver Parks and Recreation. *Denver Mountain Parks Master Plan.* 2008.

———. *Denver Mountain Parks Strategic Plan.* 2000.

———. *Game Plan.* 2003.

———. *Metro Mountain Recreation and Open Space Project.* 1989.

———. Genesee Experiential Outdoor Center Brochure. http://www.denvergov.org/Portals/626/documents/recreation/Outdoor_GeneseeBroch2012.pdf

Denver Year Book: Presenting the Municipal Facts of a Great City. Denver: F.J. Wolf, 1943.

Halpin, Kelly. "Red Rocks Park & Amphitheater: Evolution of the Landscape." Report to National Park Service. March 30, 2012.

Jefferson County, Colorado. "Jefferson County Historical Census Population, 1870–2010."

Mountain Parks Committee. "Executive Committee Report to the Joint Committee of the Mountain Park Project." December 7, 1911. In Records of the Olmsted Associates, Series B, Job No. 5582.

National Association of Civilian Conservation Corps Alumni (NACCCA), Chapter 7. Alumni records and interviews. Collection housed at Denver Mountain Parks Headquarters, Morrison.

National Natural Landmark Program. Nomination for Summit Lake Park, prepared by William A. Weber, 1964.

National Register of Historic Places. Denver Mountain Parks, Multiple Property Submissions. Registration Forms for Red Rocks Park/Mt. Morrison Civilian Conservation Corps Camp/Morrison Park District, Corwina/O'Fallon/Pence Park District, Dedisse, Bergen, Genesee, Colorow Point, Lookout Mountain, Bear Creek Scenic Mountain Drive, and Lariat Trail Scenic Mountain Drive, prepared by Ann Moss, 1988. Registration Forms for Echo Lake, Summit Lake, Daniels, Katherine Craig, Fillius, Little, Starbuck, prepared by Maureen van Norden, 1995.

Senate Bill No. 302, 15 April 1913. *Laws Passed at the Nineteenth Session of the General Assembly of the State of Colorado, 1913.* pp. 422–24.

State Historical Fund, History Colorado Center. "Grants Awarded through Fiscal Year 2012."

Newspapers

Canyon Courier, 1963–2006.

Clear Creek Courant, February 12, 1997.

Colorado Transcript, 1912–2012.

The Denver Post, 1906–2012.

Denver Republican, May 15, 1906.

Denver Times, 1906–1914.

Jefferson County Republican, June 12, 1941.

New York Times, March 31, 2004.

Rocky Mountain News, 1907–2012.

Westword, 1994–2004.

Manuscripts and Collections

American Bison Society Papers. Conservation Collection, Denver Public Library.

Buffalo Bill Museum and Grave Archives. Golden, Colo.

Burnham Hoyt Papers. Western History Collection, Denver Public Library.

Denver Chamber of Commerce Collection, WH1216, Western History Collection, Denver Public Library.

Denver Parks and Recreation Department Collection, WH1316, Western History Collection, Denver Public Library.

John Brisben Walker Clipping File. Western History Collection, Denver Public Library.

John Brisben Walker Files. Jefferson County Historical Society.

Kingsley A. Pence Scrapbook. Stephen H. Hart Library, History Colorado Center.

Olmsted Brothers. Records of the Olmsted Associates, Series B, Job No. 5580 and 5582. Western History Collection, Denver Public Library.

S.R. DeBoer Papers. Western History Collection, Denver Public Library.

Interviews and Correspondence

Baird, Susan. Interview by Sally L. White, January 24, October 12, 2012.

Berger, W. Bart. Interview by Sally L. White, 2012.

Carle, Bill (H.W. Stewart Co.). Interview by Sally L. White, January 8, 2013.

Christie, David. Interview by Sally L. White, October 2, 2012.

Etter, Carolyn. Interview by Sally L. White, December 1, 2012.

Friesen, Steve. Email correspondence with Sally L. White, December 27, 2012.

Gannon, Richard. Interview by Sally L. White, 2012.

Hillyard, Fabby. Interview by Sally L. White, November 27, 2012, and email correspondence.

Homola, Martin. Interview by Sally L. White, April 11, 2012.

Tall Bull, William. Interview by Sally L. White, 2012.

Tripp-Addison, A.J. Interviews by Sally L. White, March 31, October 16, December 10, 2012.

Index

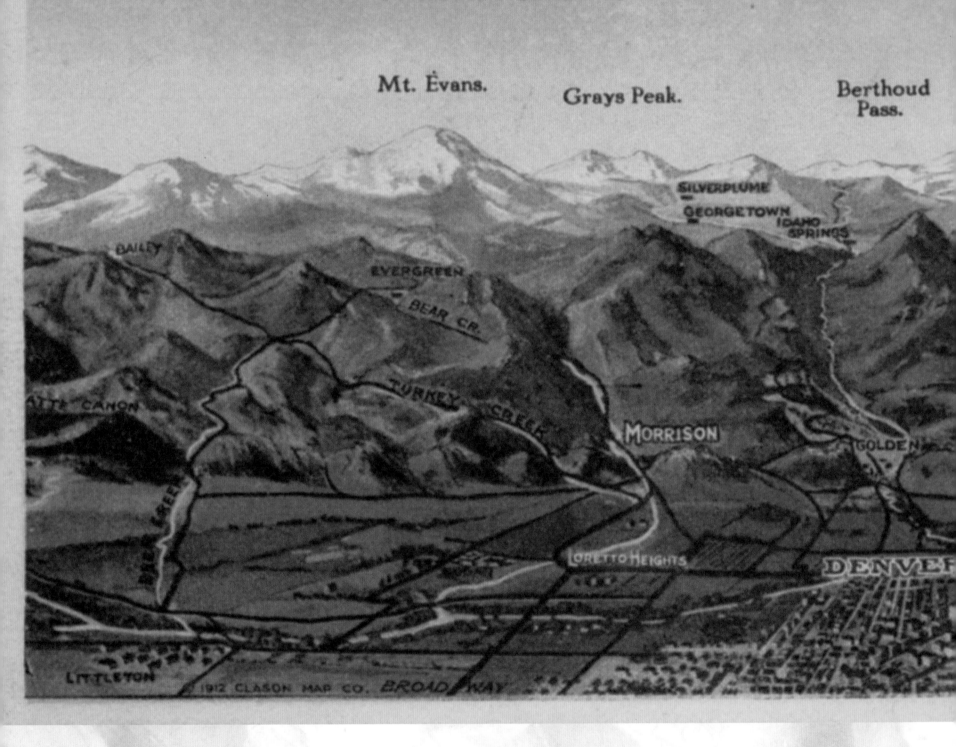